Cool Hotels
Asia Pacific

teNeues

Editor in chief: Paco Asensio

Project coordination and text: Llorenç Bonet

Art director: Mireia Casanovas Soley

Layout: Emma Termes Parera

Research: Marta Casado Lorenzo

German translation: Martin Fischer

French translation: Michel Ficerai

Italian translation: Grazia Suffriti

Published by teNeues Publishing Group

teNeues Publishing Company
16 West 22nd Street, New York, NY 10010, USA
Tel.: 001-212-627-9090, Fax: 001-212-627-9511

teNeues Book Division
Kaistraße 18
40221 Düsseldorf, Germany
Tel.: 0049-(0)211-994597-0, Fax: 0049-(0)211-994597-40

teNeues Publishing UK Ltd.
P.O. Box 402
West Byfleet
KT14 7ZF, Great Britain
Tel.: 0044-1932-403509, Fax: 0044-1932-403514

teNeues France S.A.R.L.
4, rue de Valence, 75005 Paris, France
Tel.: 0033-1-55 76 62 05, Fax: 0033-1-55 76 64 19
www.teneues.com

ISBN: 3-8238-4581-0

Editorial project: © 2004 LOFT Publications
Via Laietana 32, 4º Of. 92
08003 Barcelona, Spain
Tel.: 0034 932 688 088
Fax: 0034 932 687 073
e-mail: loft@loftpublications.com
www.loftpublications.com

Printed by: Anman Gràfiques del Vallès, Spain
2004

Bibliographic information published by
Die Deutsche Bibliothek.
Die Deutsche Bibliothek lists this publication
in the Deutsche Nationalbibliografie;
detailed bibliographic data is available
in the Internet at http://dnb.ddb.de

The tourist lure of the Asiatic coast and the islands of the Pacific has always been based on the attraction of their paradisiacal landscapes and the refinement of their exotic cultures, two commonplaces that have remained fixed in the popular Western tradition since Paul Gauguin painted his famous scenes of Tahiti more than 100 years ago. When the painter set himself up in the Pacific, the region was part of a series of still little explored colonies. Now, a century later, this part of the planet is clearly aiming to be future world power, since it is currently registering one of the highest growths of the global economy. This enormous change is reflected in the tourist industry: until the 1970s the zone was frequented basically by tourists with buying power in search of peace, luxury and exoticism, or else by people with fewer resources who saw in the region an alternative to the Occident, contact with nature and a little known spirituality. Those who visit the Pacific tend to do so with aims that blend these two visions, but now a third way has been added: the business trip. And in their turn, Japan and Hong Kong, two traditionally economical destinations, have also become tourist destinations. This is true above all of the former, both because of its interior tourism and because of the increased mobility of recent years.

Within the framework of this situation, Australia is enjoying the advantage of its geographical proximity to the Asiatic continent in the development of its changes. Its expectations in terms of economic growth in the years to come are highly optimistic. And in regard to tourism, it now offers a business/holiday fusion in determined destinations like Sydney, Melbourne, New Zealand

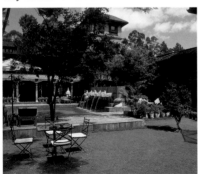
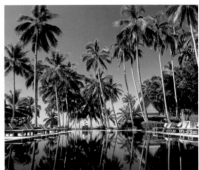

and, in general, all of the East Coast that is very close to what the neighboring continent can offer.

The regions of the Asiatic interior are undergoing an equally favorable but much slower evolution. Witness, for example, the north of India and Nepal, with their super-high quality tourist enclaves. There is also the Middle East, which represents a great unknown: the cradle of civilization is in a permanent situation of armed conflict that keeps the region from exploiting its tourist offers. It has become a barrier between Europe and Asia. A major change in this situation in conjunction with a Turkey capable of acting as a cultural hinge between both continents would help this region to undertake a new phase in its development.

In this globalized panorama where the intentions of the traveler include more than a single type of demand, the hotel industry has adapted to the new reality of each zone. One of its main lures is the spectacular natural landscape, but there is an ever greater need not only for well cared for services but also the possibility of satisfying both the vacation-maker and the business type—who are often the same person. This is why the idea of a boutique-hotel has become so extended in recent years. It is a resource with trips that are adaptable to the specific needs of each customer, both in coastal zones considered purely touristic and in large financial capitals. Their offer includes both: business resources—fast Internet connection, good communications—and vacation resources—spas, cool ambience, and a varied recreational offer.

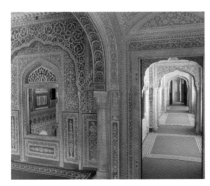
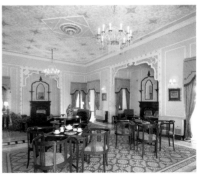

Seit Paul Gauguin vor über 100 Jahren seine berühmten Bilder auf Tahiti malte, sind paradiesische Landschaften und der Reiz exotischer Kulturen für Reisende aus dem Westen die wichtigsten Anziehungspunkte der Küsten des Pazifiks und der Inseln in der Südsee geblieben. Als der französische Maler sich in der Südsee niederließ, waren die Inseln noch kaum erforschte Kolonien europäischer Großmächte, doch ein Jahrhundert später ist diese Weltgegend auf dem besten Wege, eine bedeutende Wirtschaftsmacht zu werden, denn sie weist eine der höchsten Wachstumsraten weltweit auf. Diese Entwicklung spiegelt sich auch im Tourismus wider. Bis in die siebziger Jahre besuchten vor allem gut situierte Touristen mit großer Kaufkraft auf der Suche nach Ruhe, Luxus und Exotik die Region oder es kamen weniger wohlhabende Menschen dorthin, die eine Alternative zum westlichen Lebensstil suchten, ein Leben im Einklang mit der Natur und eine ungekannte Spiritualität. Unter den Besuchern der Pazifikregion finden sich zwar heute auch noch Vertreter dieser beiden Kategorien, aber es hat sich eine dritte dazugesellt: die Geschäftsreisenden. Und auf der anderen Seite sind Japan und Hong Kong, zwei traditionelle Geschäftsziele, auch zu touristischen Reisezielen geworden. Vor allem in Japan ist eine ansteigende Tendenz beim Inlands- und Auslandstourismus zu beobachten.

Auch die wirtschaftliche Entwicklung in Australien profitiert von der geografischen Nähe zum südostasiatischen Kontinent. Die Wachstumsperspektiven für die nächsten Jahre sind sehr optimistisch und man erwartet wie in Südostasien eine Überlagerung touristischer und geschäftlicher Aufenthalte, vor allem in Zentren wie Sydney und Melbourne sowie an der Ostküste und in Neuseeland.

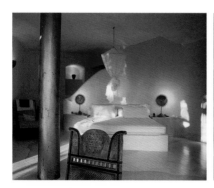
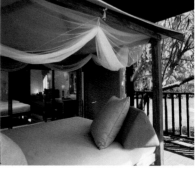

Die Länder im Inneren des asiatischen Kontinentes machen ebenfalls eine, wenn auch sehr viel langsamere Aufwärtsentwicklung durch. Dies gilt vor allem für Nordindien und Nepal, wo es bereits hochwertige touristische Einrichtungen gibt. Sehr viel ungewisser sieht die Zunkunft dagegen im Mittleren Osten, der Wiege bedeutender Zivilisationen des Alterums, aus. Die andauernden Kriegswirren lassen eine Nutzung des touristischen Potenzials der Region nicht zu, die so zu einer Barriere zwischen Europa und Asien geworden ist. Eine Schlüsselrolle in dieser Situation kommt der Türkei zu, die in kultureller Hinsicht gewissermaßen als Scharnier zwischen den beiden Kontinenten fungieren und zum Auslöser einer neuen Entwicklungsetappe in der Region werden kann.

Die Hotelbranche hat sich im Zuge der fortschreitenden Globalisierung den veränderten Gegebenheiten in jeder Weltgegend anzupassen gewusst und ist bemüht, eine passende Unterkunft für alle Bedürfnisse anzubieten. Zu den zugkräftigsten Argumenten für eine Reise nach Südostasien zählt zwar immer noch die atemberaubende landschaftliche Schönheit, aber es gilt mittlerweile, guten Service zu bieten und nicht nur den Touristen, sondern auch den Geschäftsreisenden zufrieden zu stellen – vor allem da es sich dabei immer häufiger um ein und dieselbe Person handelt. In den letzten Jahren hat sich daher das Konzept des Boutique-Hotels immer mehr durchgesetzt, erlaubt es doch, auf die Bedürfnisse jedes einzelnen Gastes zugeschnittene Angebote zu machen, und zwar sowohl in den als rein touristisch geltenden Küstengebieten als auch in den großen Finanzmetropolen: Berücksichtigt werden sowohl die Wünsche der Geschäftsreisenden – Internetanschluss, gute Verkehrsverbindungen – als auch die Vorlieben der Erholungsurlauber – durchgestyltes Ambiente, Wellnesseinrichtungen und ein umfassendes Freizeitangebot.

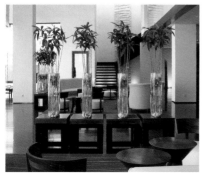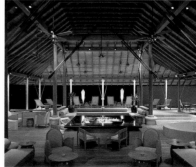

La publicité touristique de la côte asiatique et des îles du Pacifique se fonde depuis toujours sur l'attrait de ses paysages paradisiaques et le raffinement de ses cultures exotiques, deux clichés inscrits dans la tradition populaire occidentale depuis leur illustration par Paul Gauguin dans ses célèbres scènes de Tahiti, il y a plus de cent ans. Lorsque le peintre s'établit dans le Pacifique, la région faisait partie de colonies encore peu explorées. Aujourd'hui, un siècle ayant passé, cette partie de la planète affiche clairement ses ambitions de future puissance mondiale, se targuant d'un des taux de croissance les plus élevés de l'économie mondiale. Ce changement spectaculaire se reflète dans l'industrie du tourisme : avant les années 70, cette zone était visitée essentiellement par des touristes bénéficiant d'un pouvoir d'achat élevé et en quête de tranquillité, de luxe et d'exotisme, ou par des voyageurs moins fortunés imaginant cette destination comme une alternative à l'Occident, au contact de la nature et d'une spiritualité encore peu connue. Actuellement, les visiteurs du Pacifique associent ces deux visions pour lui en ajouter une troisième, le voyage d'affaires. À leur tour, le Japon et Hong Kong, deux destinations traditionnellement économiques, se sont également convertis en objectifs touristiques. Surtout le premier, tant pour son tourisme intérieur que pour la majeure mobilité de ces dernières années.

Dans cette conjoncture, l'Australie jouit de l'avantage d'une proximité géographique avec le continent asiatique dans le déroulement de son évolution. Ses attentes en termes de croissance économique pour les prochaines années sont très optimistes et, pour ce qui est du tourisme, il présente déjà une fusion affaires/vacances – en certains endroits comme Sydney, Melbourne, la Nouvelle

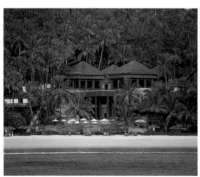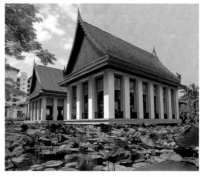

Zélande et, d'une manière générale, toute la côte orientale – très similaire à celle du continent voisin.

Les régions de l'intérieur du continent asiatique connaissent une évolution tout aussi favorable, bien que plus lente. Le Nord de l'Inde et le Népal en sont la preuve, terres d'accueil d'enclaves touristiques de qualité. D'autre part, le Moyen Orient se pose en grande inconnue : berceau des civilisations majeures, la situation de conflit guerrier permanent qu'il expérimente ne lui permet pas d'exploiter sa face touristique et l'a converti en une barrière entre l'Europe et l'Asie. Un changement drastique de situation combiné à capacité de la Turquie, à même culturellement de s'offrir en charnière entre les deux continents pourrait aider cette région à entamer une nouvelle étape de son développement.

Dans un panorama globalisé où les intentions du voyageur couvrent plus d'un seul type de demande, l'industrie hôtelière s'est adaptée à la nouvelle réalité de chaque zone. Ses paysages naturels spectaculaires constituent l'un de ses principaux attraits. Cependant, deviennent chaque jour davantage nécessaires non seulement des services soignés mais aussi la capacité de satisfaire le vacancier comme l'homme d'affaires – bien souvent une même et unique personne. Pour cette raison, le concept de « boutique-hôtel » s'est-il répandu ces dernières années. Il s'agit d'une ressource proposant des offres ajustables aux nécessités spécifiques de chaque client, tant pour les zones côtières censément uniquement touristiques que pour les grandes capitales financières. Son offre inclut des ressources d'affaires – connexion Internet à haut débit, communications satisfaisantes – mais aussi vacancières – balnéaire, ambiance cool et ludique.

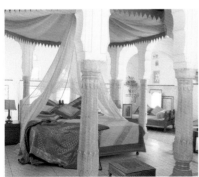 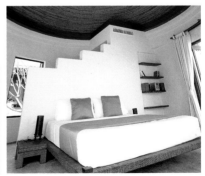

El reclamo turístico de la costa asiática y de las islas del Pacífico se ha basado siempre en el atractivo de sus paisajes paradisiacos y en el refinamiento de sus exóticas culturas, dos tópicos que quedaron fijados en la tradición popular occidental desde que Paul Gauguin pintara sus famosas escenas de Tahití hace más de cien años. Cuando el pintor se estableció en el Pacífico la región formaba parte de unas colonias aún poco exploradas, sin embargo ahora, después de un siglo, esta parte del planeta apunta claramente a ser una futura potencia mundial, pues registra uno de los crecimientos más elevados de la economía global. Este enorme cambio se refleja en la industria turística: hasta los años setenta esta zona era visitada básicamente por turistas con un alto poder adquisitivo que buscaban tranquilidad, lujo y exotismo, o bien por gentes con menos recursos que veían en este destino una alternativa a Occidente, contacto con la naturaleza y una espiritualidad poco conocida. En la actualidad, quienes visitan el Pacífico lo hacen con objetivos que aúnan estas dos visiones, pero además se ha añadido una tercera vía, la del viaje de negocios. A su vez, Japón y Hong Kong, dos destinos tradicionalmente económicos, se han convertido también en destinos turísticos; sobre todo el primero, tanto por el turismo interior como por la mayor movilidad de los últimos años.

En el marco de esta coyuntura, Australia disfruta de la ventaja de la cercanía geográfica con el continente asiático en el desarrollo de su evolución. Su expectativa en cuanto al crecimiento económico de los próximos años es muy optimista y en lo que respecta al turismo ya presenta una fusión negocios/vacaciones en determinados puntos como Sydney, Melbourne,

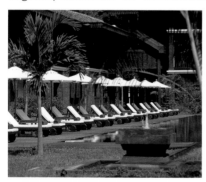
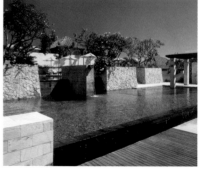

Nueva Zelanda y en general toda la costa oriental muy similar a la que ofrece el continente vecino.

Las regiones del interior asiático están experimentado una evolución igualmente favorable aunque mucho más lenta. El testigo lo llevan el norte de la India y Nepal, donde ya existen enclaves turísticos de alta calidad. Por otra parte, Oriente Medio supone una gran incógnita; cuna de grandes civilizaciones, la permanente situación de conflicto bélico que vive no le permite explotar su vertiente turística y la ha convertido en una barrera entre Europa y Asia. Un cambio rotundo de esta situación en conjunción con una Turquía que culturalmente puede actuar como bisagra entre ambos continentes ayudaría a esta región a emprender una nueva etapa en su desarrollo.

En este panorama globalizado donde las intenciones del viajante abarcan más de un tipo de demanda, la industria hotelera se ha adaptado a la nueva realidad de cada zona. Uno de sus máximos reclamos lo constituye el espectacular paisaje natural, pero cada vez son necesarios no sólo servicios bien cuidados sino también la posibilidad de satisfacer tanto al cliente vacacional como al empresario –que son en muchas ocasiones la misma persona–. Por esta razón la idea de boutique-hotel se ha extendido en los últimos años; es un recurso que plantea ofertas ajustables a las necesidades específicas de cada cliente, tanto en zonas costeras consideradas puramente turísticas como en grandes capitales financieras. Su oferta incluye tanto recursos de negocios –conexión rápida a internet, buenas comunicaciones– como vacacionales –spas, ambiente cool y variada oferta lúdica–.

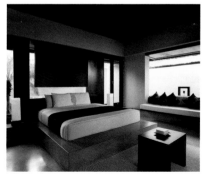 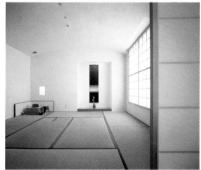

La promozione turistica della costa asiatica e delle isole del Pacifico è stata sempre basata sul fascino dei suoi paesaggi paradisiaci e sulla raffinatezza della cultura esotica, due luoghi comuni rimasti fermi nella tradizione popolare occidentale da quando Paul Gaugin dipinse le sue famose scene di Tahiti più di cent'anni fa. Quando il pittore si stabilì nel Pacifico la regione formava parte di alcune colonie ancora poco esplorate, ciò nonostante ora, dopo un secolo, questa parte del pianeta aspira chiaramente ad essere una futura potenza mondiale, visto che registra una delle crescite più elevate dell'economia globale. Quest'enorme cambiamento si riflette sull'industria turistica: fino agli anni settanta la zona era visitata fondamentalmente da turisti con un alto potere acquisitivo in cerca di tranquillità, lusso ed esotismo, o semmai da gente con meno risorse economiche che vedeva in questo destino un'alternativa all'Occidente, un contatto con la natura ed una spiritualità ancora poco conosciuta. Attualmente chi visita il Pacifico lo fa con l'obiettivo di unire queste due visioni, ed inoltre si è aggiunta una terza via, quella dei viaggi d'affari. Il Giappone ed Hong Kong, due destini tradizionalmente economici, si sono trasformati in destini turistici, soprattutto il primo, sia per il turismo interno che per la maggior mobilità degli ultimi anni.

L'Australia, alla luce di queste circostanze, si è avvantaggiata dalla vicinanza geografica col continente asiatico. La sua prospettiva di crescita economica per i prossimi anni è molto ottimista e, per ciò che riguarda il turismo, mostra già una combinazione affari/vacanze in punti determinati come Sidney, Melbourne, Nuova Zelanda ed in generale in tutta la costa orientale, molto simile a quella che offre il continente vicino.

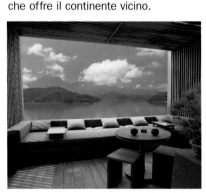
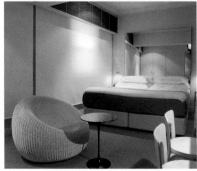

Anche le regioni interne del continente asiatico stanno sperimentando un'evoluzione favorevole, però molto più lenta. In testa sono India e Nepal, dove già esistono zone turistiche di alta qualità. D'altra parte il Medio Oriente ipotizza una grande incognita; culla di grandi civiltà, la permanente situazione di conflitto bellico che vive non le permette di sfruttare il suo versante turistico e l'ha convertito in una barriera tra Europa ed Asia. Un netto cambiamento di questa situazione insieme ad una Turchia che culturalmente può agire come cerniera tra i due continenti, aiuterebbe questa regione ad intraprendere una nuova tappa del proprio sviluppo.

In questo panorama globalizzato, dove le intenzioni del viaggiatore abbracciano vari tipi di domanda, l'industria alberghiera si è adattata alla nuova realtà in ogni zona. Uno dei suoi massimi richiami è costituito dallo spettacolare paesaggio naturale, però ogni volta di più sono necessari non solo servizi ben curati ma anche la possibilità di soddisfare sia il cliente vacanziero che l'impresario, che in molte occasioni sono la stessa persona. Per questo motivo l'idea della boutique-hotel si è estesa tanto negli ultimi anni; è una risorsa che propone offerte adattabili alle necessità specifiche di ogni cliente, sia in zone costiere considerate puramente turistiche, che in grandi capitali finanziarie. La loro offerta include sia proposte d'affari – come l'accesso rapido a internet e buone comunicazioni – che vacanziere – come centri benessere, un ambiente cool ed una variata offerta ricreativa.

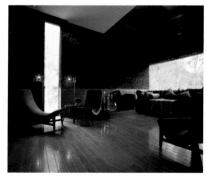
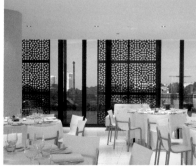

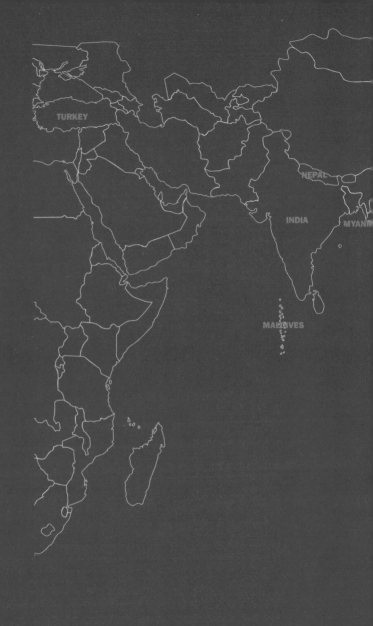

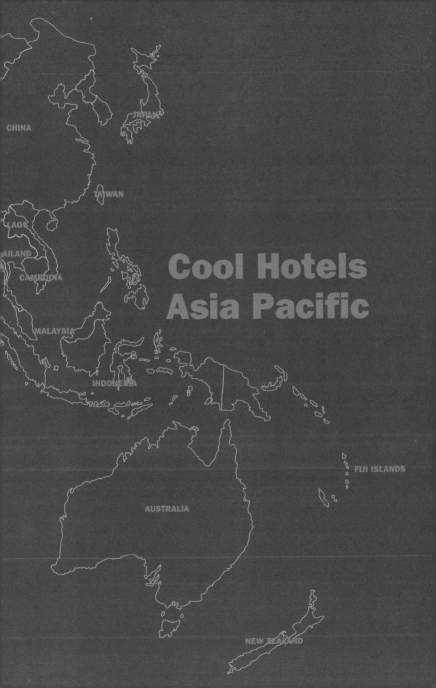

Cool Hotels
Asia Pacific

CHINA

JAPAN

TAIWAN

LAOS

AILAND

CAMBODIA

MALAYSIA

INDONESIA

FIJI ISLANDS

AUSTRALIA

NEW ZEALAND

West Asia and Indian Subcontinent

Turkey
Maldives
Nepal
India

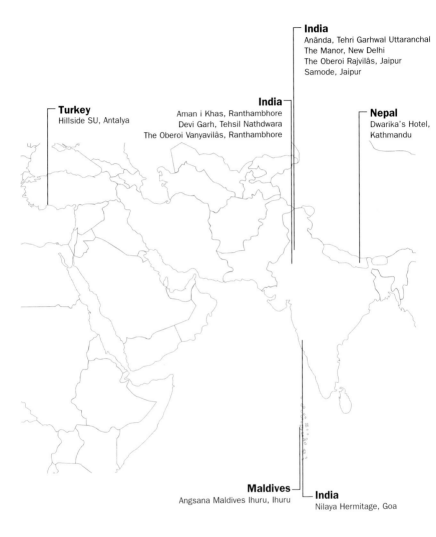

Turkey
Hillside SU, Antalya

India
Aman i Khas, Ranthambhore
Devi Garh, Tehsil Nathdwara
The Oberoi Vanyavilâs, Ranthambhore

India
Anânda, Tehri Garhwal Uttaranchal
The Manor, New Delhi
The Oberoi Rajvilâs, Jaipur
Samode, Jaipur

Nepal
Dwarika's Hotel,
Kathmandu

Maldives
Angsana Maldives Ihuru, Ihuru

India
Nilaya Hermitage, Goa

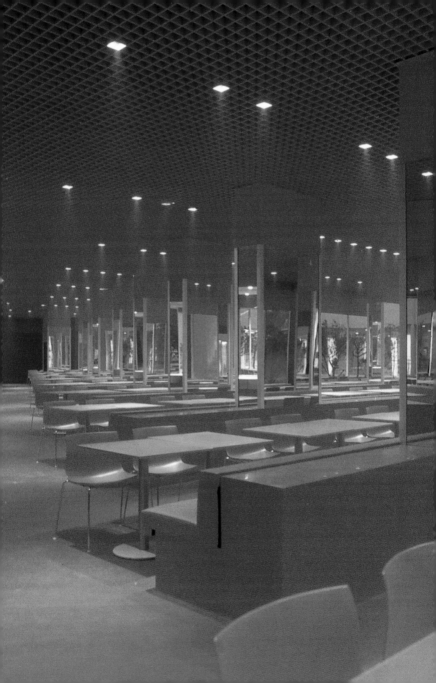

Hillside SU

Address: **Konyaalti, Antalya,**
Turkey
Tel.: **+90 242 249 0700**
Fax: **+90 242 249 0707**
www.hillside.com.tr

Architect: **Eren Talu**
Opening date: **2003**
Photos: **© Tamer Yilmaz**

21

Style: Contemporary design

Rooms: 294

Special features: Stunning design for
a dynamic lifestyle

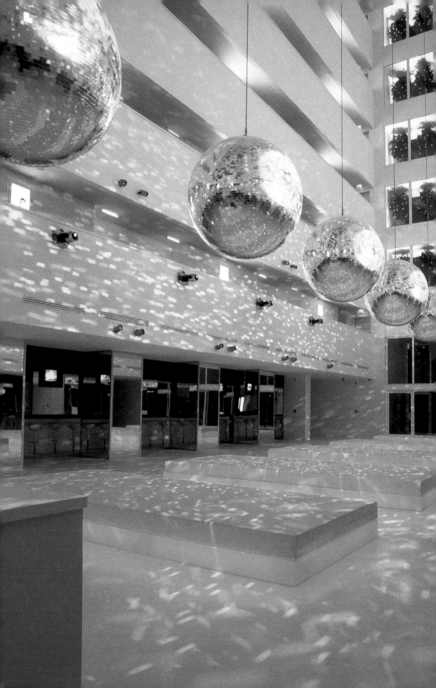

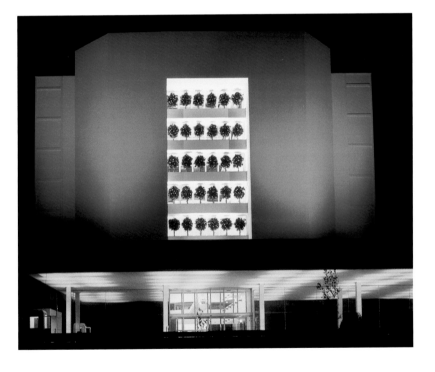

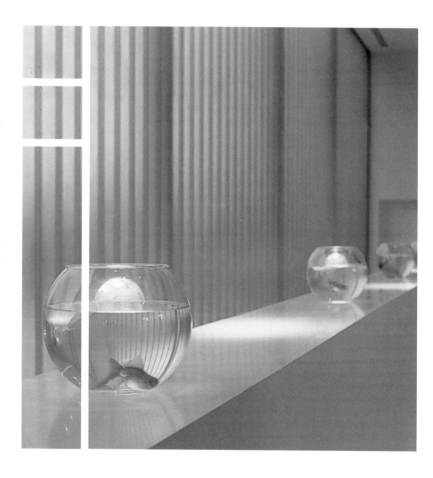

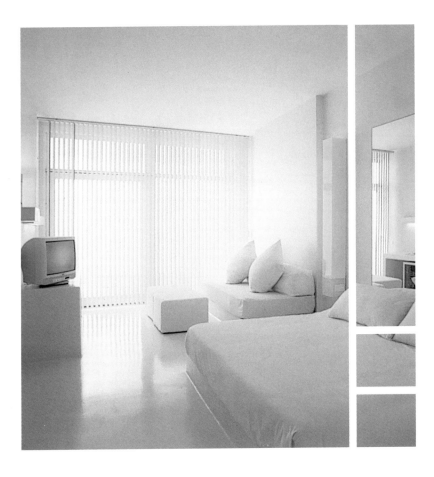

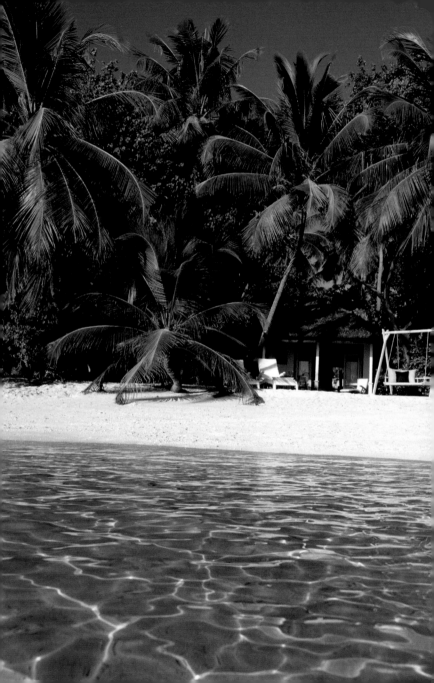

Angsana Maldives Ihuru

Address: **Ihuru, North Malé Atoll,**
 Maldives
Tel.: **+960 443502**
Fax: **+960 445933**
www.angsana.com

Architect: **Ho Kwoncjan/Architrave Design & Planning**
Interior Designer: **Dharmali Kusumadi/Architrave Design**
 & Planning
Opening date: **2001**
Photos: **© Angsana Media**

27

Style: Minimal & Pacific

Rooms: 45 villas

Special features: Spectacular environment

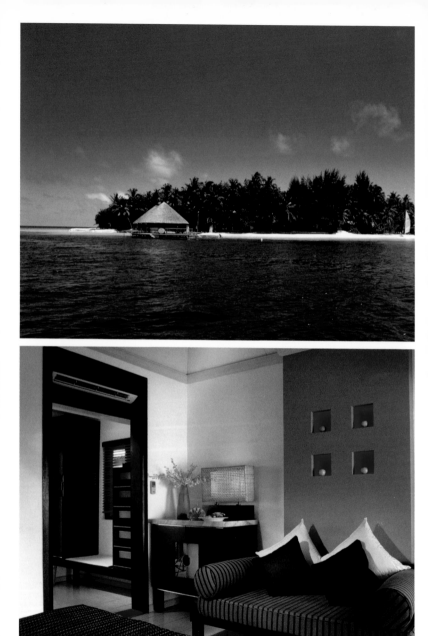

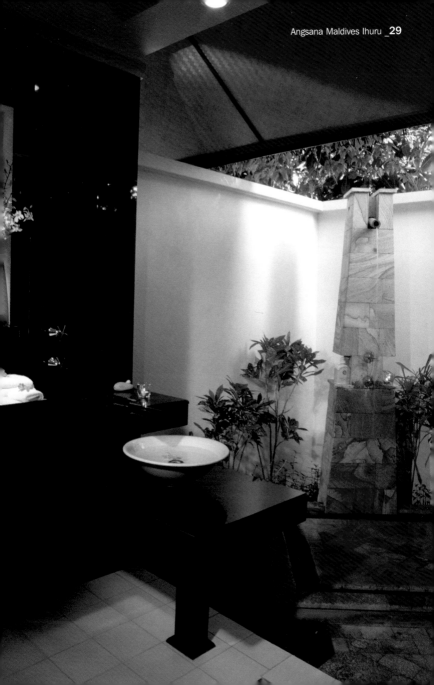

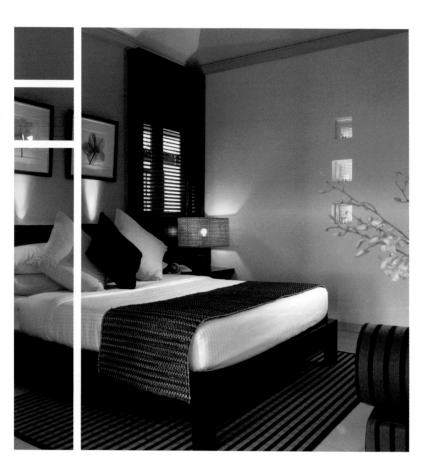

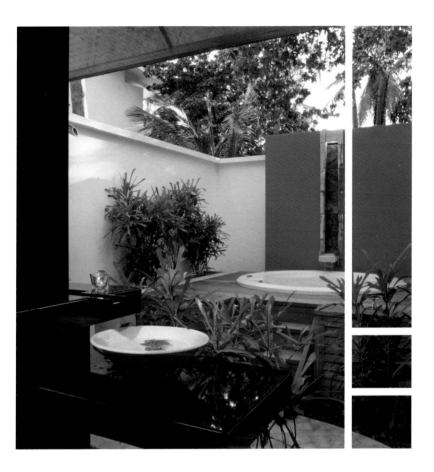

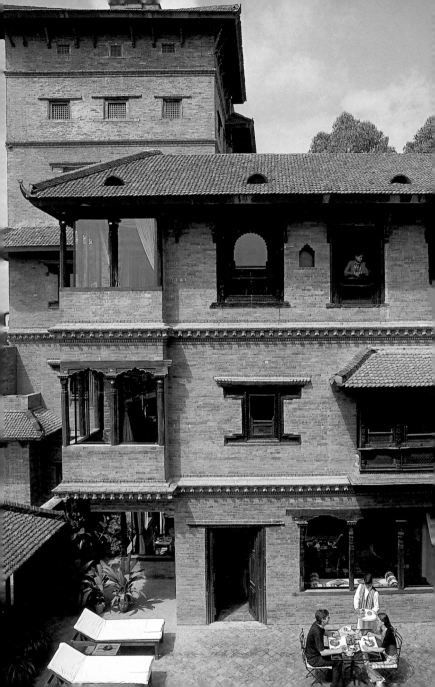

Dwarika's Hotel

Address: **P.O. Box 459, Battisputali,**
Kathmandu, Nepal
Tel.: **+977 1 4479488**
Fax: **+977 1 4478378**
www.dwarikas.com

Design and restoration: **Dwarika Das Shrestha**
Opening date: **1998**
Photos: **© Dwarika Hotel**

33

Style: Newari style restored

Rooms: 74 deluxe rooms and suites

Special features: The hotel is committed to the sustainable development of the area, so all the refurbishings have been made by local craftsmen

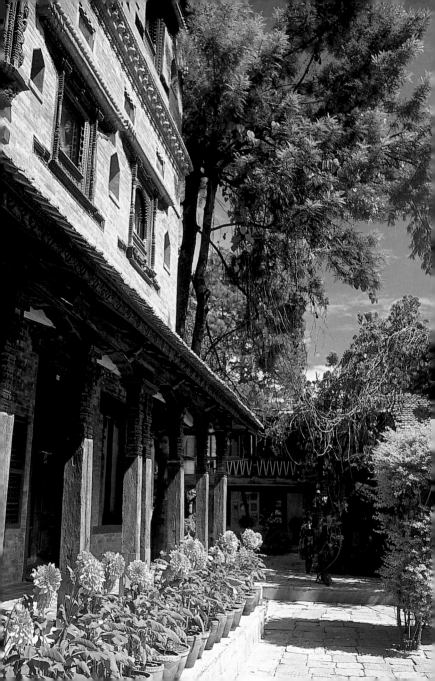

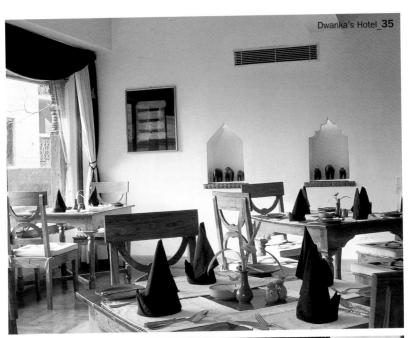

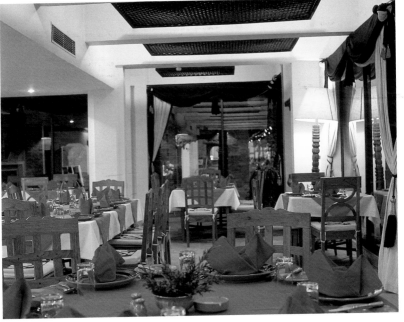

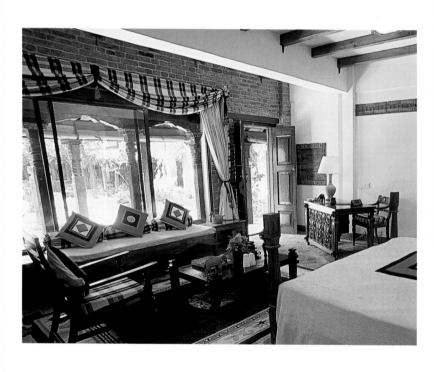

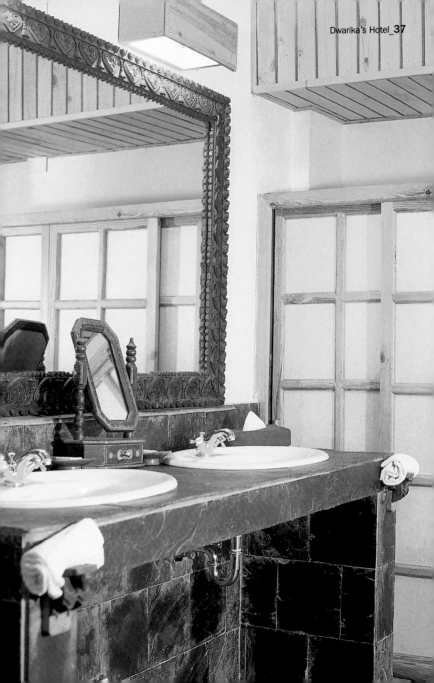

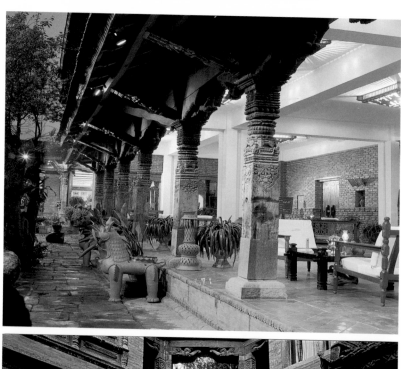

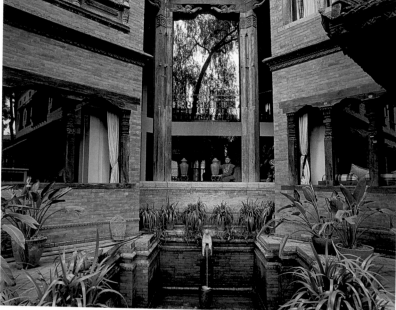

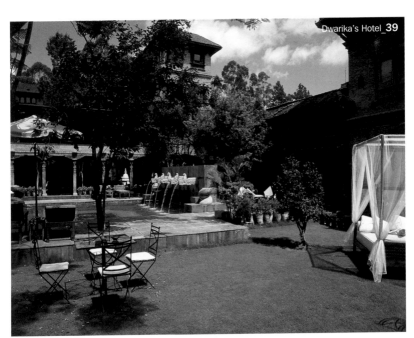

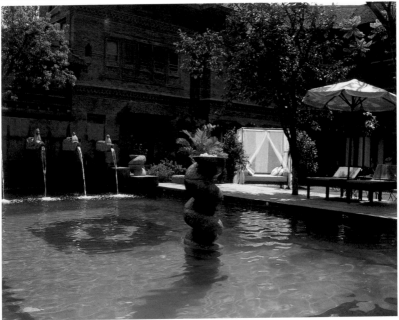

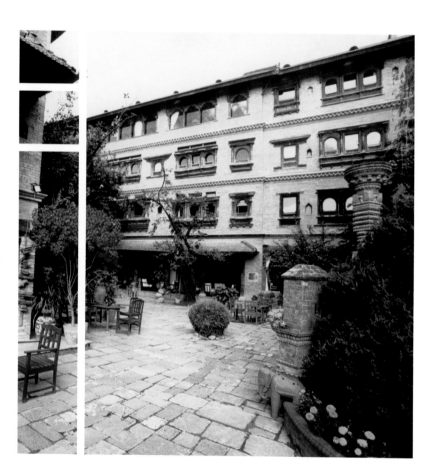

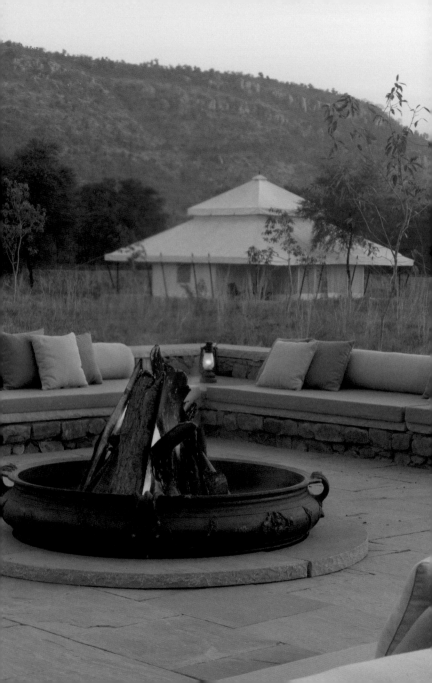

Aman i Khas

Address: **Aman i Khas,**
 Ranthambhore, Rajasthan, India
Tel.: **+91 7462 252052**
Fax: **+91 7462 252178**
www.amanresorts.com

Architect: **Jean-Michel Gathy**
Opening date: **2003**
Photos: **© Amanresorts**

43

Style: Inspired by the bygone era of local traveling tents

Rooms: 10 tents

Special features: Set in the rugged hills of Rajasthan on the outskirts of Ranthambhore National Park

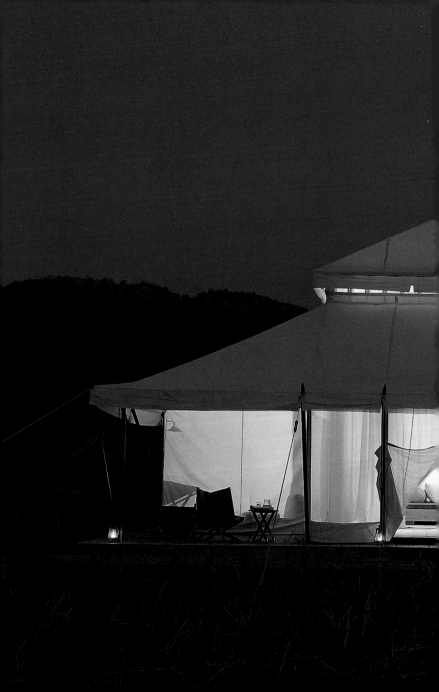

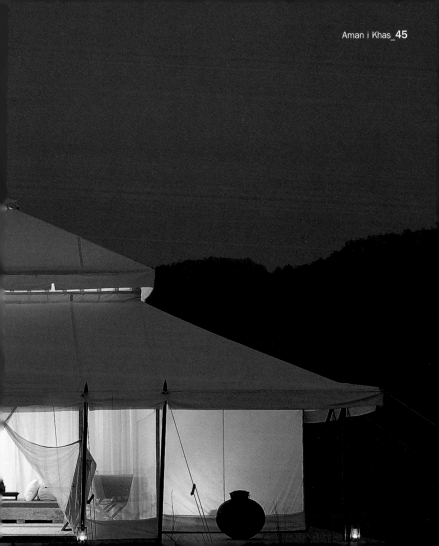

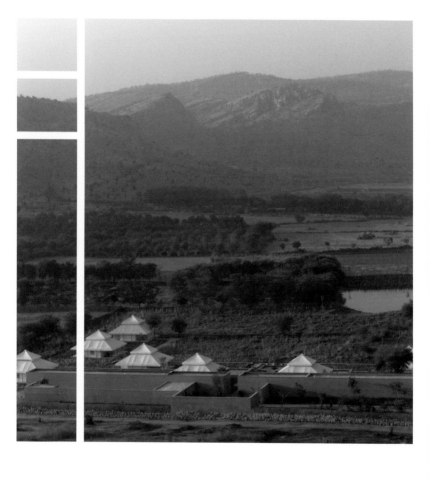

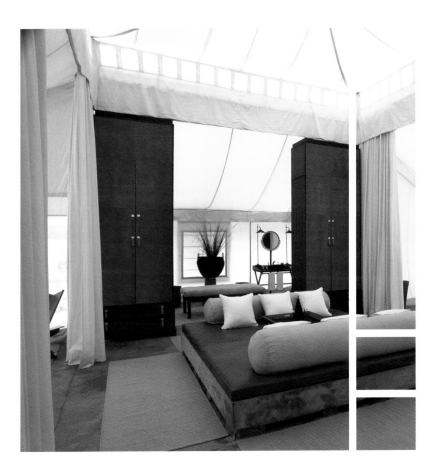

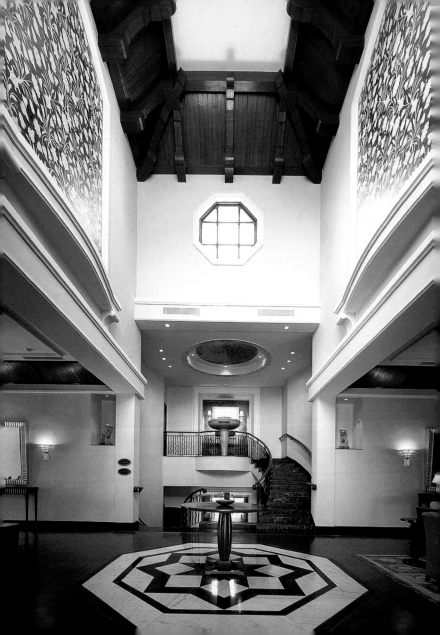

Anânda

Address: **The Palace Estate, Rishikesh,**
Tehri Garhwal Uttaranchal 249175, India
Tel.: **+91 1378 227500**
Fax: **+91 1378 227550**
www.anandaspa.com

Architect & designers: **Chada, Siembieda & Associates**
Opening date: **2000**
Photos: © **Anânda**

49

Style: XIX century palace restored

Rooms: 70 deluxe rooms and 5 suites

Special features: Healthy environment with
ayurveda and yoga programs;
spa of 21,000 sq. feet area
(1,950 m²)

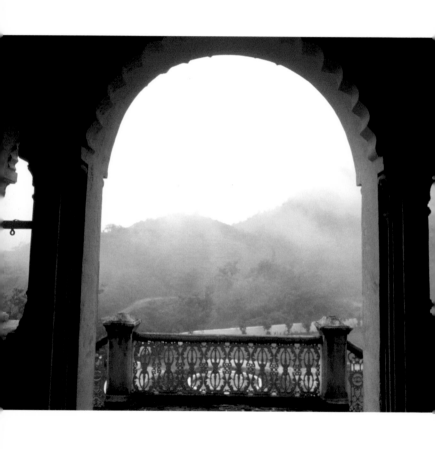

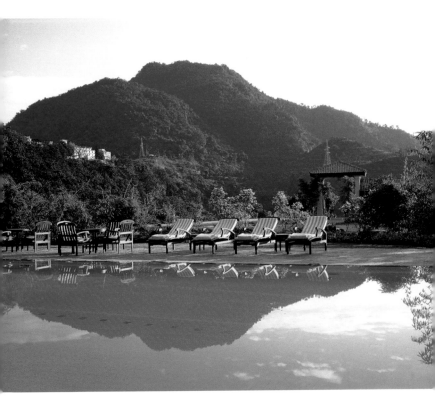

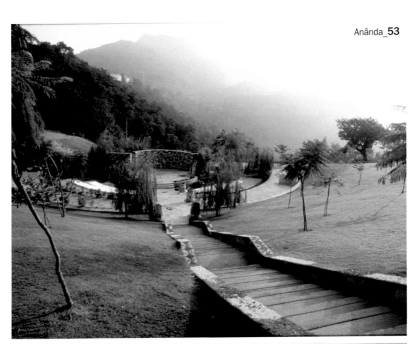

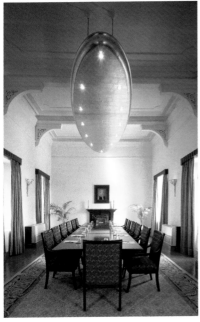

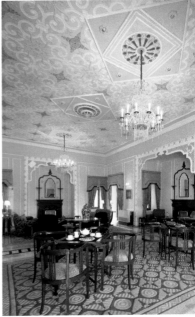

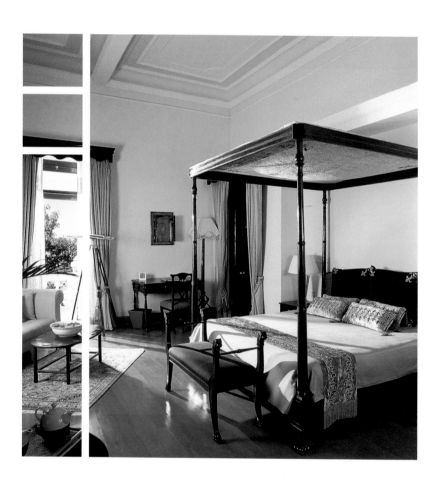

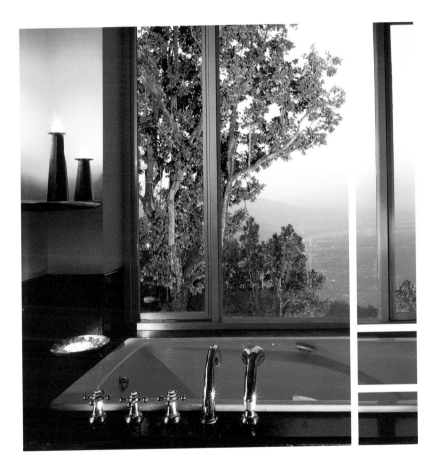

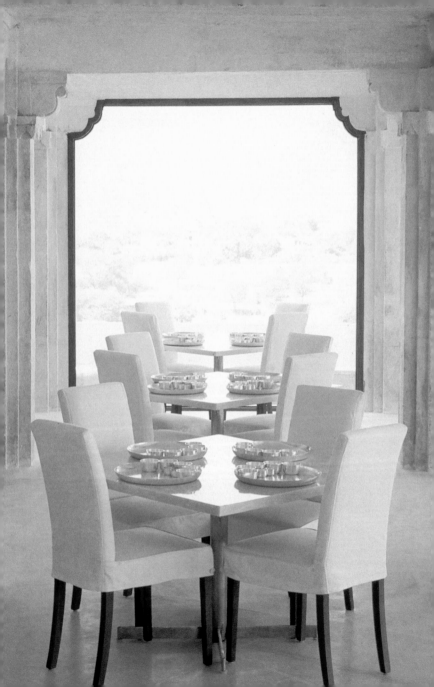

Devi Garh

Address: **Village Delwara, Tehsil Nathdwara,**
 Dist. Rajsamand, Rajasthan, India
Tel.: **+91 2953 289211**
Fax: **+91 2953 289357**
www.deviresorts.com

Owner & designer: **Heike Thelen,**
 Gerd Tepass
Architects: **Gautam Bhatia, Naveen Gupta**
Interior design: **Rajiv Saini**
Opening date: **1997**
Photos: © **Amit Pasricha**

57

Style: Indian style

Rooms: 23 suites and 6 luxury tents

Special features: Local materials like marble and semi-precious stones have been used in the restoration of this XVIII century fort

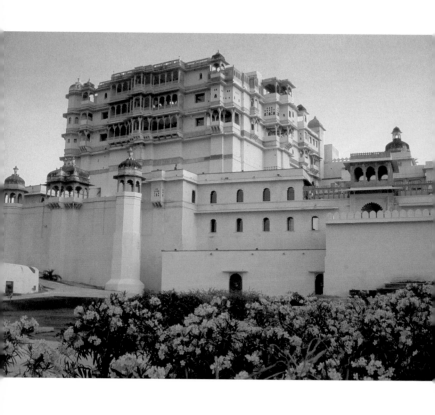

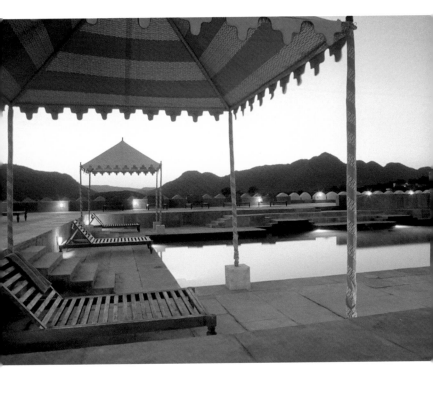

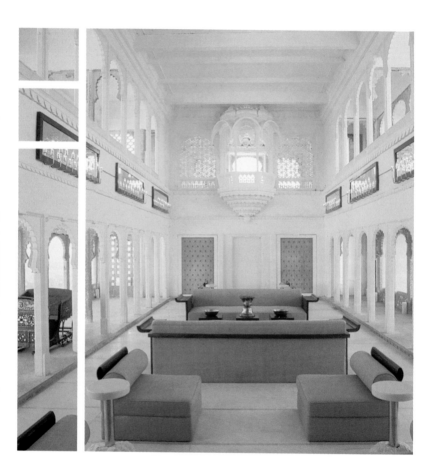

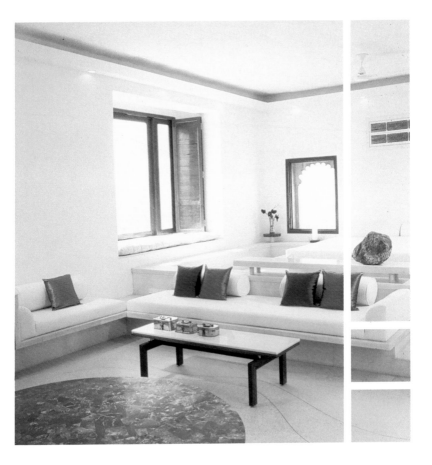

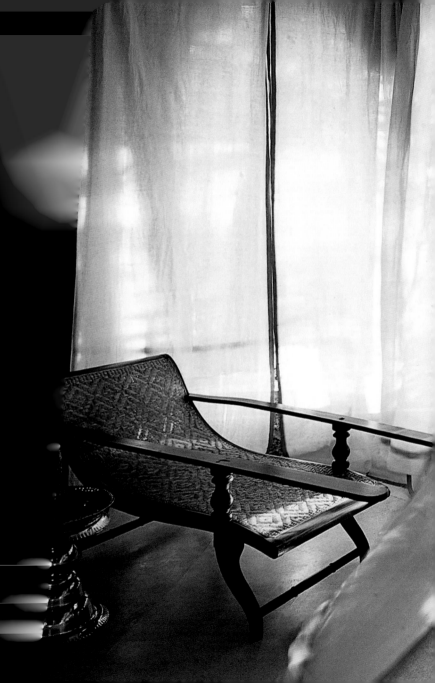

Nilaya Hermitage

Address: **Arpora Bhati, Goa 403518, India**
Tel.: **+91 832 2276793**
Fax: **+91 832 2276792**
www.nilayahermitage.com

Owner & designer: **Dean D'Cruz**
Opening date: **1994**
Photos: © **Nilaya Hermitage**

63

Style: Tropical

Rooms: 10

Special features: Healthy relaxing spa

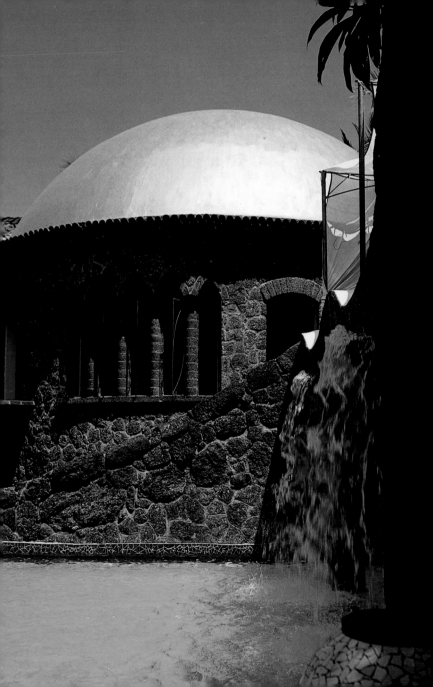

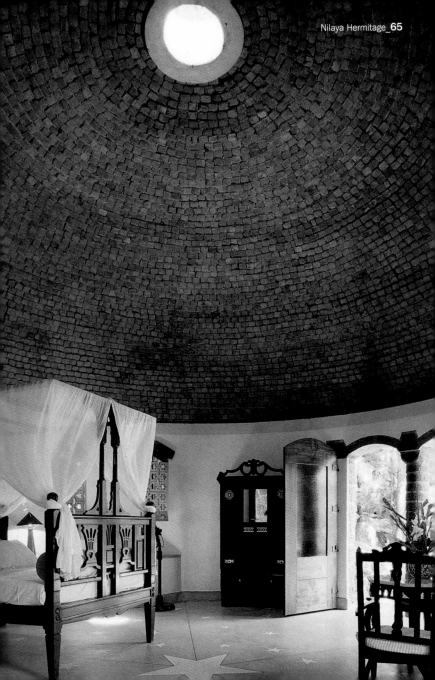

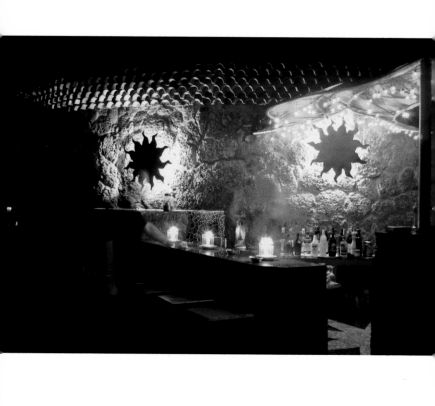

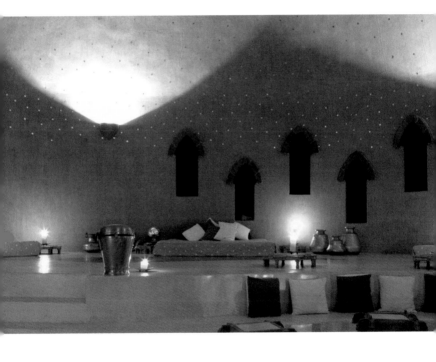

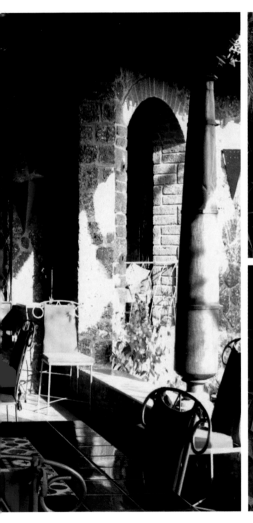

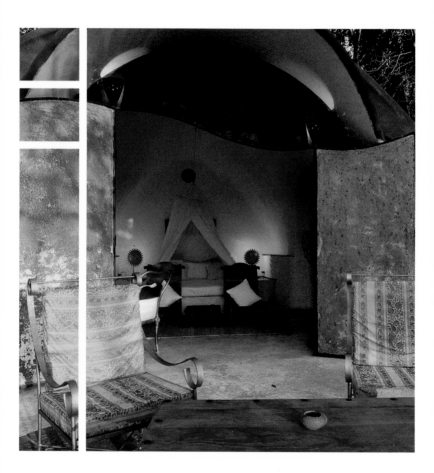

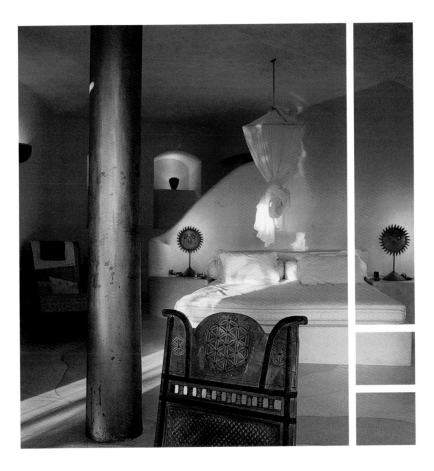

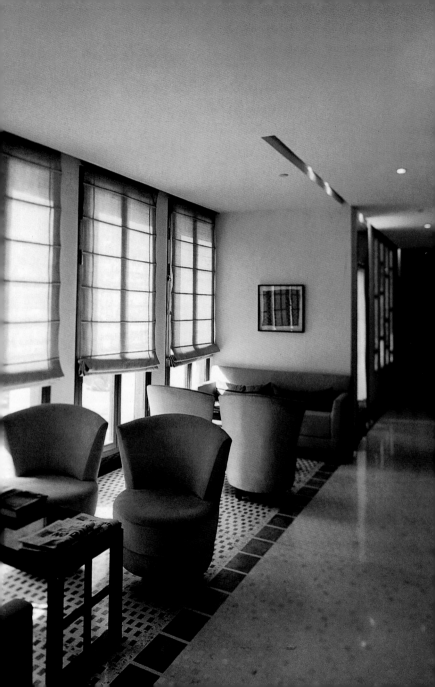

The Manor

Address: **77 Friends Colony West,**
New Delhi 110065, India
Tel.: **+91 11 2692 5151**
Fax: **+91 11 2692 2299**
www.themanordelhi.com

Opening date: **1999**
Photos: **© Martin Kunz**

73

Style: Modern style

Rooms: 10

Special features: An oasis in the centre
of this sprawling bustling city

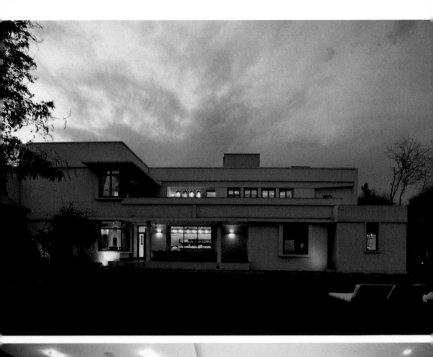

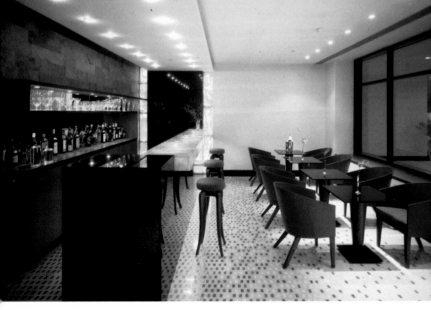

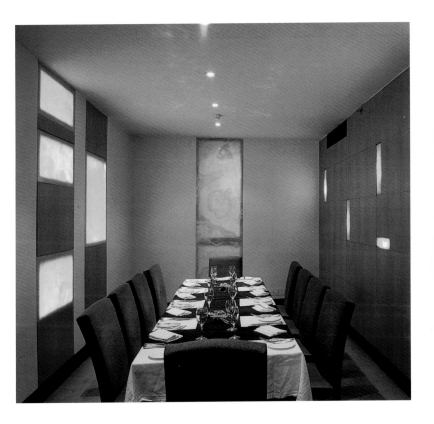

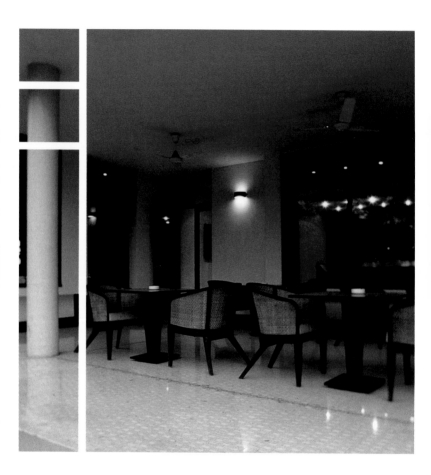

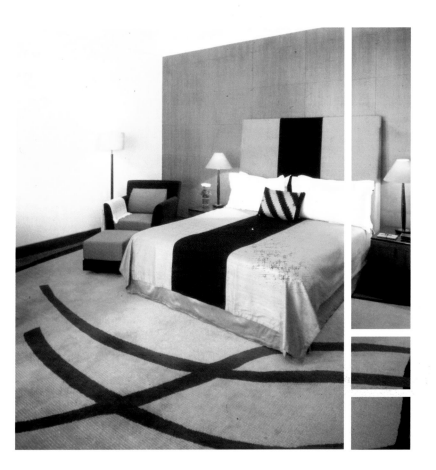

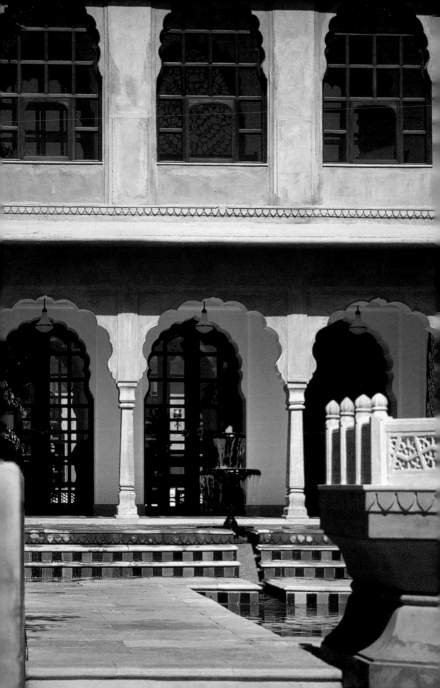

The Oberoi Rajvilâs

Address: **Goner Road, Jaipur 303012,**
Rajasthan, India
Tel.: **+91 141 268 0101**
Tel.: **+91 141 268 0202**
www.oberoihotels.com

Architect: **Pag Paghi**
Opening date: **1997**
Photos: **© Oberoi**

79

Style: Old Rajasthan
Rooms: 54 deluxe rooms, 14 luxury tents,
3 villas with private swimming pools

Special features: Elephant safari, holistic treatments

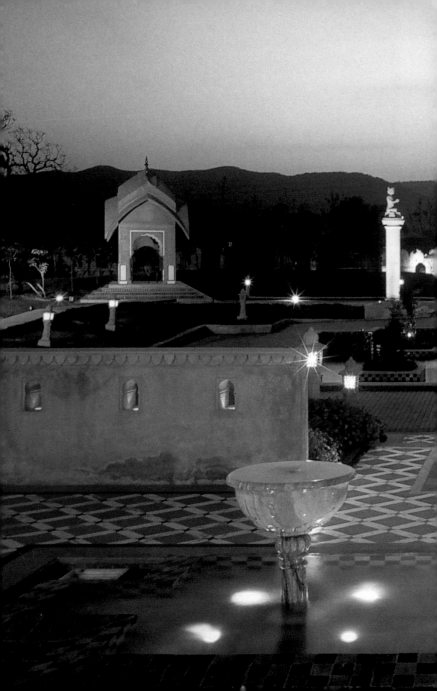

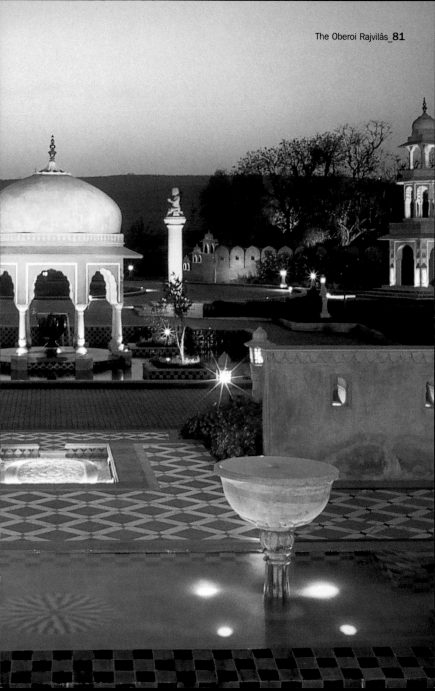

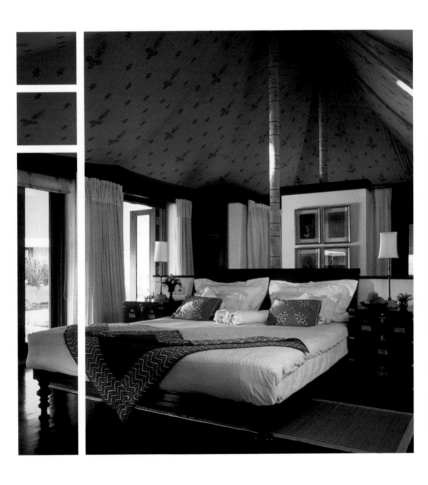

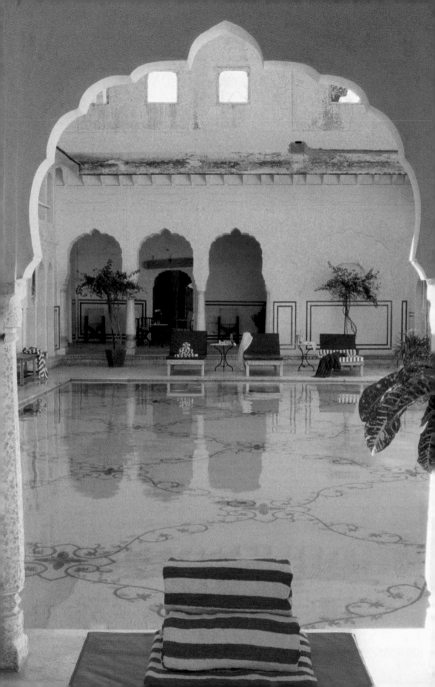

Samode

Address: **Gangapole, Jaipur 302002,**
Rajasthan, India
Tel.: **+91 141 2632370**
Fax: **+91 141 2631397**
www.samode.com

Architect: **Build in the middle of XIX century for the**
prime minister of Jaipur court
Opening date: **1988**
Photos: © **Samode**

85

Style: XIX Indian style

Rooms: 22 in Samode Haveli, 43 in Samode Palace

Special features: Living in a palace
with modern comfort

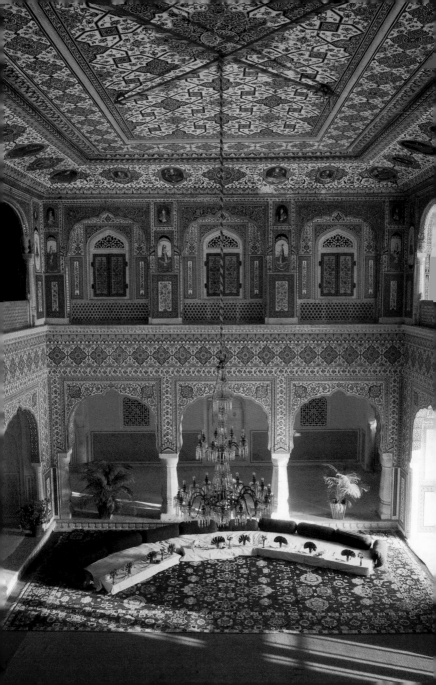

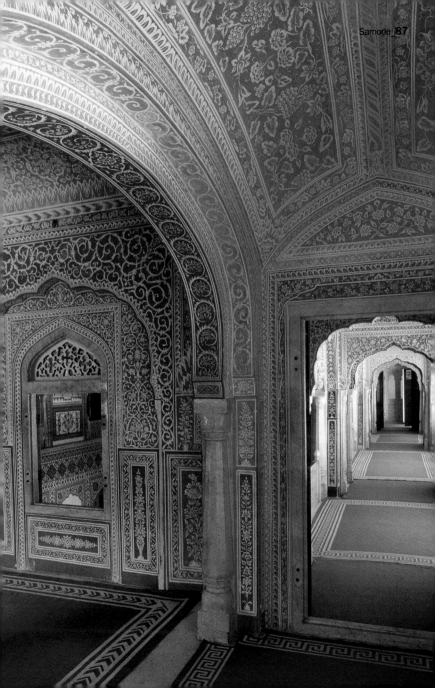

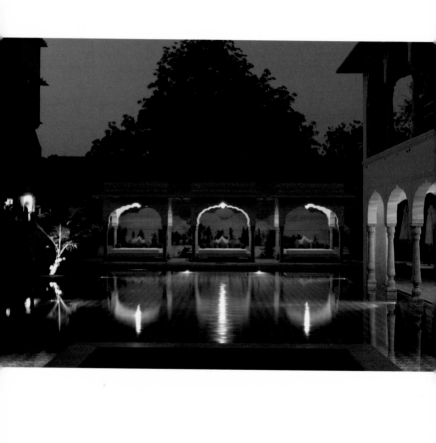

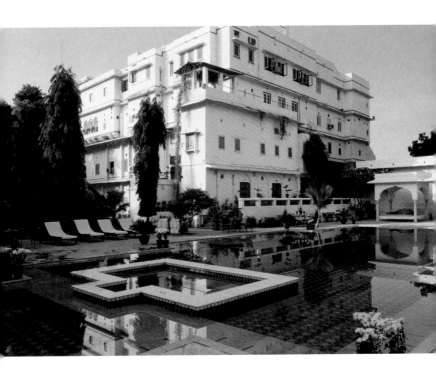

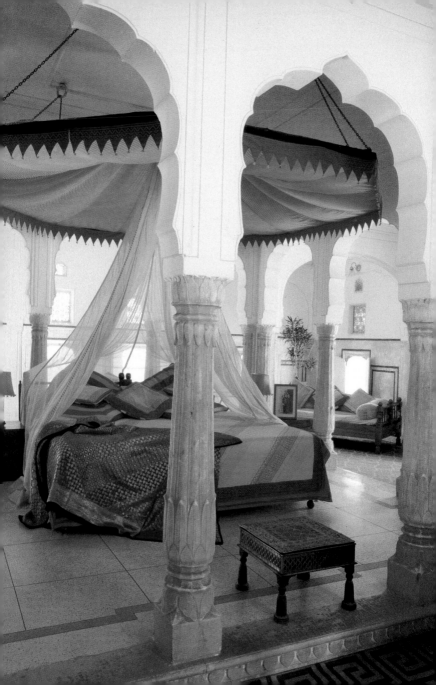

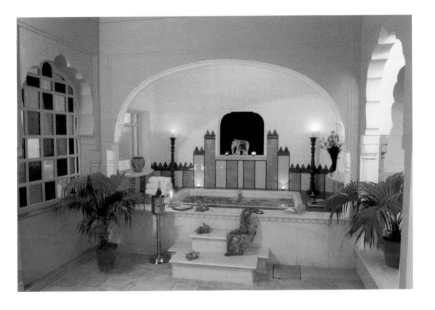

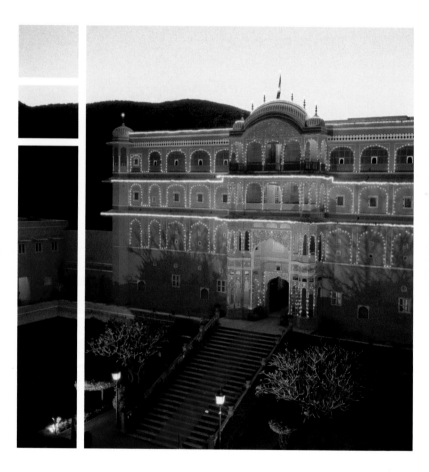

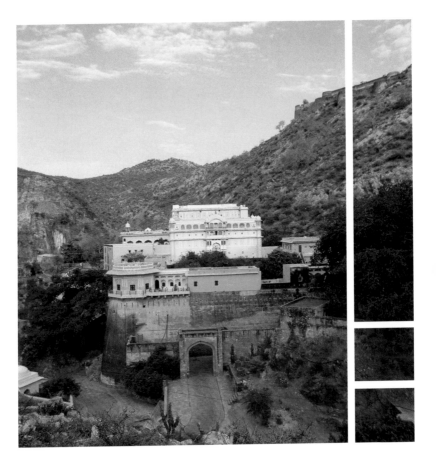

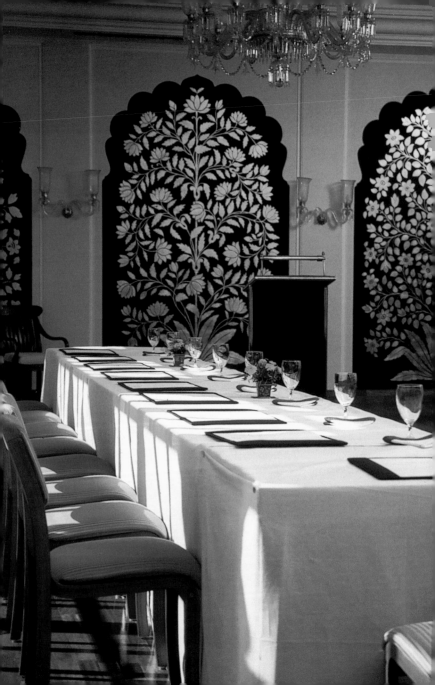

The Oberoi Vanyavilâs

Address: **Ranthambhore Road,**
Sawai Madhopur 322001, Rajasthan, India
Tel.: **+91 7462 22 3999**
Fax: **+91 7462 22 3988**
www.oberoivanyavilas.com

Opening date: **2001**
Photos: © **Oberoi Resorts**

95

Style: Safari

Rooms: 12 rooms and 12 luxury tents

Special features: Luxury tents in a jungle resort

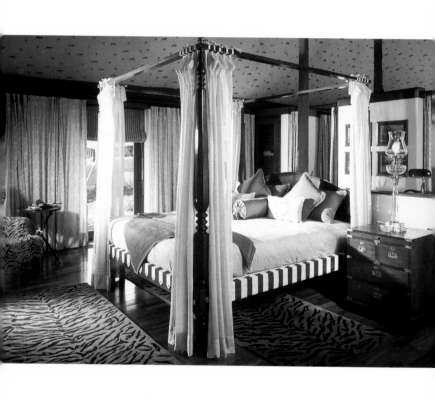

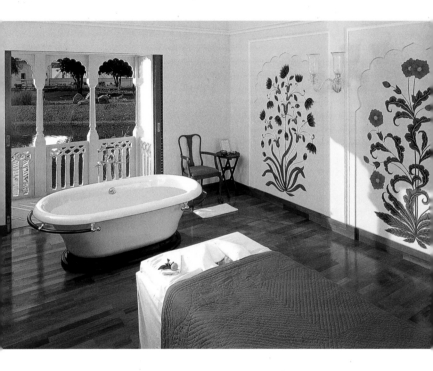

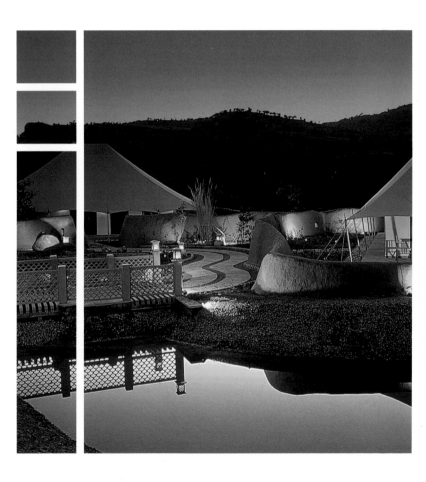

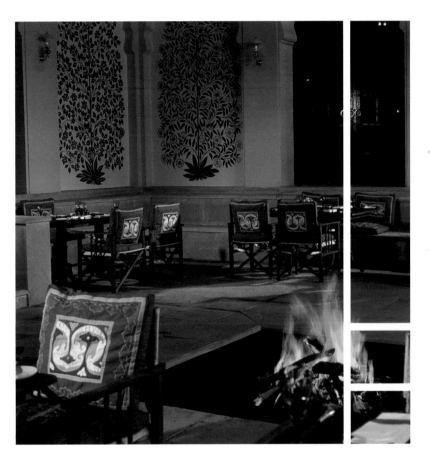

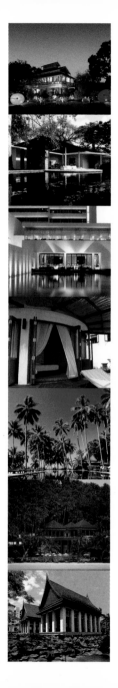

Continental
Southeast Asia

Myanmar
Laos
Cambodia
Thailand

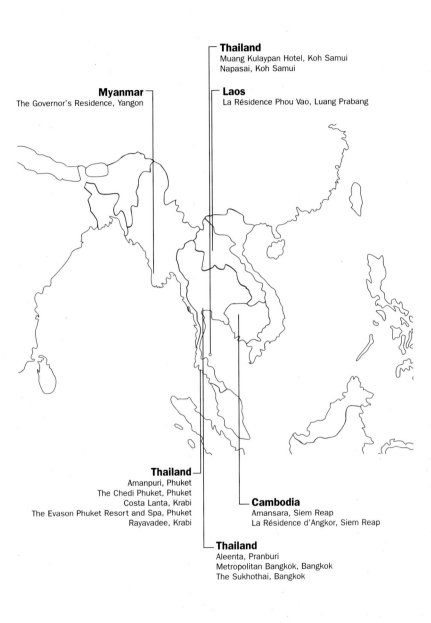

Myanmar
The Governor's Residence, Yangon

Thailand
Muang Kulaypan Hotel, Koh Samui
Napasai, Koh Samui

Laos
La Résidence Phou Vao, Luang Prabang

Thailand
Amanpuri, Phuket
The Chedi Phuket, Phuket
Costa Lanta, Krabi
The Evason Phuket Resort and Spa, Phuket
Rayavadee, Krabi

Cambodia
Amansara, Siem Reap
La Résidence d'Angkor, Siem Reap

Thailand
Aleenta, Pranburi
Metropolitan Bangkok, Bangkok
The Sukhothai, Bangkok

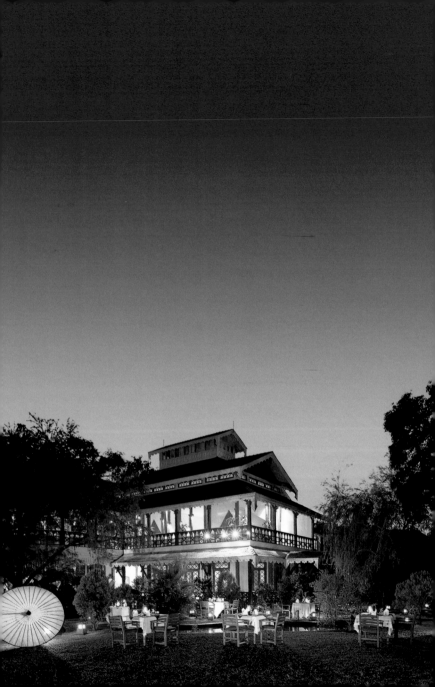

The Governor's Residence

Address: **35 Taw Win Road, Dagon Township,**
Yangon, Myanmar
Tel.: **+95 1 229860**
Fax: **+95 1 228260**
www.pansea.com

Opening date: **1997**
Photos: **© Pansea Group**

103

Style: Colonial

Rooms: 47 rooms and 2 suites

Special features: Lotus lake attached
to the building

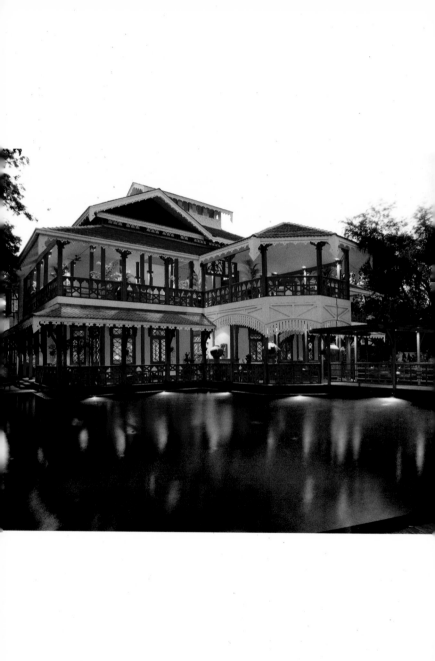

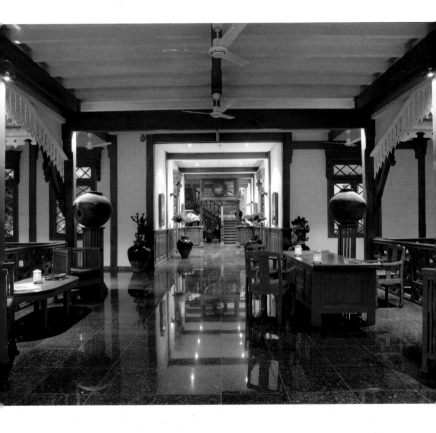

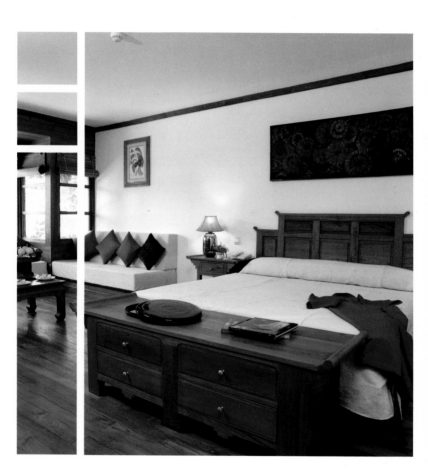

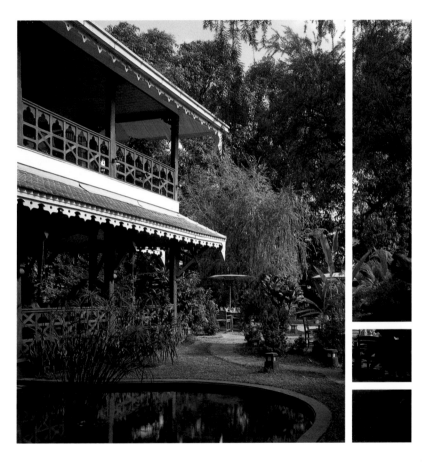

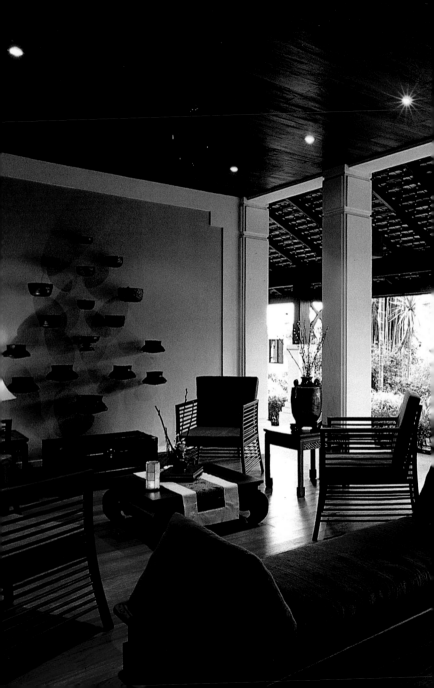

La Résidence Phou Vao

Address: **3 P.O. Box 50, Luang Prabang, Laos**
Tel.: **+856 71 212194**
Fax: **+856 71 212534**
www.pansea.com

Architect: **François Greck**
Opening date: **2002**
Photos: **© Pansea Group**

109

Style: Colonial

Rooms: 32 superior rooms and 2 suites

Special features: Magnificent restaurant over the landscape with French cuisine and traditional Laotian dishes

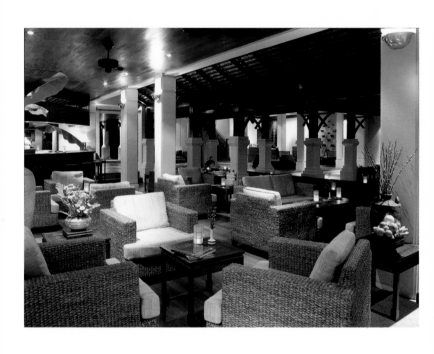

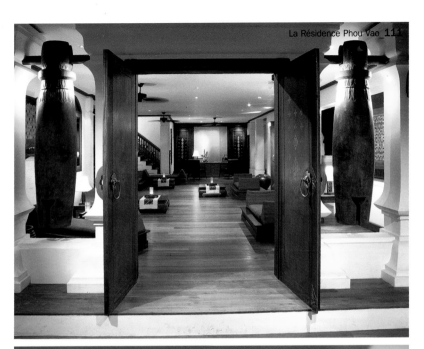

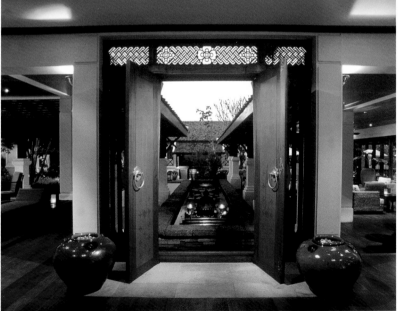

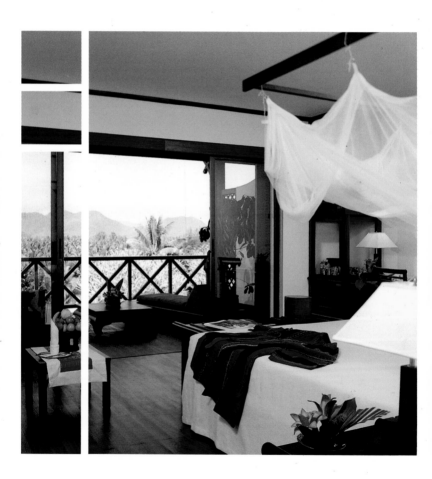

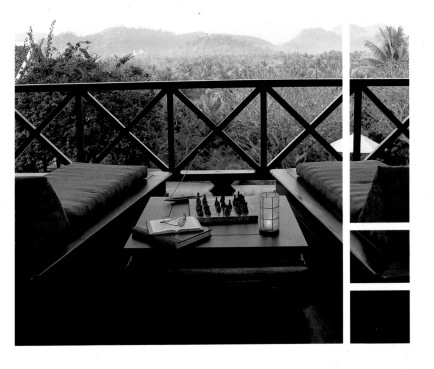

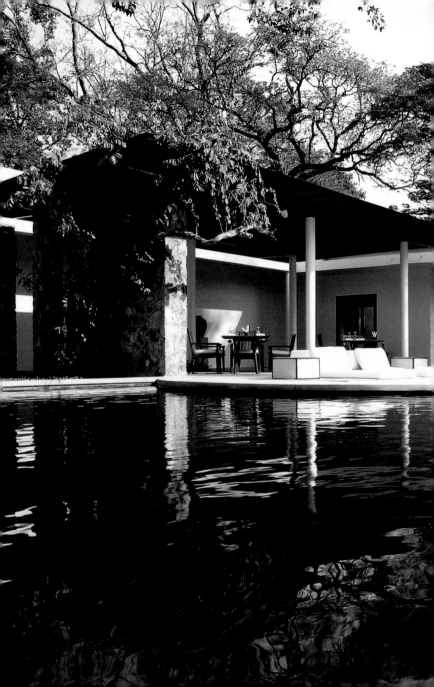

Amansara

Address: **Road to Angkor,**
 Siem Reap, Cambodia
Tel.: **+855 63 760333**
Fax: **+855 63 760335**
www.amanresorts.com

Architect: **Kerry Hill Architects**
Opening date: **2002**
Photos: **© Amanresorts**

115

Style: Minimalist

Rooms: 12 suites

Special features: Visits to Angkor temple and others cultural tours

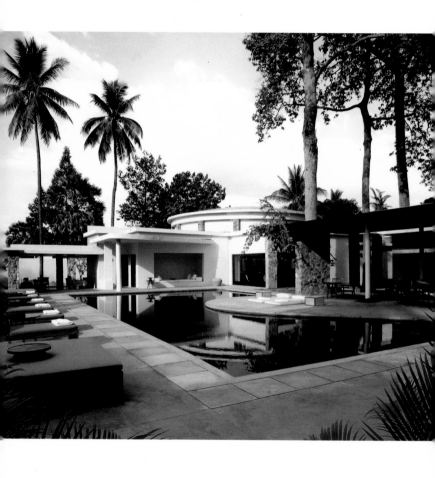

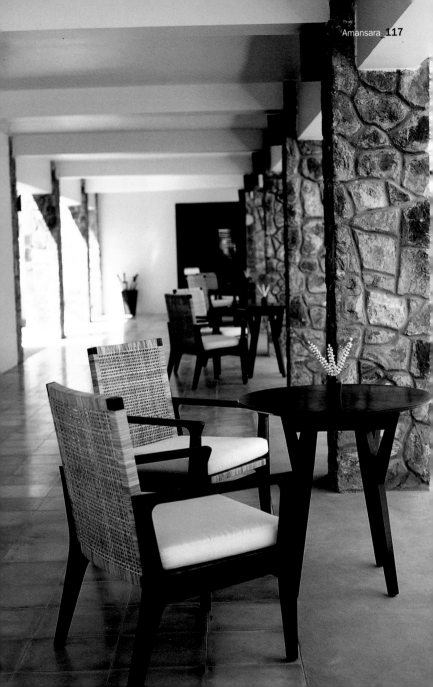

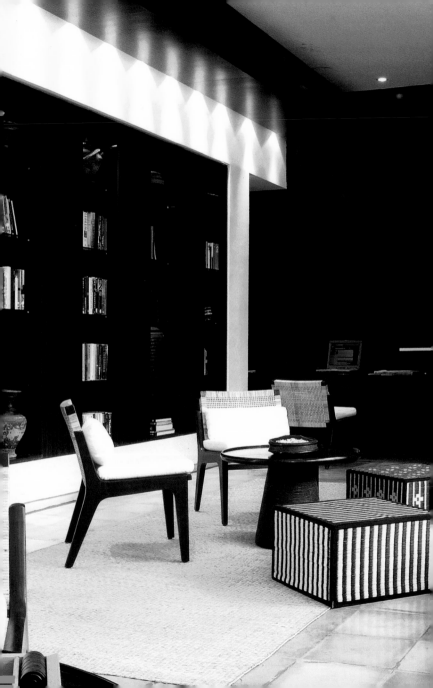

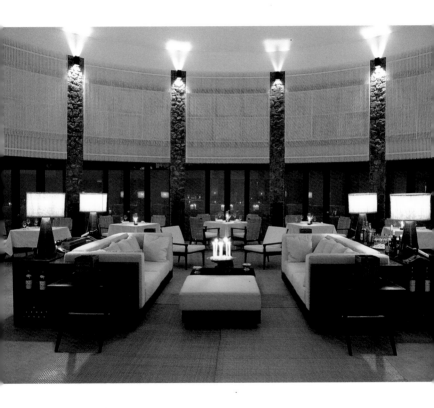

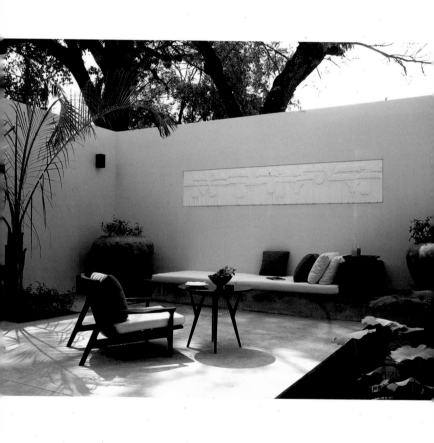

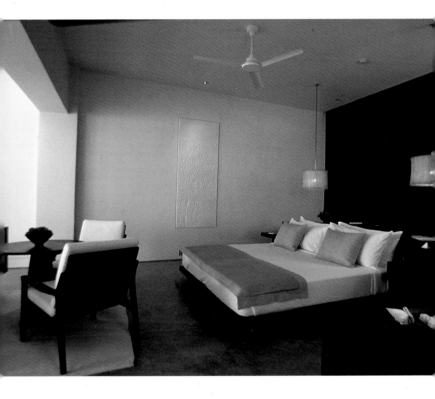

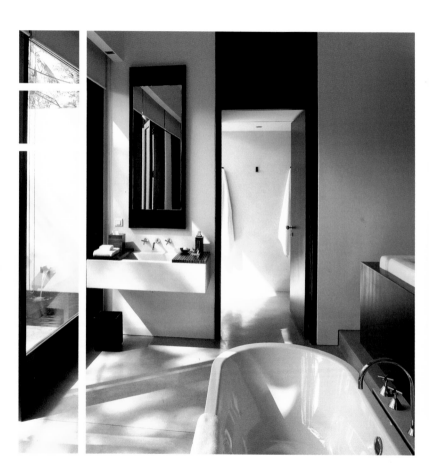

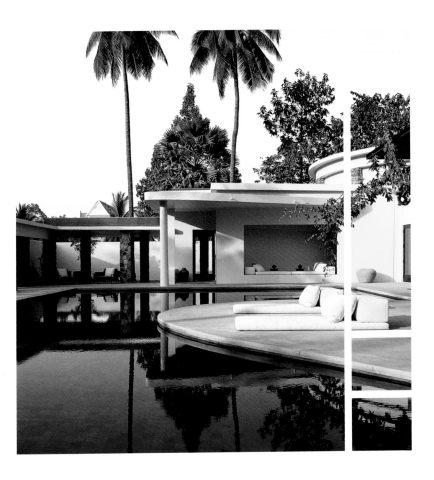

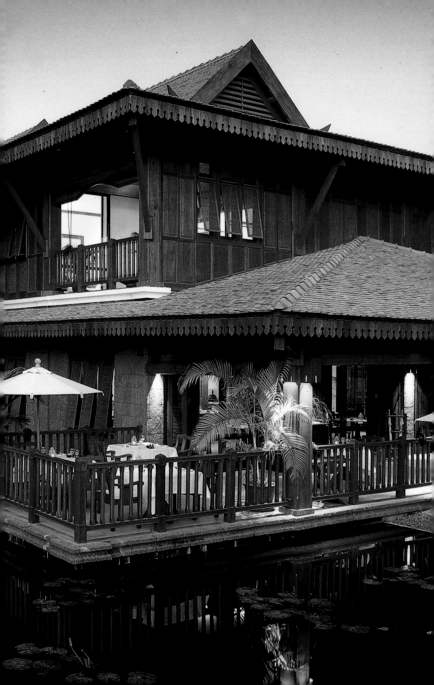

La Résidence d'Angkor

Address: **River Road,**
Siem Reap, Cambodia
Tel.: **+855 63 963390**
Fax: **+855 63 963391**
www.pansea.com

Architect: **Atelier Amedeo et Associés**
Opening date: **2001**
Photos: **© Pansea Group**

Style: Khmer style

Rooms: 54 rooms and 1 suite

Special features: Visit the ancient Cambodian temples

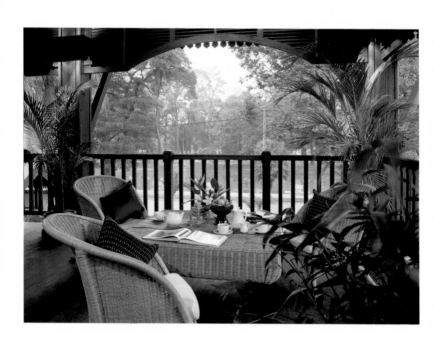

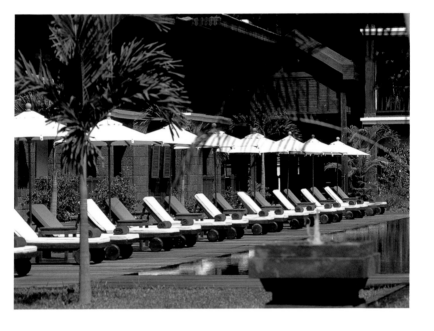

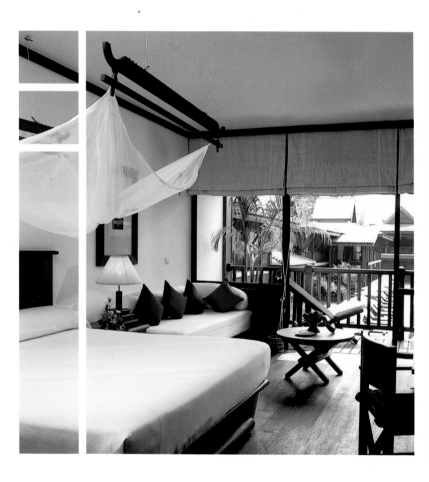

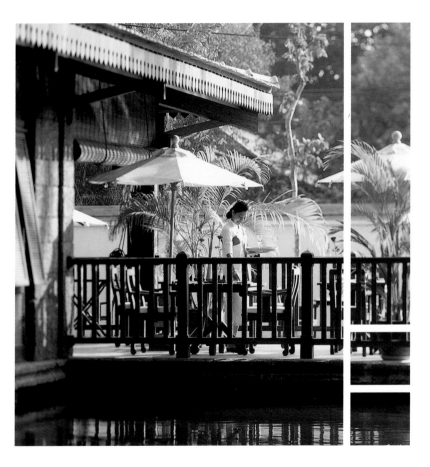

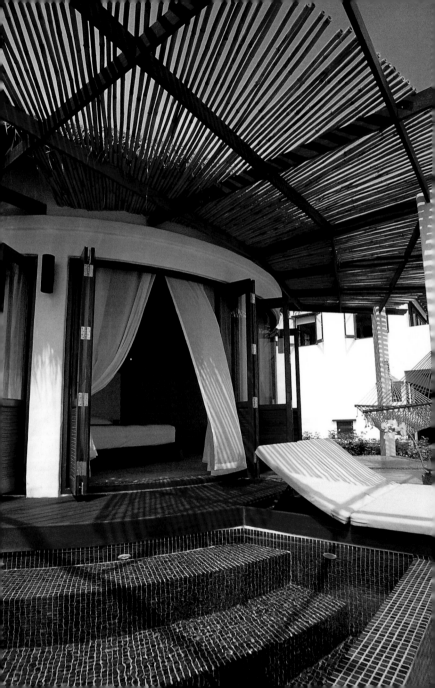

Aleenta

Address: **183 Moo 4, Paknampran,**
Pranburi, Thailand
Tel.: **+66 (0) 32 570 194**
Fax: **+66 (0) 32 570 222**
www.aleenta.com

Architects and interior designers: **Simple Space**
Opening date: **2002**
Photos: © **Aleenta**

131

Style: Healthy minimal

Rooms: 4 ocean suites, 3 pool suites and 3 villas

Special features: Yoga retreats, Aleenta relaxing music

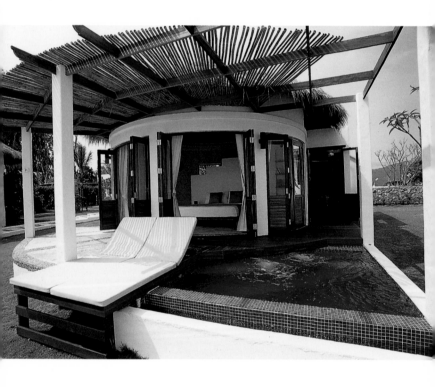

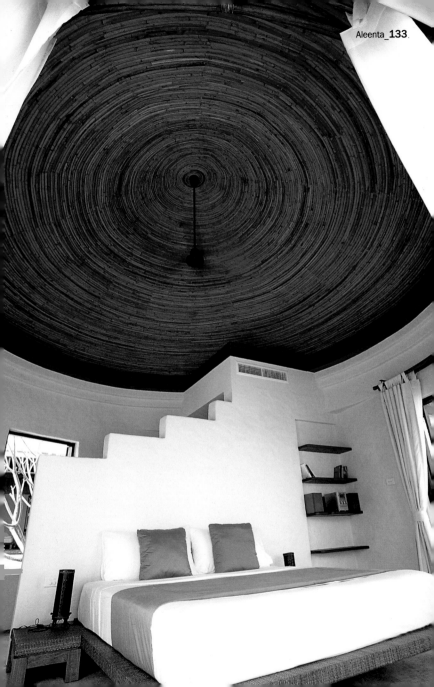

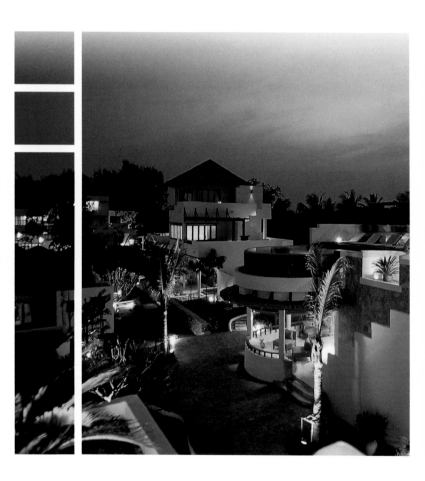

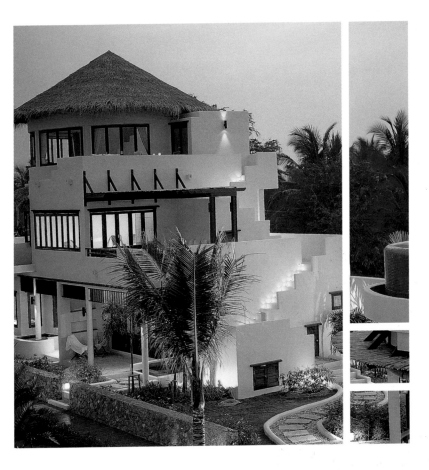

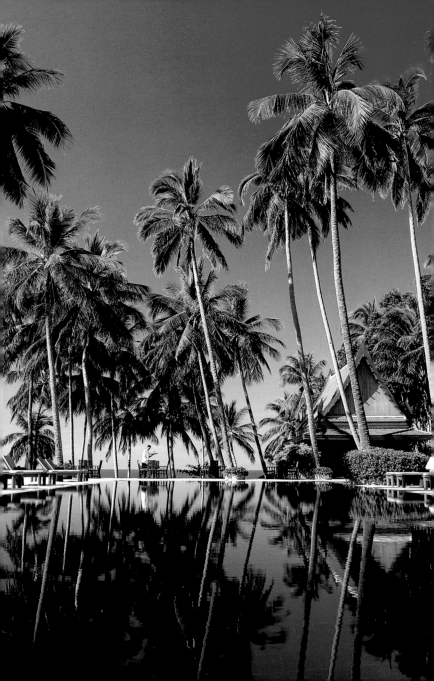

Amanpuri

Address: **Pansea Beach,**
Phuket 83000, Thailand
Tel.: **+66 (0) 76 324333**
Fax: **+66 (0) 76 324100**
www.amanresorts.com

Architect: **Edward Tuttle**
Opening date: **1988 (spa 2001)**
Photos: © **Amanresorts**

Style: Ancient Thai temple complex

Rooms: 40 pavilions and 30 villas

Special features: Cruises on different types of yachts as well as excursions on traditional boats

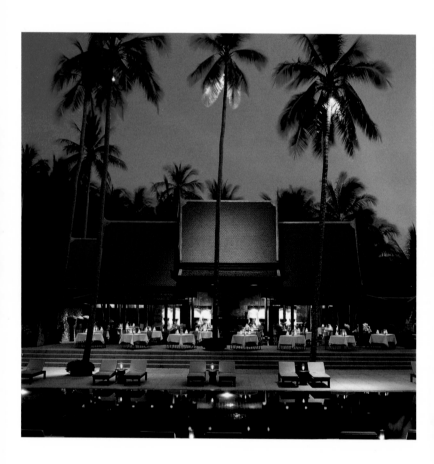

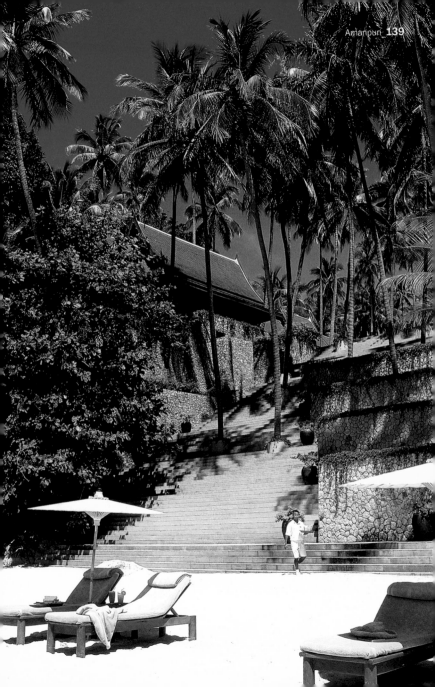

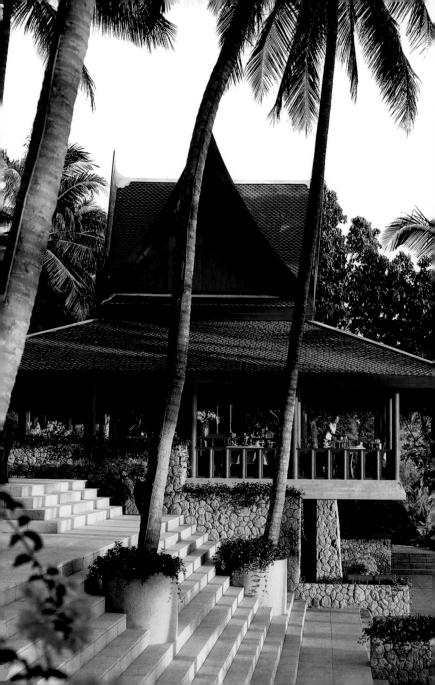

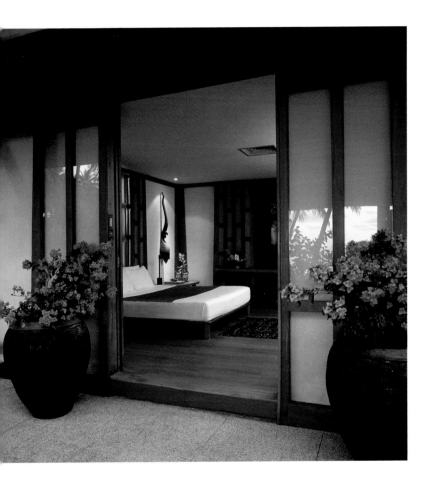

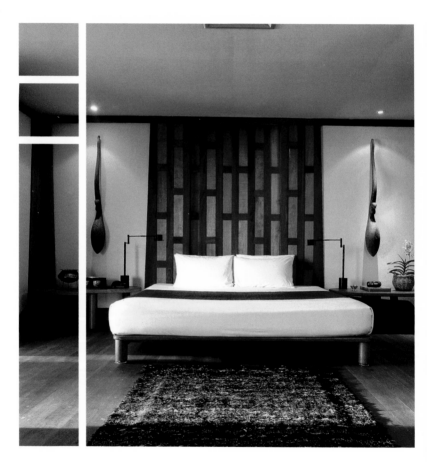

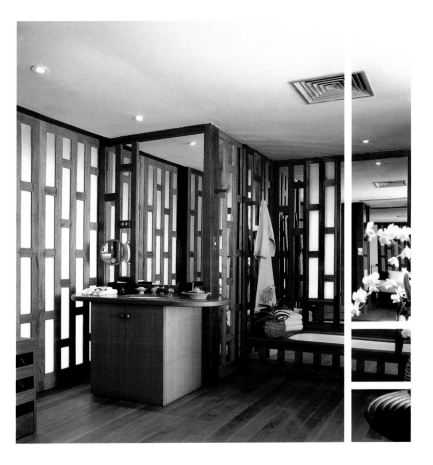

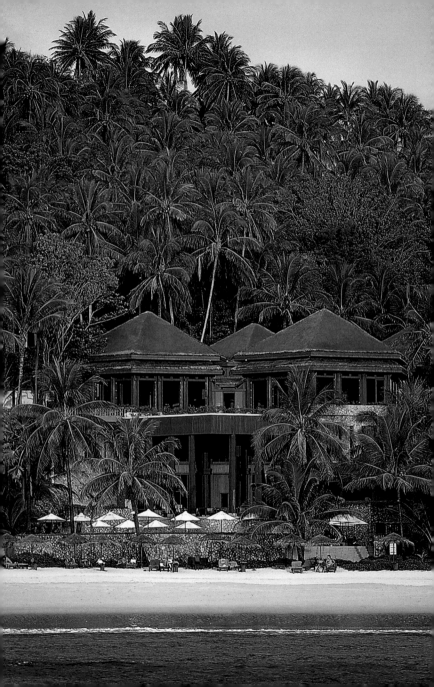

The Chedi Phuket

Address: **Pansea Bay 118 Moo 3,**
Choeng Talay Talang, Phuket 83110, Thailand
Tel.: **+66 (0) 76 324017**
Fax: **+66 (0) 76 324252**
www.ghmhotels.com

Designer: **Edmond Turtle**
Opening date: **1995**
Photos: © **Martin Kunz**

145

Style: Pacific style

Rooms: 89 one-bedroom cottages and 19 two-bedroom cottages

Special features: An extensive array of water sports

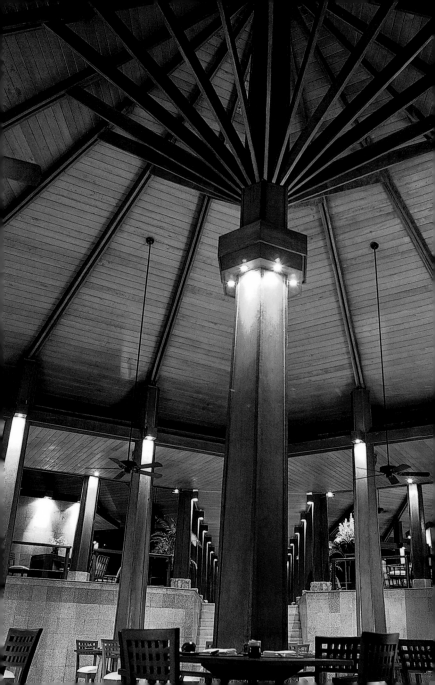

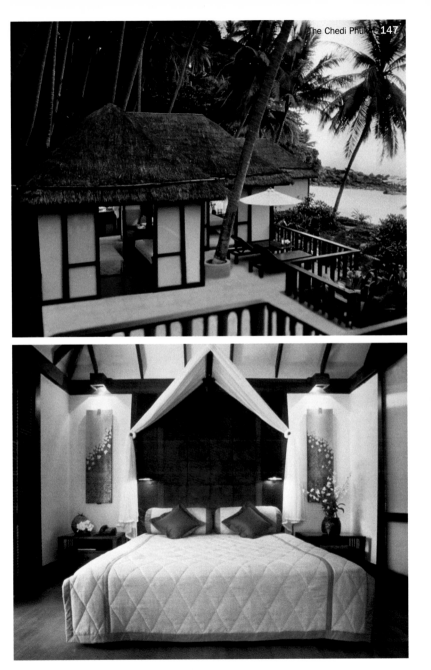

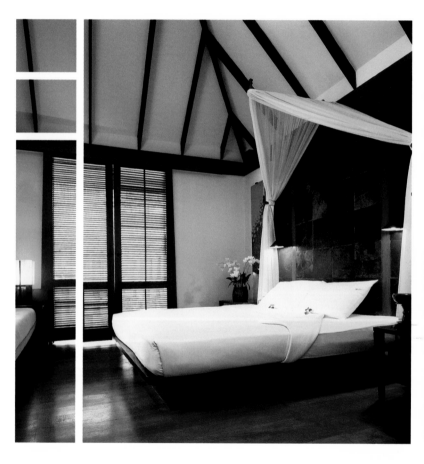

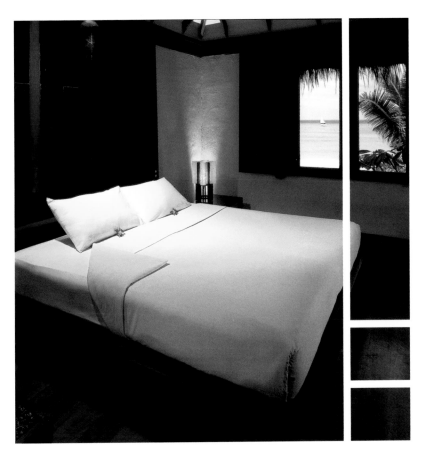

Costa Lanta

Address: 212 Moo 1, Saladan, Amphur Koh Lanta,
Lanta Yai Island, Krabi, Thailand
Tel.: **+66 (0) 75 618 092**
www.costalanta.com

Architect: **Duangrit Bunnag**
Opening date: **2001**
Photos: **© Costa Lanta**

151

Style: Minimalism

Rooms: 22

Special features: Each room functions modularly, opened or closed, isolated or connected

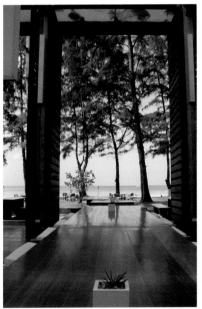

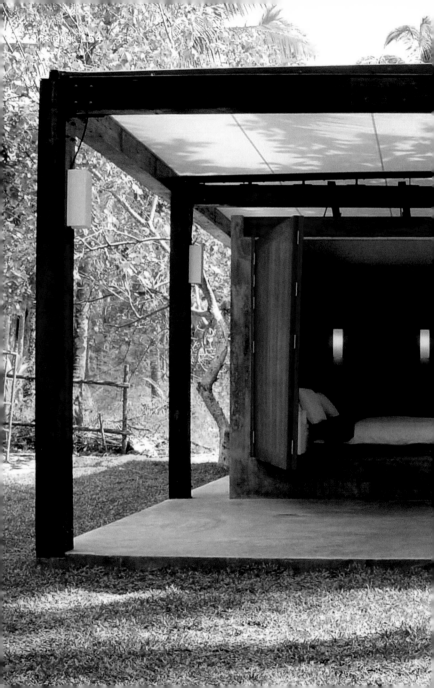

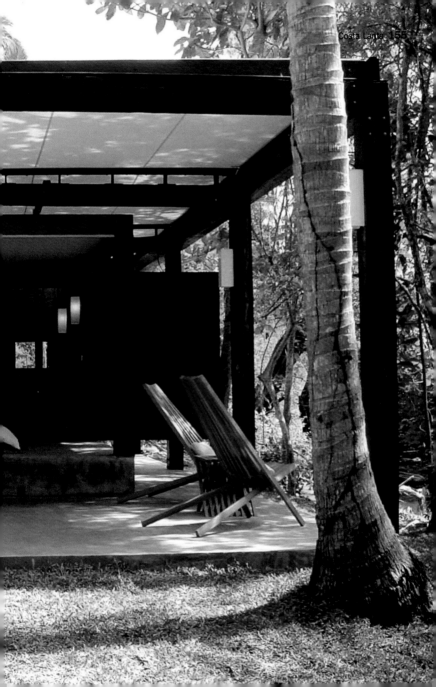

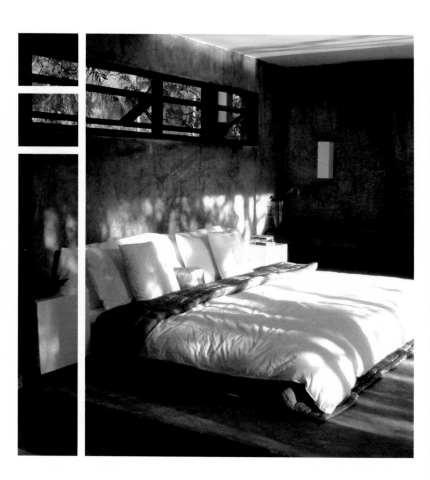

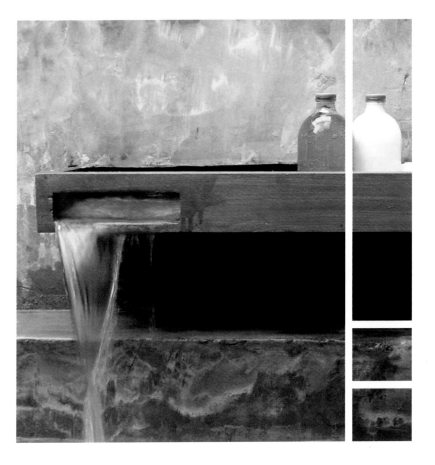

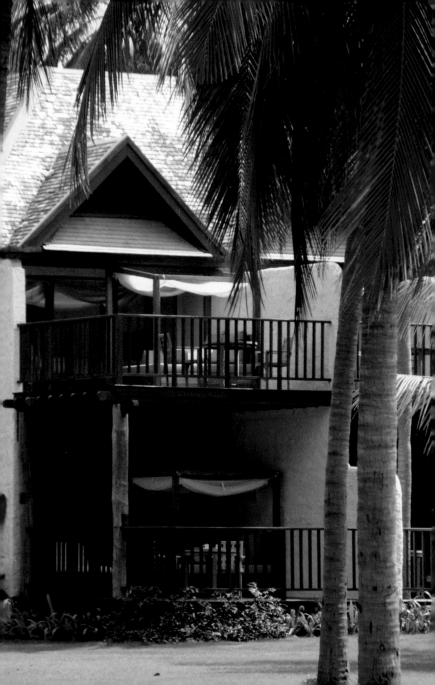

The Evason Phuket Resort and Spa

Address: **100 Vised Road, Rawai Beach**
Phuket 83130, Thailand
Tel.: **+66 (0) 76 3810107**
Fax: **+66 (0) 76 381018**
www.phuket.com/evason

Opening date: **2000**
Photos: **© Martin Kunz**

159

Style: Pacific
Rooms: 46 Evason rooms, 122 Evason studio rooms, 91 Evason
deluxe rooms, 7 Evason junior suite rooms, 10 Evason duplex
suites, 1 honeymoon suite on Bon island, 7 deluxe pool villas

Special features: Bon Island, at ten minutes
of the hotel, exclusively
for the use of the Evason's guests

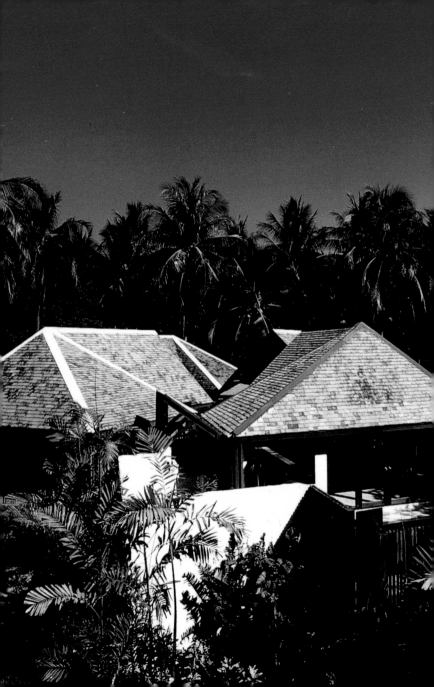

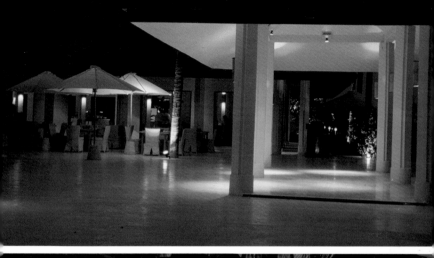

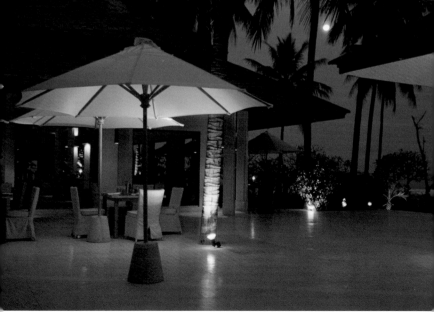

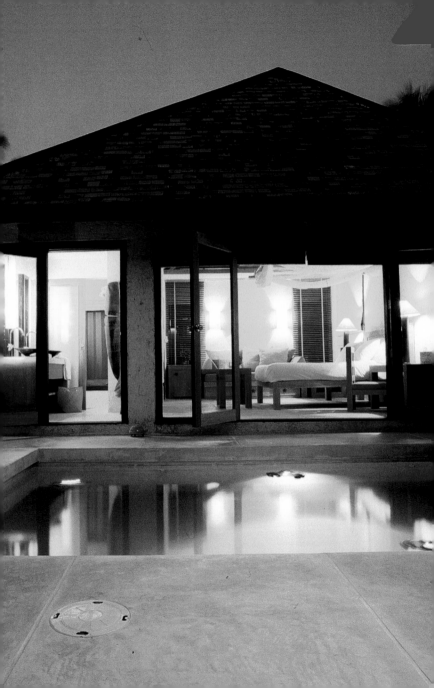

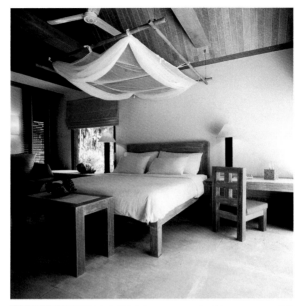

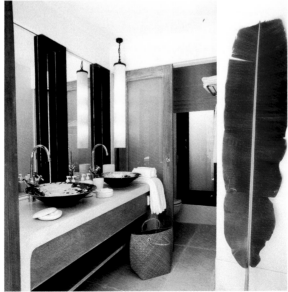

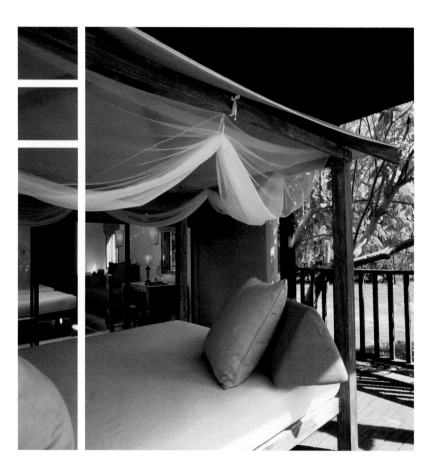

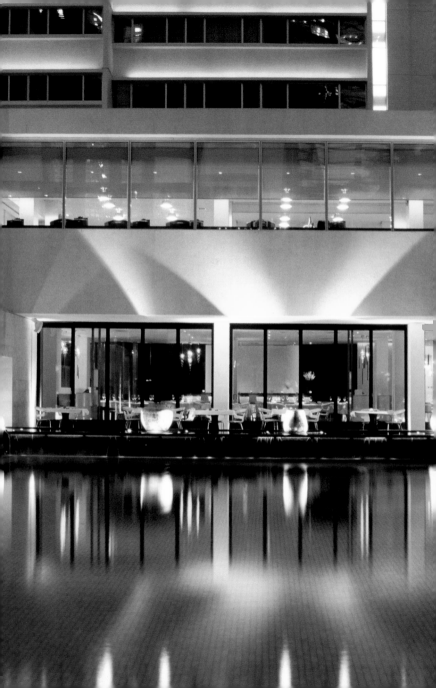

Metropolitan Bangkok

Address: **27 South Sathorn Road, Tungmaek,**
Sathorn, Bangkok 10120, Thailand
Tel.: **+66 (0) 2 625 3333**
Fax: **+66 (0) 2 625 3300**
www.metropolitan.como.bz

Interior designer: **Kathryn Kng**
Lighting designers: **Arnold Chand/Isometrix**
Opening date: **2003**
Photos: **© Zapaimages/Reto Guntli**

167

Style: Contemporary

Rooms: 176 rooms (including 4 penthouse suites and 1 presidential suite)

Special features: Most rooms range between
550 and 580 squ. feet

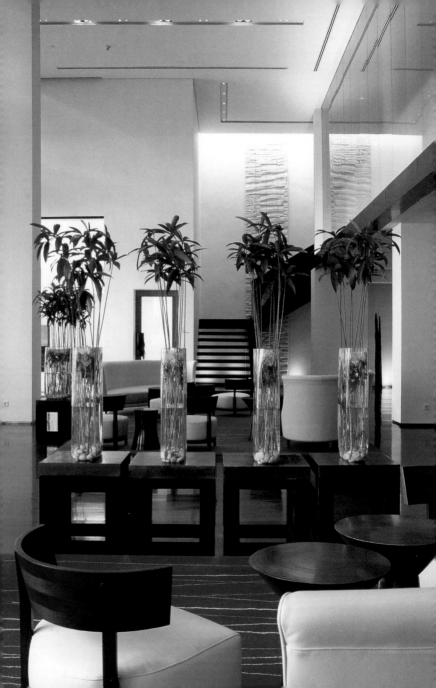

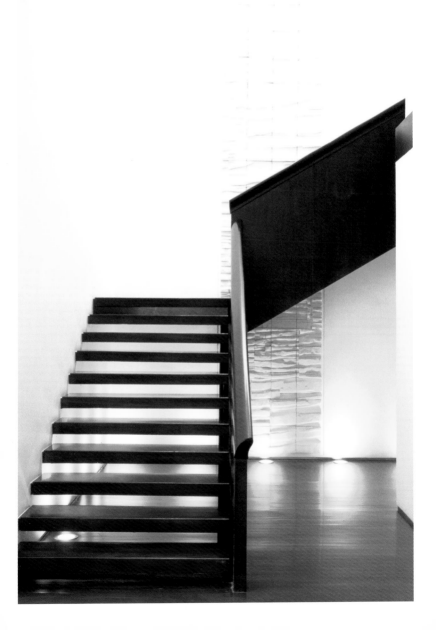

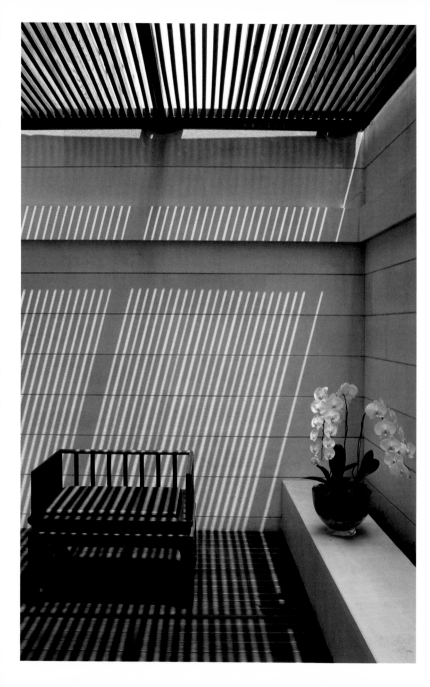

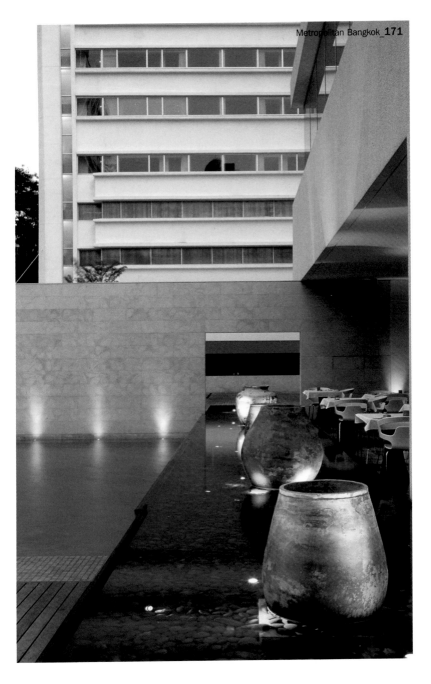

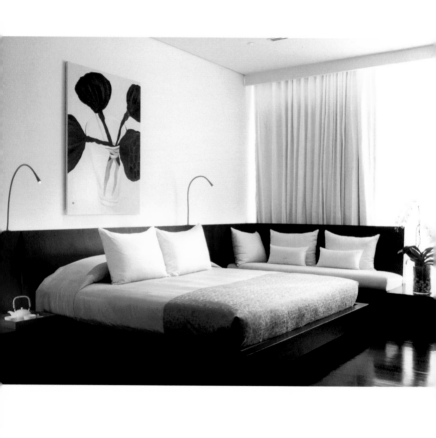

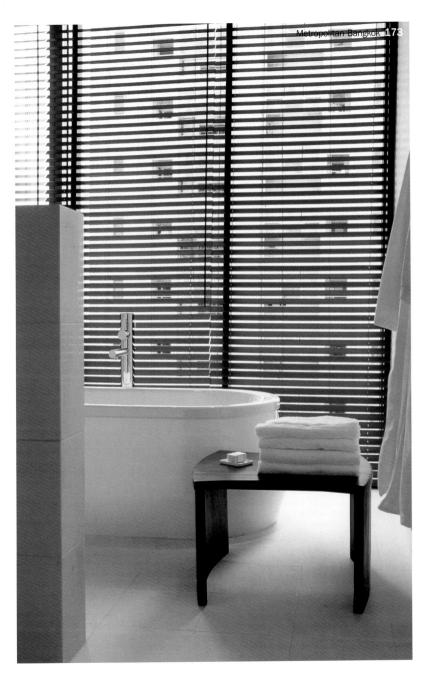

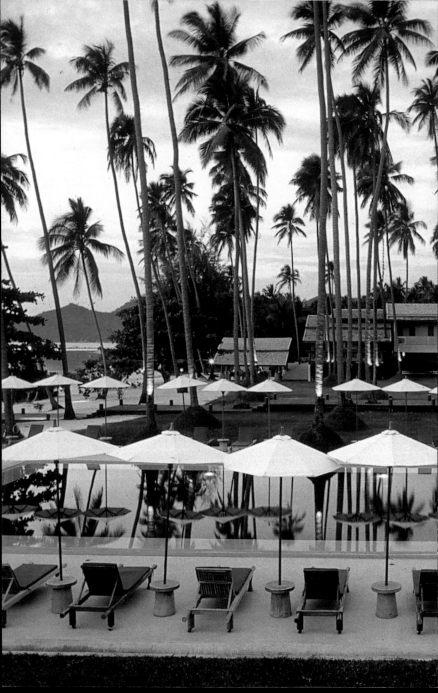

Muang Kulaypan Hotel

Address: **100 Moo 2 Chaweng Beach,**
Koh Samui 84320, Suratthani, Thailand
Tel.: **+66 (0) 77 230849**
Fax: **+66 (0) 77 230031**
www.kulaypan.com

Architect: **M.L. Archava Varavana**
Opening date: **1996**
Photos: © **M.L. Archava Varavana**
and Khun Udomdej Bunyaraksh

177

Style: Contemporary and Pacific

Rooms: 41

Special features: Gorgeous beaches

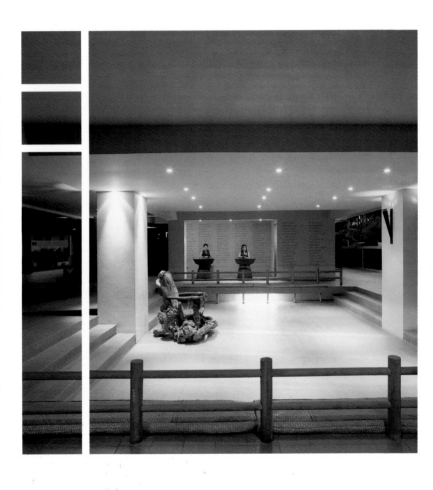

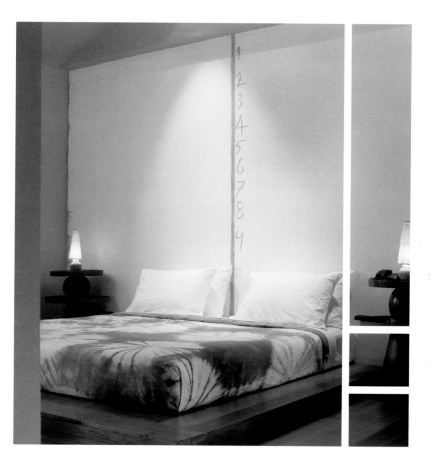

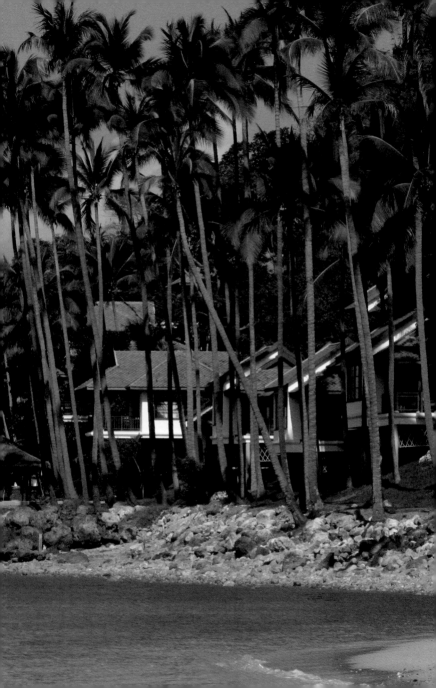

Napasai

Address: **65/10 Ban Tai, Maenam,**
Koh Samui 84330, Suratthani, Thailand
Tel.: **+66 (0) 77 429200**
Fax: **+66 (0) 77 429201**
www. pansea.com

Architect: **Atelier Amedeo et Associés**
Opening date: **2004**
Photos: **© Pansea Group**

181

Style: Pacific
Rooms: 4 family beachfront cottages, 6 garden spa cottages, 11 beachfront cottages, 34 seaview cottages, 14 private villas

Special features: Spa treatments rooted in Thai traditional medicine

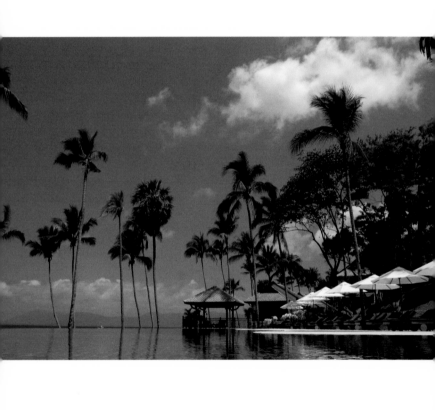

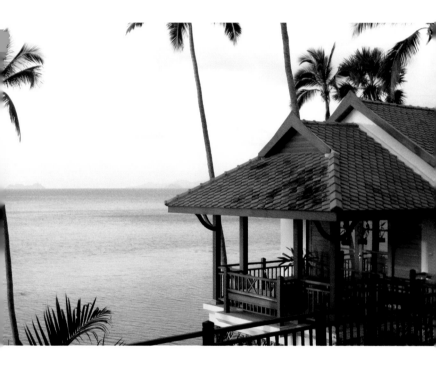

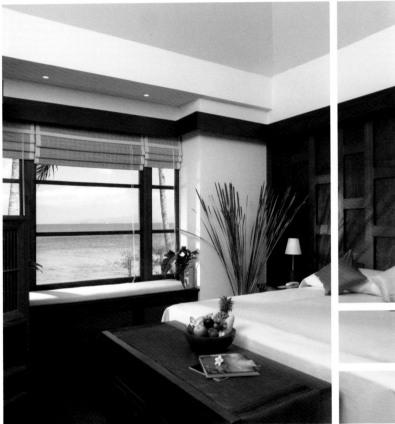

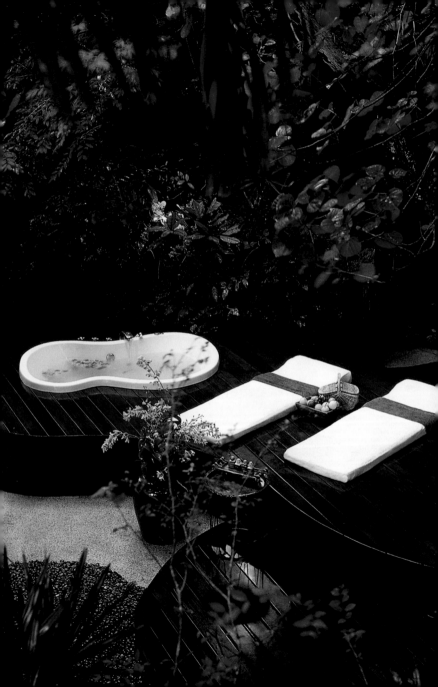

Rayavadee

Address: **214 Moo 2, Tambol Ao Nang**
Amphur Muang, Krabi, Thailand
Tel.: **+66 (0) 75 620740**
Fax: **+66 (0) 75 620630**
www.rayavadee.com

Interior designer: **Vichada Pongsathorn**
Opening date: **1992**
Photos: **© Rayavadee**

187

Style: Comfortable Thailand

Rooms: 98 pavillons and 5 villas

Special features: The spa, the beaches, walks in Khao Phanom Bencha National Park

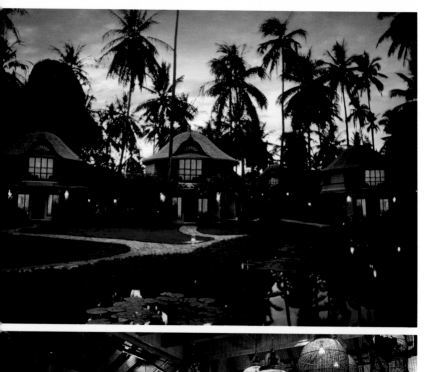

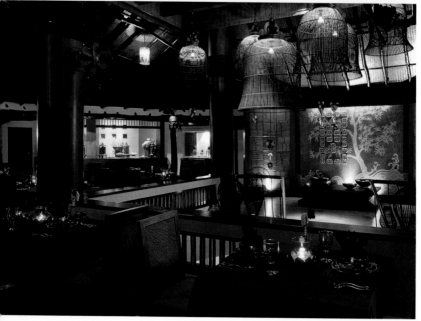

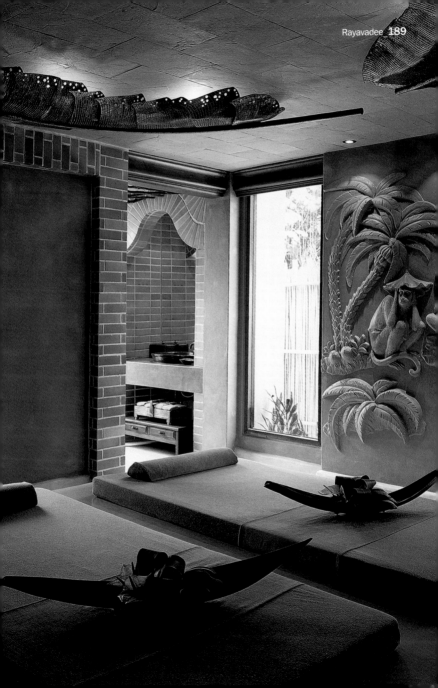

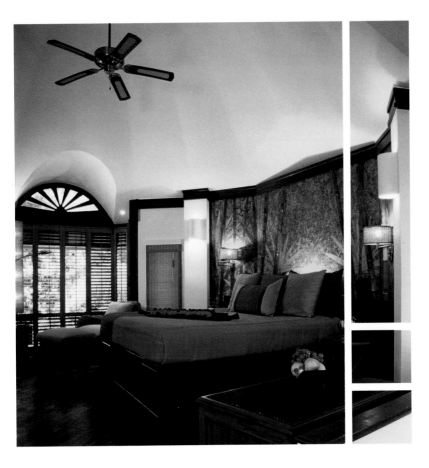

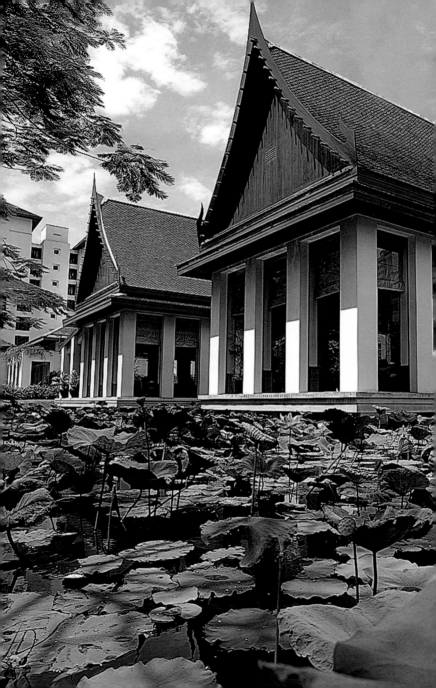

The Sukhothai

Address: **13-3 South Sathorn Road,**
Bangkok 10120, Thailand
Tel.: **+66 (0) 2344 8888**
Fax: **+66 (0) 2344 8899**
www.sukhothai.com

Architect: **Kerry Hill Architects**
Interior designer: **Edward Tuttle**
Opening date: **1991**
Photos: **© The Sukhothai**

195

Style: Contemporary

Rooms: 219

Special features: Good ambience for business travelers

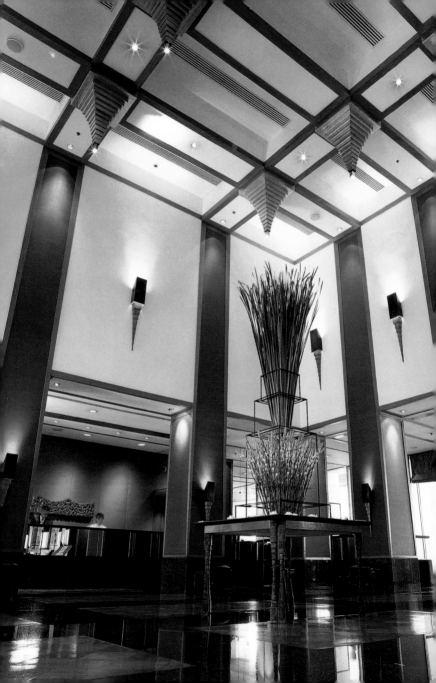

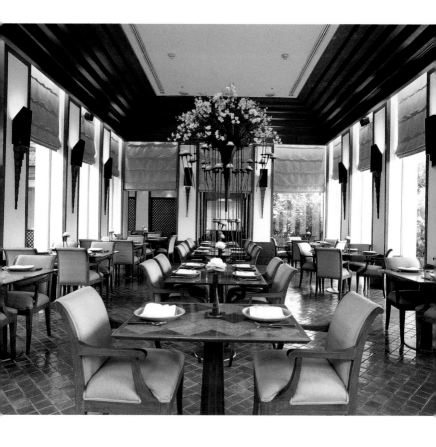

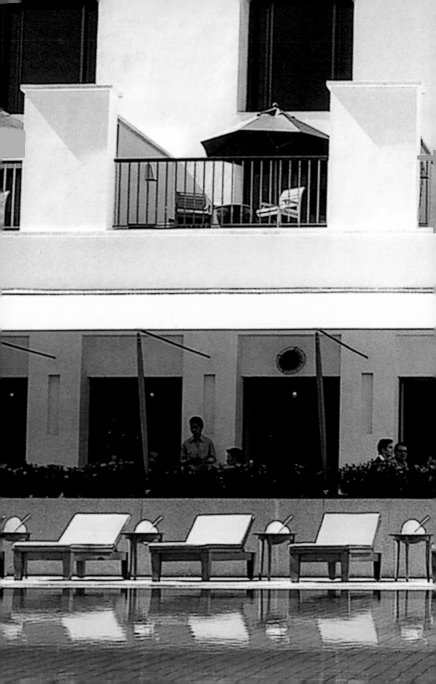

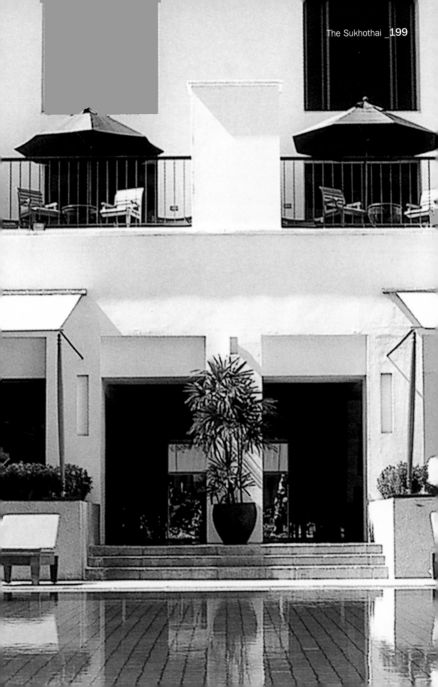

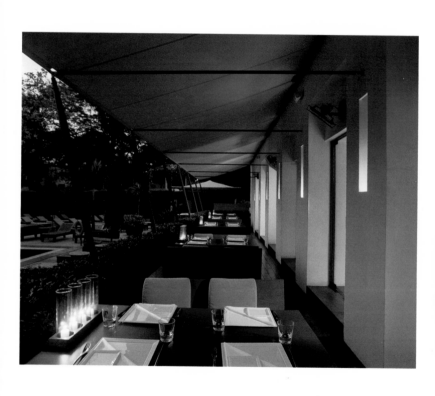

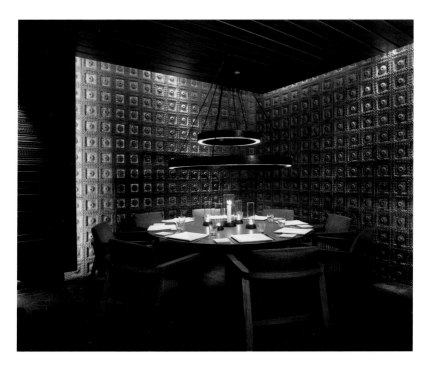

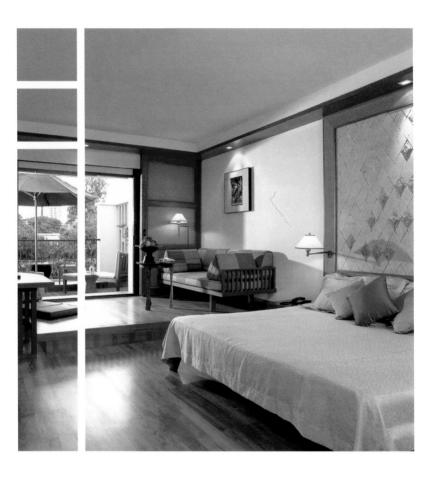

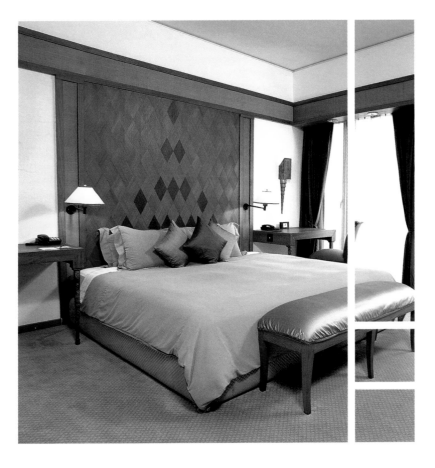

Southeast Asian Islands

Indonesia

Malaysia

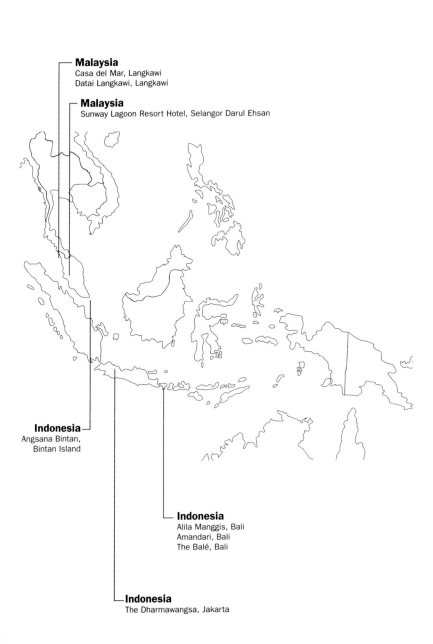

Malaysia
Casa del Mar, Langkawi
Datai Langkawi, Langkawi

Malaysia
Sunway Lagoon Resort Hotel, Selangor Darul Ehsan

Indonesia
Angsana Bintan,
Bintan Island

Indonesia
Alila Manggis, Bali
Amandari, Bali
The Balé, Bali

Indonesia
The Dharmawangsa, Jakarta

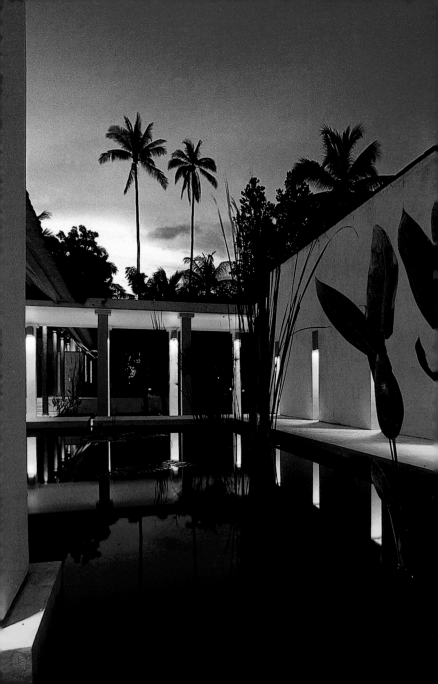

Alila Manggis

Address: **Buitan, Manggis,**
 Karangasem 80871, Bali, Indonesia
Tel.: **+62 363 41011**
Fax: **+62 363 41015**
www.alilahotels.com

Architect: **Kerry Hill Architects**
Opening date: **1994**
Photos: © **Martin Kunz**

207

Style: Contemporary

Rooms: 54 rooms and 2 suites

Special features: Weddings; cooking school specialized in Balinese food

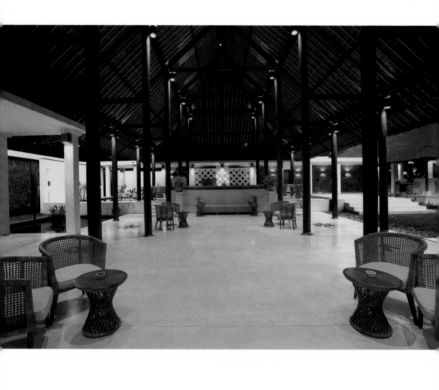

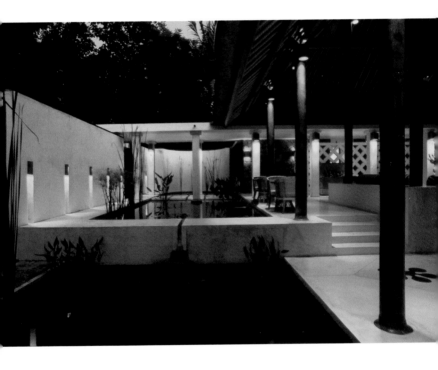

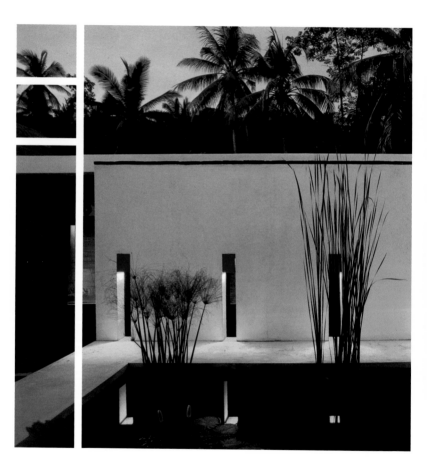

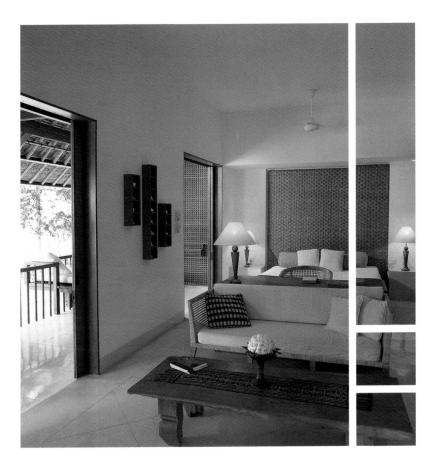

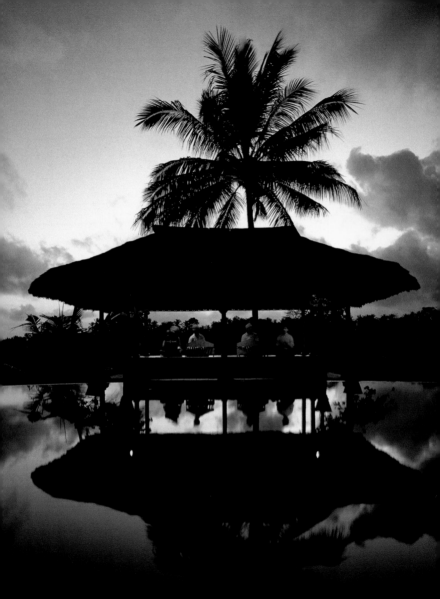

Amandari

Address: **Kedewatan, Ubud 80571,**
Bali, Indonesia
Tel.: **+62 361 975333**
Fax: **+62 361 975335**
www.amandari.com

Architect: **Peter Muller**
Opening date: **1989**
Photos: **© Aman**

213

Style: Balinese village

Rooms: 30 free-standing suites

Special features: Spa, personal guided excursions to any part of Bali

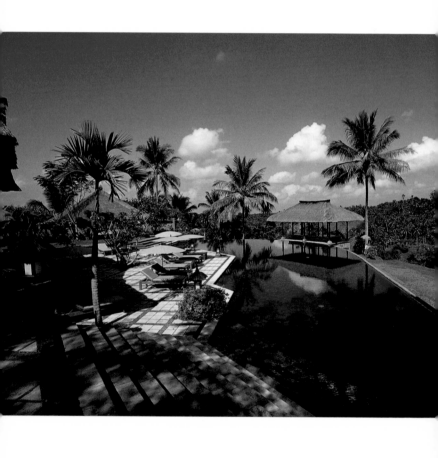

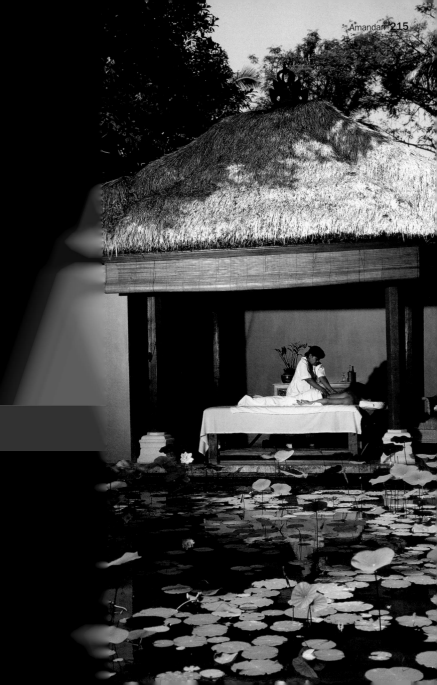

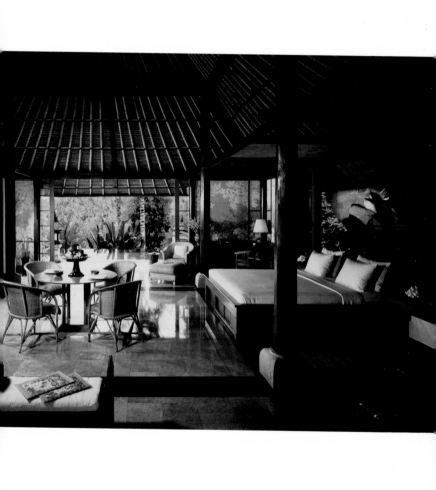

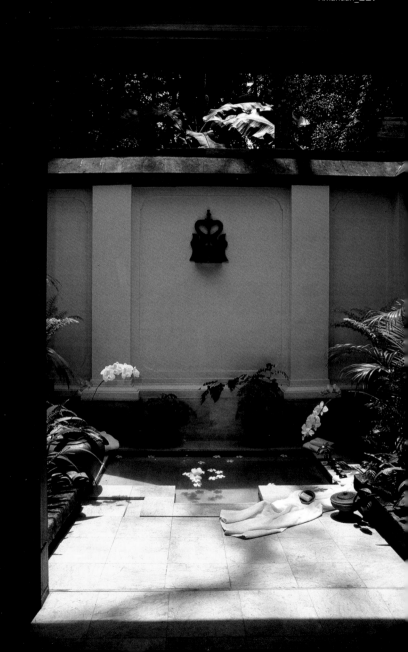

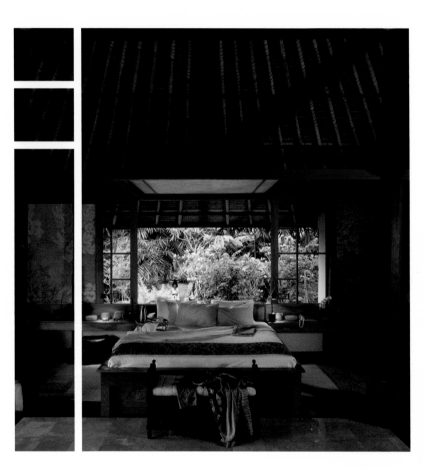

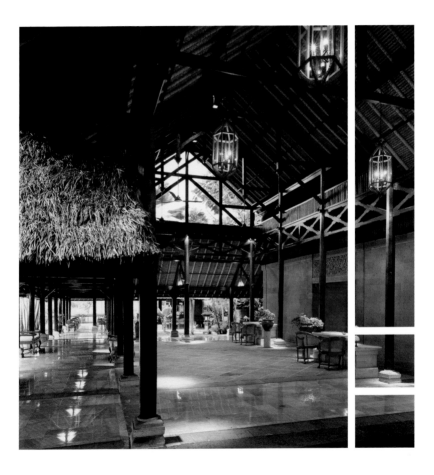

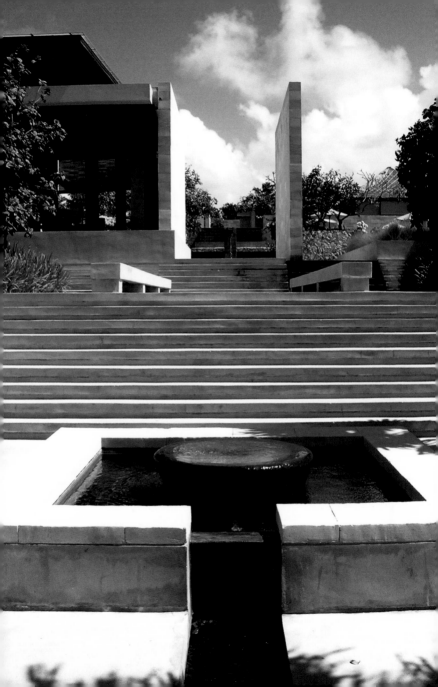

The Balé

Address: **Jalan Raya Nusa Dua Selatan,**
Nusa Dua, P.O. Box 76, 80363 Bali, Indonesia
Tel.: **+62 361 775111**
Fax: **+62 361 775222**
www.sanctuaryresorts.com

Interior Design: **Anthony Liu**
Opening date: **2001**
Photos: **© Rio Helmi and George Mitchell**

221

Style: Contemporary with Indonesian elements

Rooms: 20 pavilions with private pools

Special features: Personalized meels and
no children under 16

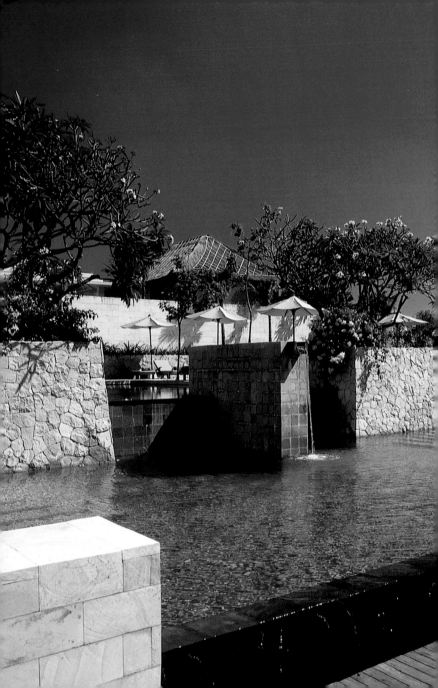

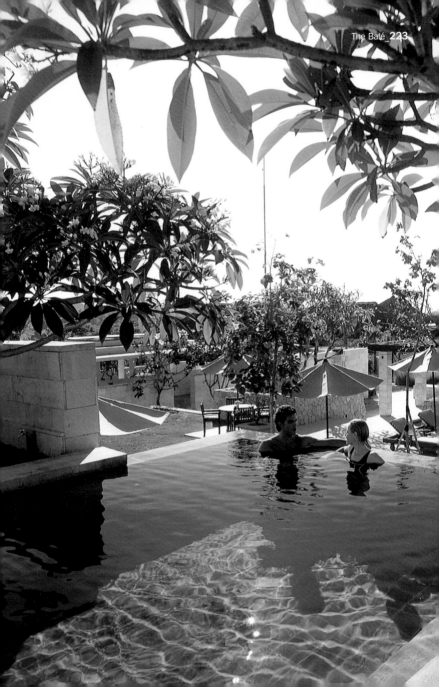

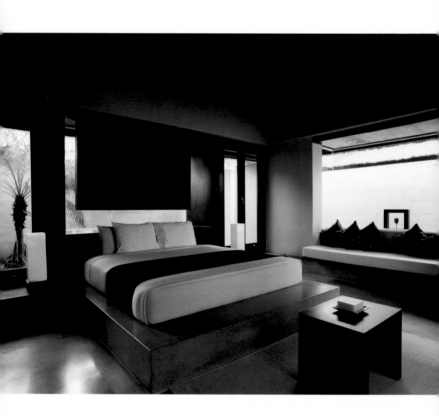

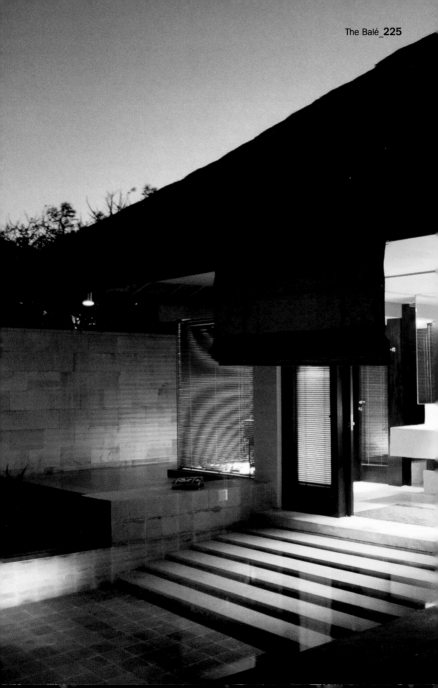

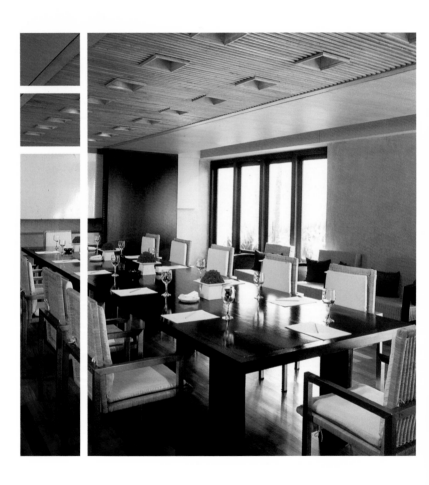

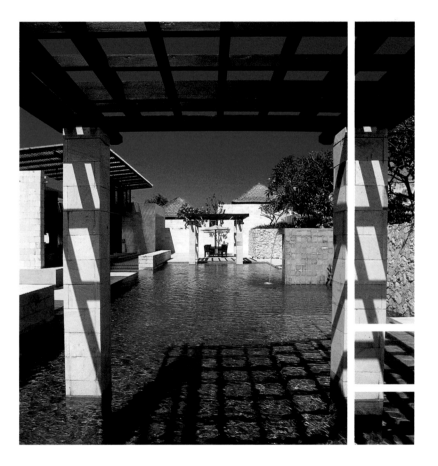

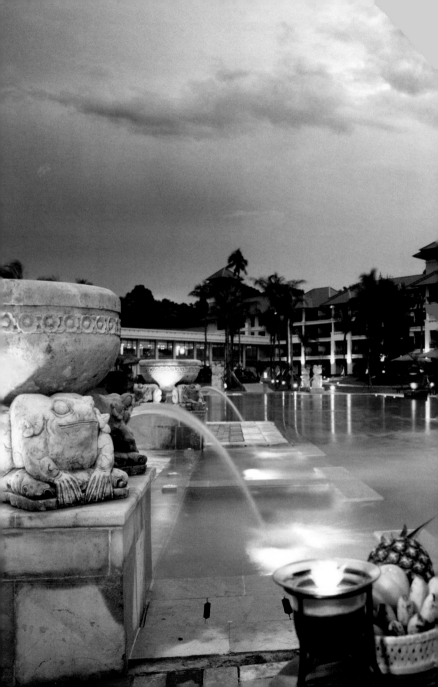

Angsana Bintan

Address: **Site A4 Lagoi,**
 Bintan Island, Indonesia
Tel.: **+62 770 693111**
Fax: **+62 770 693222**
www.angsana.com

Architect: **Ho Kwoncjan/Architrave Design & Planning**
Interior designer: **Dharmali Kusumadi/Architrave Design & Planning**
Opening date: **2000**
Photos: © **Angsana Media**

229

Style: Eclectic

Rooms: 120

Special features: Relaxed vacation in a stylish resort; excursions in catamaran; sailing

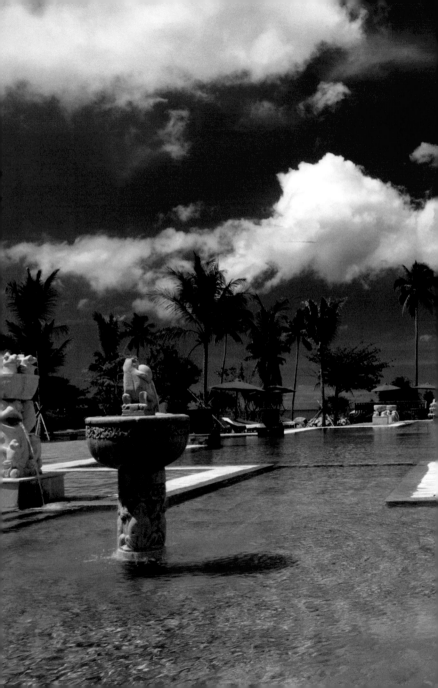

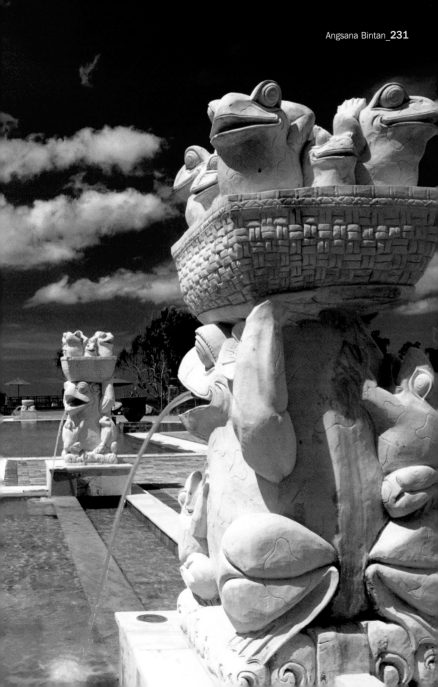

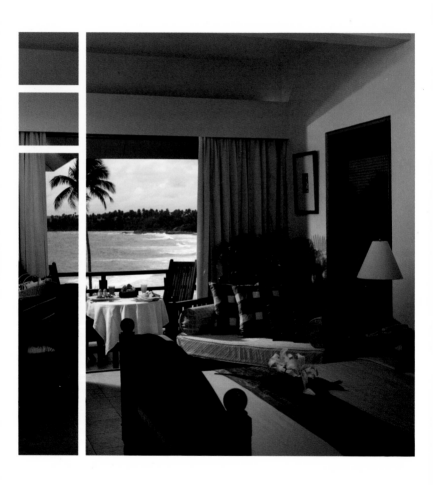

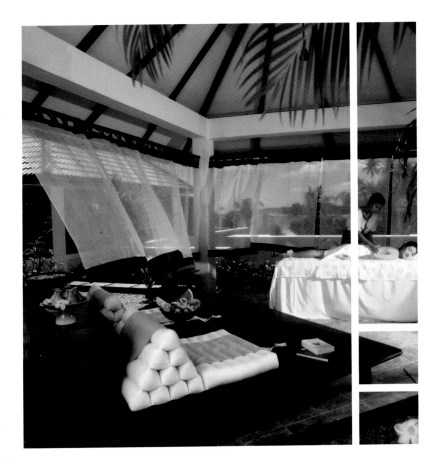

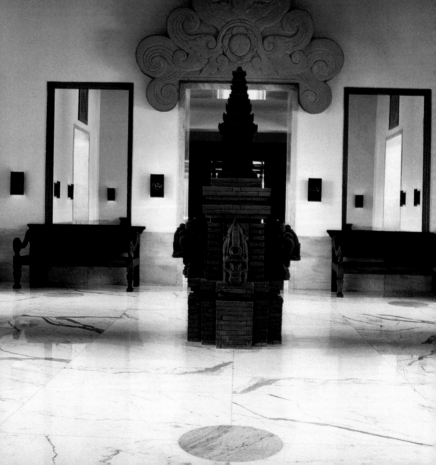

The Dharmawangsa

Address: **Jalan Brawijaya Raya 26,**
 Jakarta 12160, Indonesia
Tel.: **+62 217 258181**
Fax: **+62 217 258383**
www.dharmawangsa.com

Photos: © **Dharmawangsa**

235

Style: Inspired in XI century Indonesian style

Rooms: 100

Special features: Relaxing environment
for business, leisure
or vacation

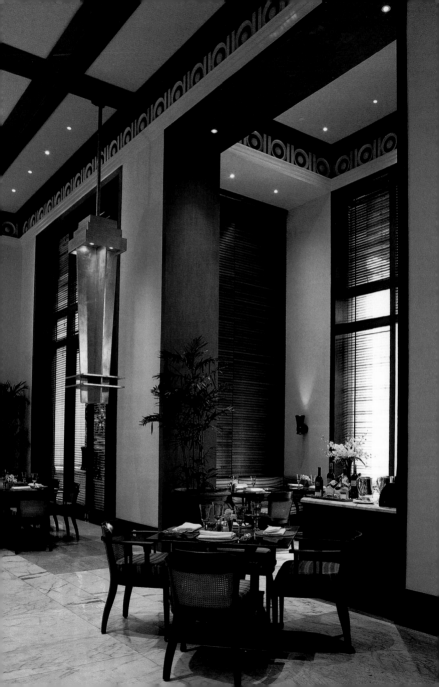

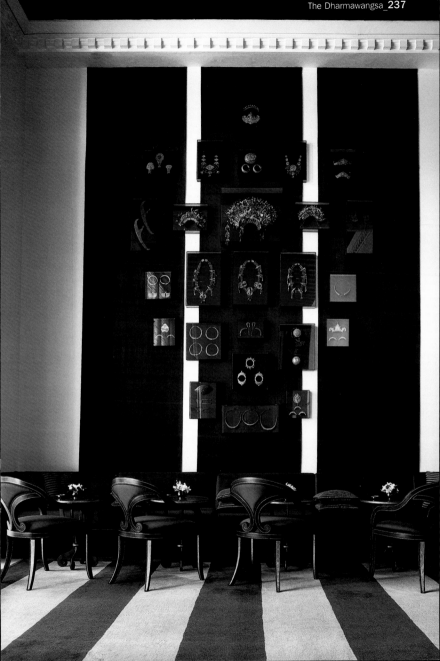

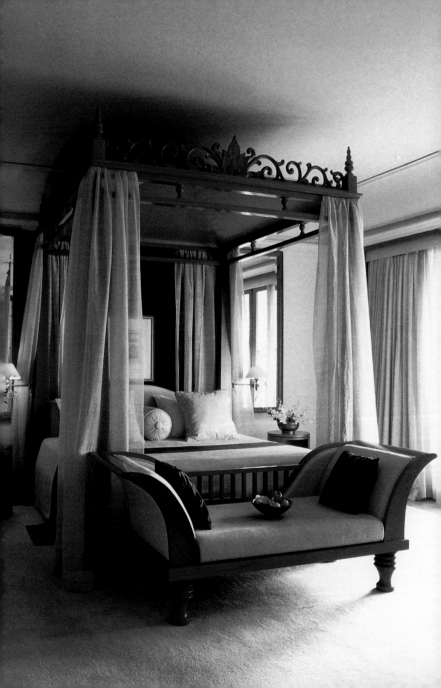

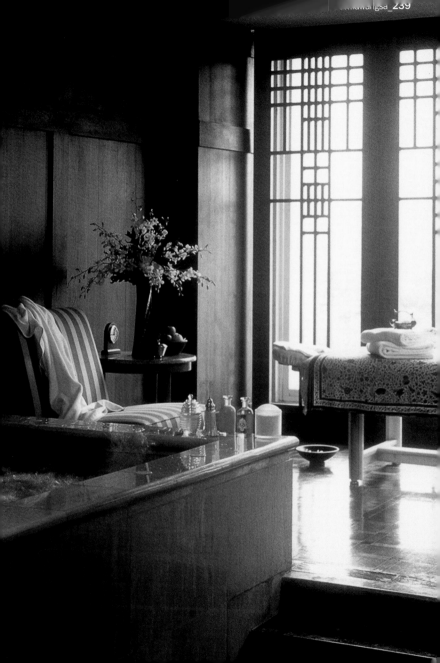

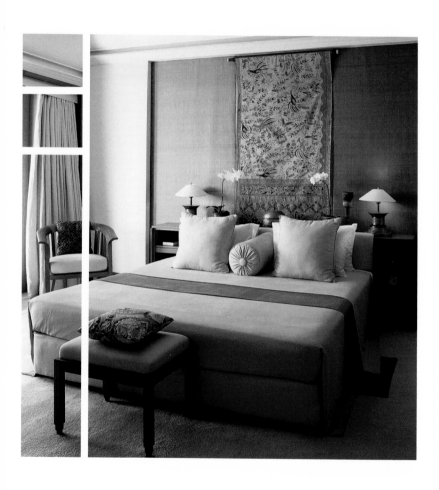

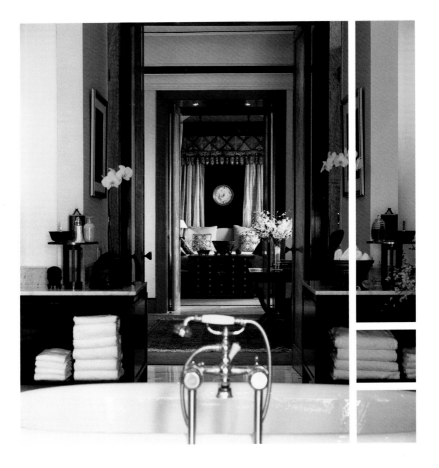

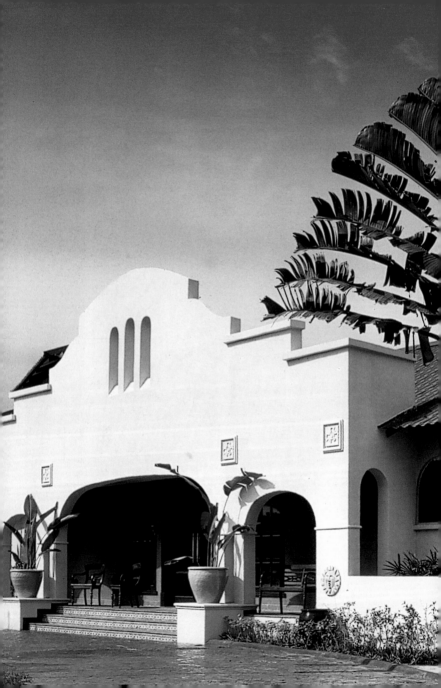

Casa del Mar

Address: **Jalan Pantai Cenang, Mukim Kedawang Langkawi,
Kedah Darul Aman 07000, Malaysia**
Tel.: **+60 (4) 955 2388**
Fax: **+60 (4) 955 2228**
www.casadelmar-langkawi.com

Opening date: **2001**
Photos: **© HPL Hotels & Resorts**

243

Style: Mediterranean

Rooms: 29

Special features: A fine selection of Latin American cigars

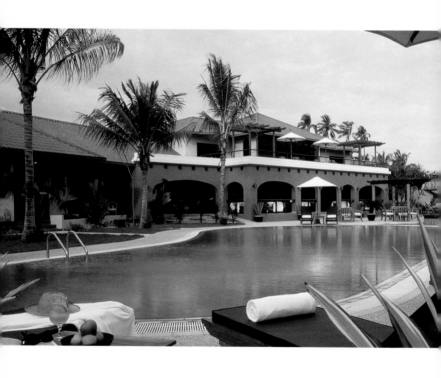

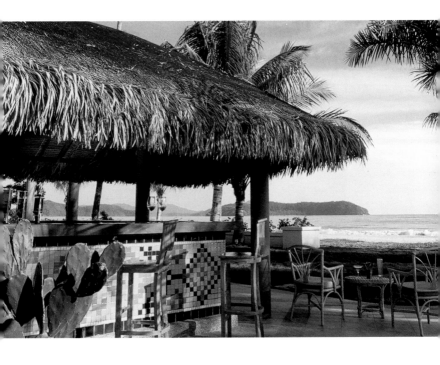

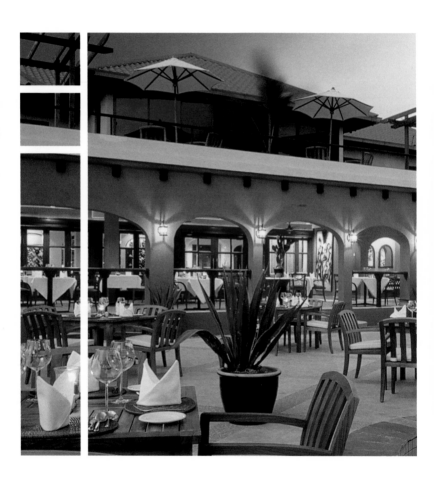

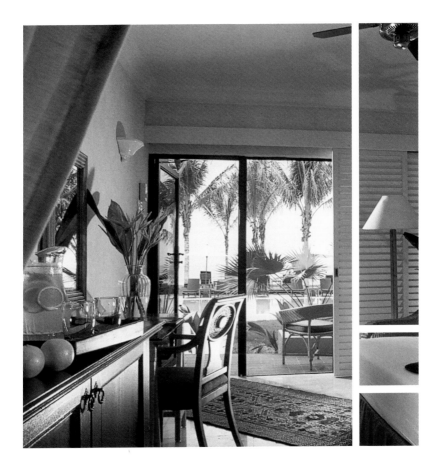

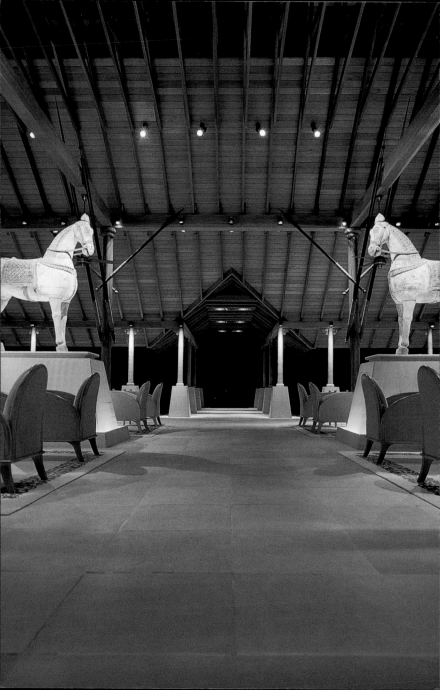

Datai Langkawi

Address: **Jalan Teluk Datai, Pulau Langkawi,
Kedah Darul Aman 07000, Malaysia**
Tel.: **+60 (4) 959 2500**
Fax: **+60 (4) 959 2600**
www.ghmhotels.com

Architects: **Kerry Hill, Victor Choo**
Designers: **Didier Lefort, Jay Yeung**
Opening date: **1993**
Photos: **© Barney Studio**

249

Style: Contemporary and Malaysian architecture

Rooms: 112

Special features: Idyllic natural retreat within the depths of a centuries-old rainforest

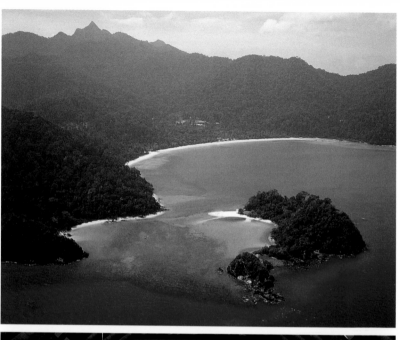

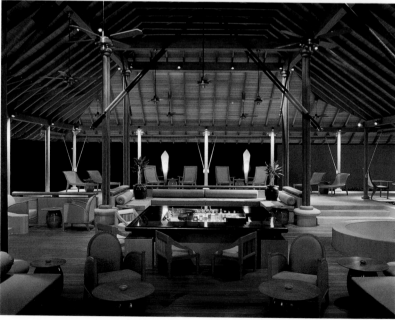

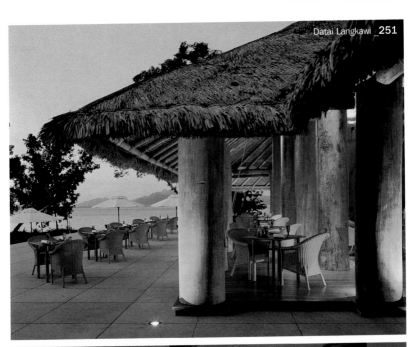

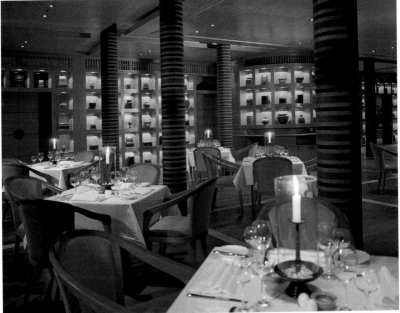

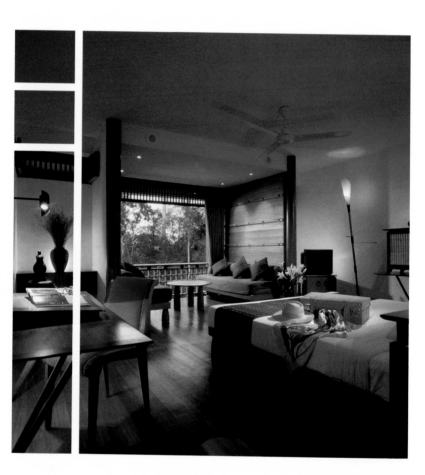

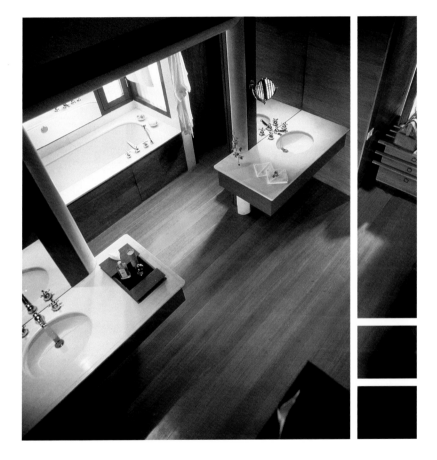

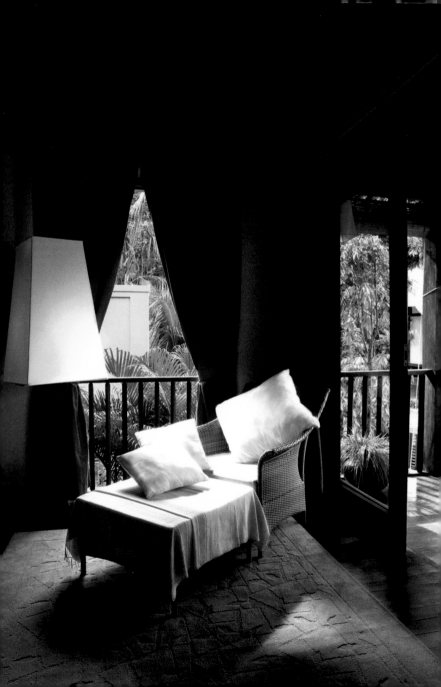

Sunway Lagoon Resort Hotel

Address: **Persiaran Lagoon, Bandar Sunway,**
 46150 Petaling Jaya, Selangor Darul Ehsan, Malaysia
Tel.: **+60 (3) 7492 8000**
Fax: **+60 (3) 7492 8001**
www.sunway.com.my/hotel

Architect: **Akiprima**
Interior designer: **Nelson Yong**
Opening date: **1997**
Photos: © **Sunway Lagoon Resort Hotel**

255

Style: Minimalist

Rooms: 1,165 business rooms (Pyramid tower) and 17 villas

Special features: The largest development in Kuala Lumpur

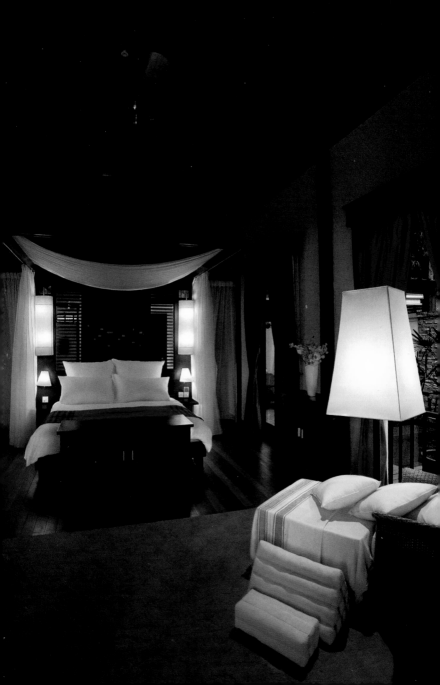

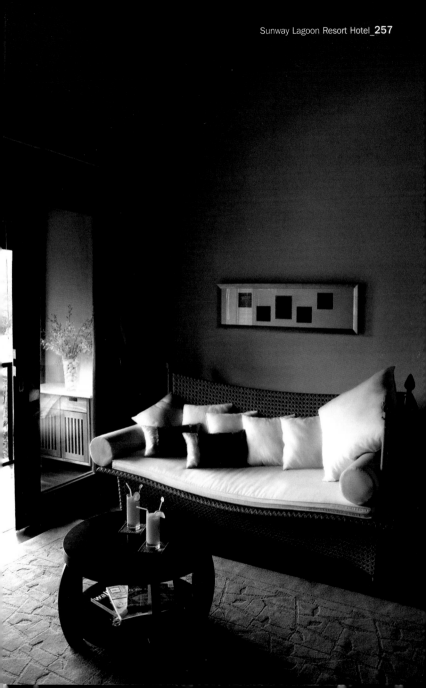

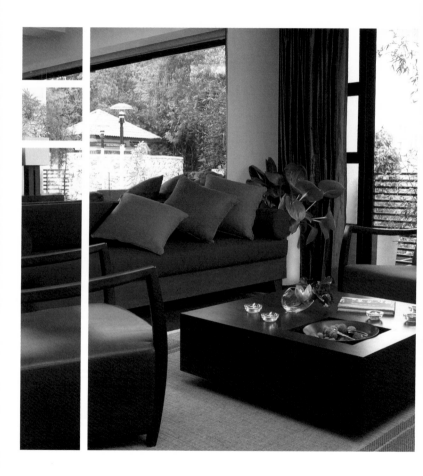

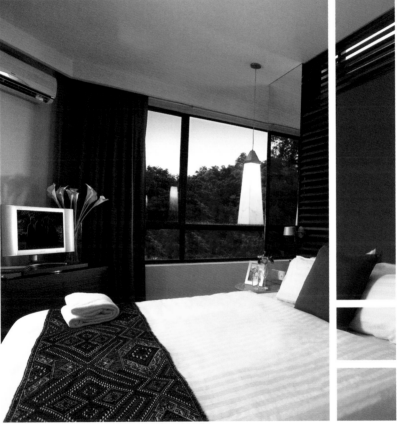

East Asia

Japan
Taiwan
China

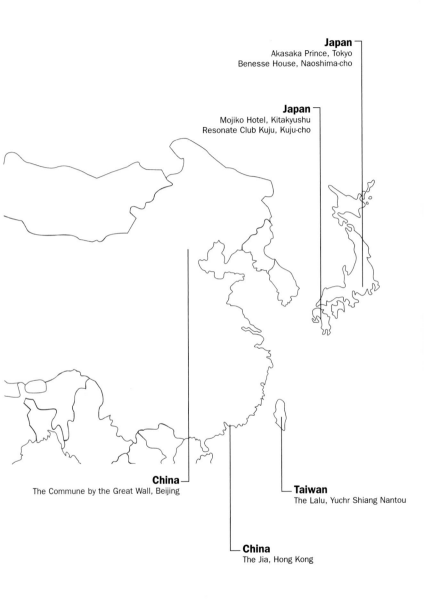

Japan
Akasaka Prince, Tokyo
Benesse House, Naoshima-cho

Japan
Mojiko Hotel, Kitakyushu
Resonate Club Kuju, Kuju-cho

China
The Commune by the Great Wall, Beijing

Taiwan
The Lalu, Yuchr Shiang Nantou

China
The Jia, Hong Kong

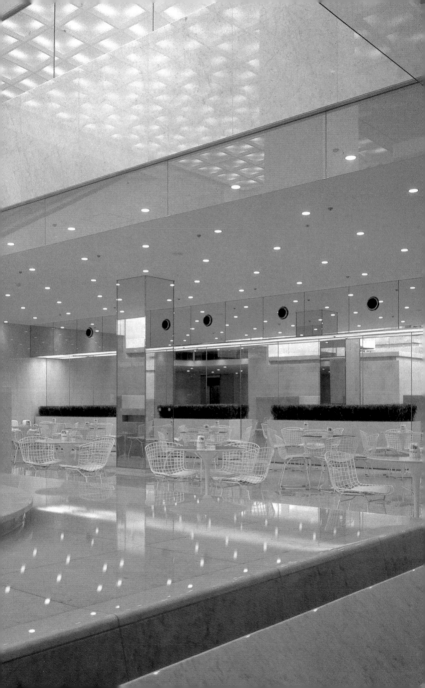

Akasaka Prince

Address: **1-2, Kioi-cho, Chiyoda-ku,**
Tokyo 102-8585, Japan
Tel.: **+81 (0) 3 3234 1111**
Fax: **+81 (0) 3 3262 5163**
www2.princehotels.co.jp

Architect: **Kenzo Tange**
Opening date: **1990**
Photos: **© Akasaka Prince Files**

263

Style: Modern

Rooms: 761

Special features: Located in the heart of the business district which hosts the entertainment areas at night

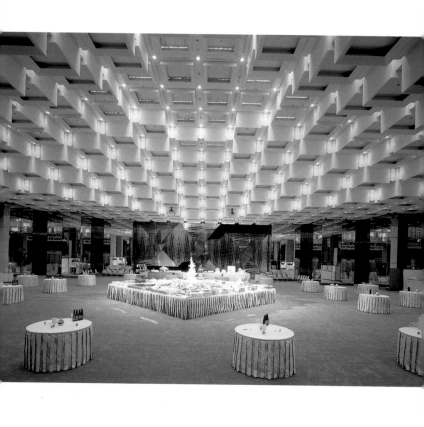

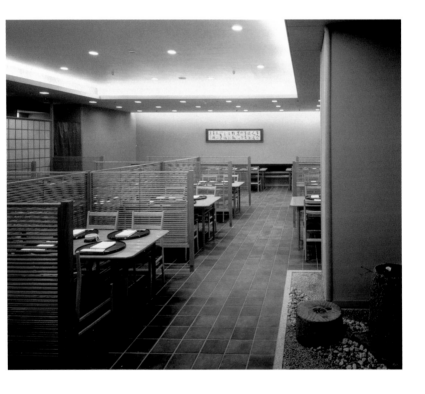

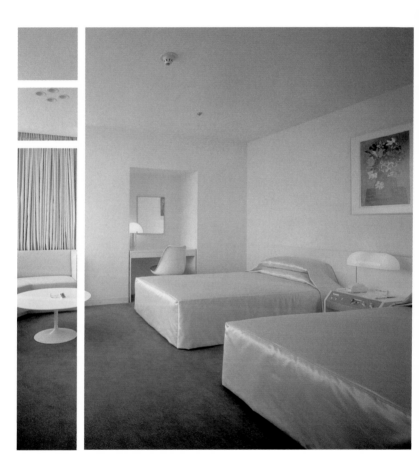

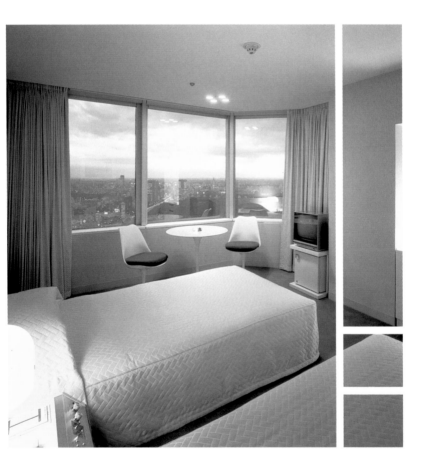

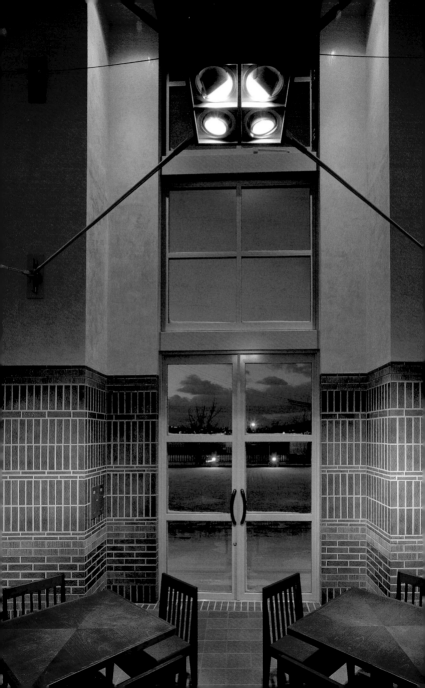

Mojiko Hotel

Address: **9-11 Minatomachi, Moji Ku,**
Kitakyushu, Fukuoka, Japan
Tel.: **+81 (0) 93 321 1111**
Fax: **+81 (0) 93 321 7111**
www.mojiko-hotel.com

Architect and interior designer: **Aldo Rossi**
Opening date: **1998**
Photos: © **Shigeru Uchida**

269

Style: International

Rooms: 134

Special features: Fantastic views
over the city and sea

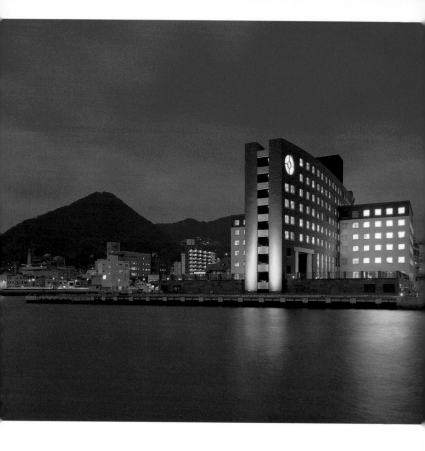

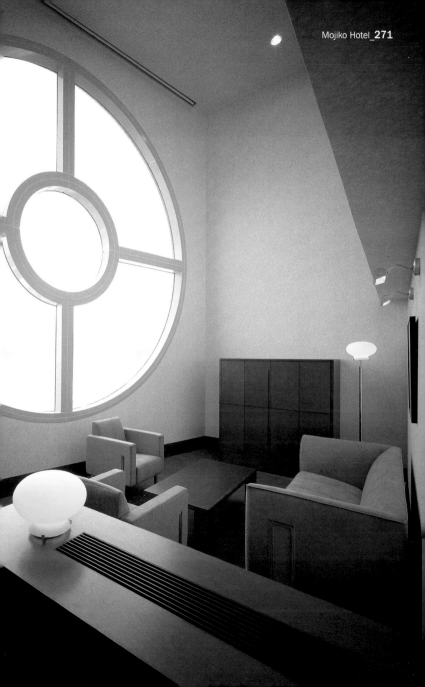

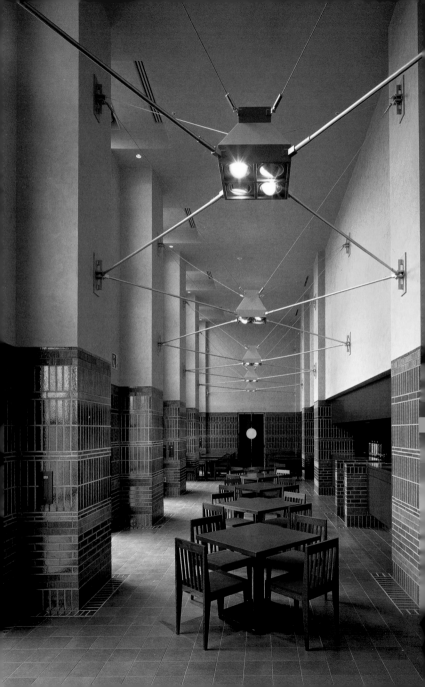

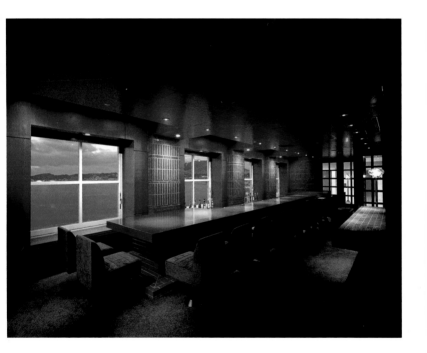

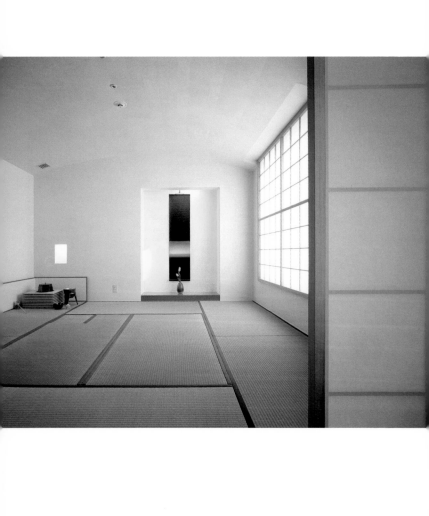

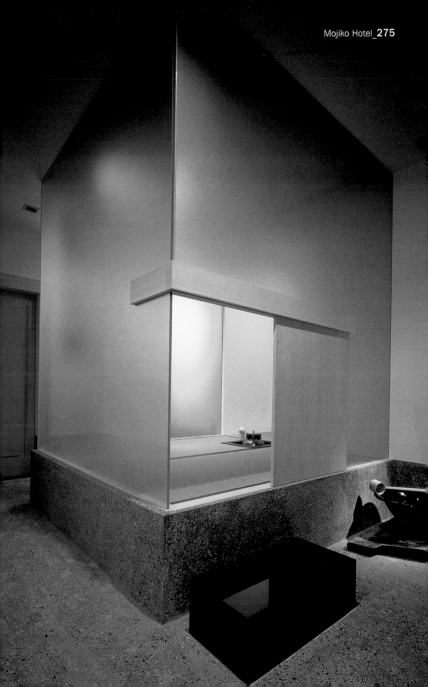

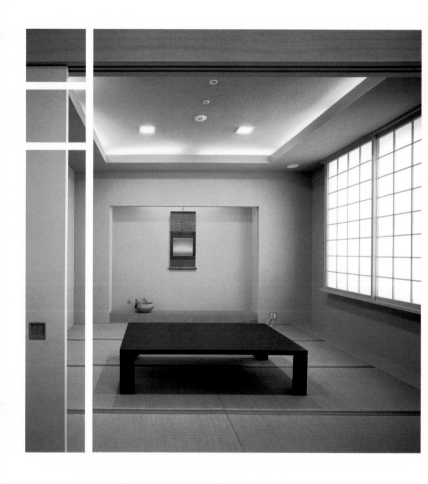

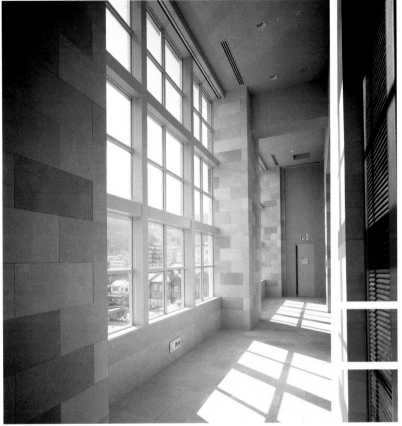

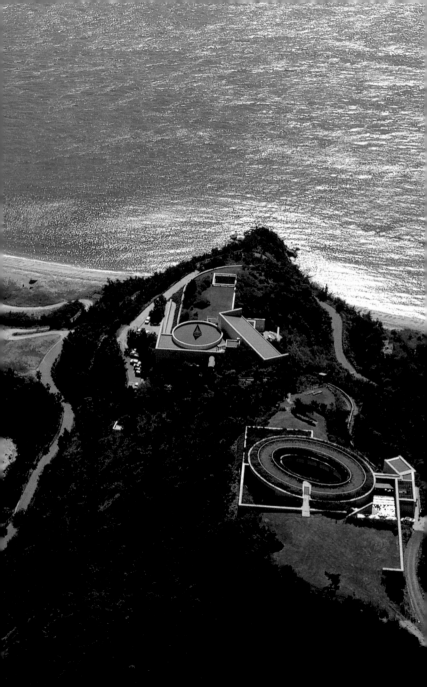

Benesse House

Address: **Gotanji, Naoshima-cho,**
Kagawa-gun 761-3110, Kagawa, Japan
Tel.: **+81 (0) 87 892 2030**
Fax: **+81 (0) 87 892 2259**
www.naoshima-is.co.jp

Architect: **Tadao Ando**
Opening date: **1995**
Photos: **Mitsuo Matasuoka, Tomio Ohashi, Tadao Ando**

279

Style: Minimalist

Rooms: 6

Special features: Forms part of the Naoshima Contemporary Art Museum complex; artworks in each room

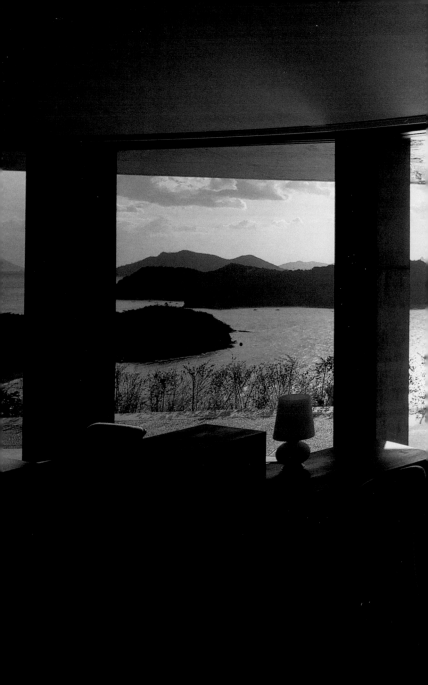

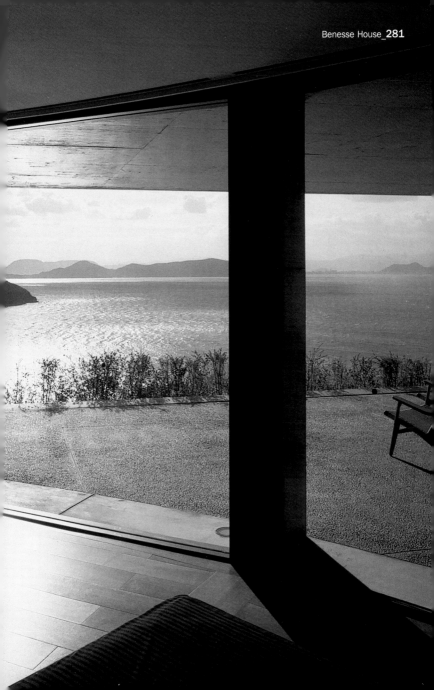

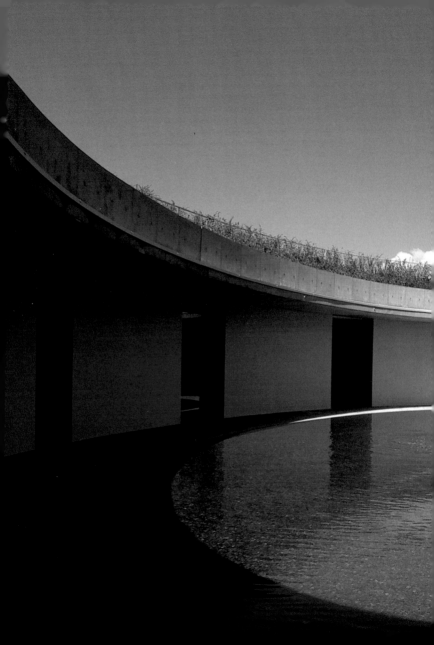

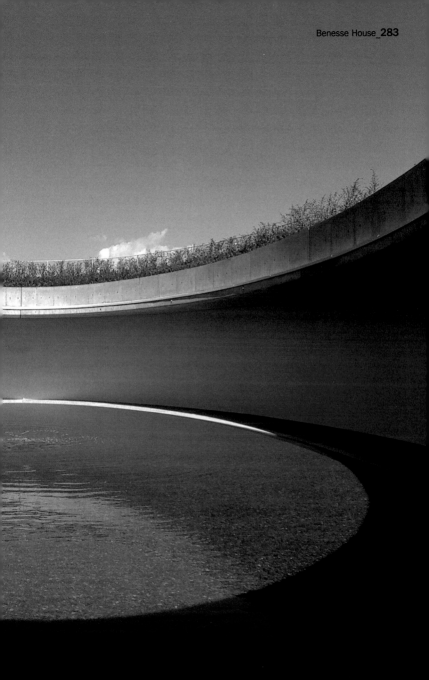

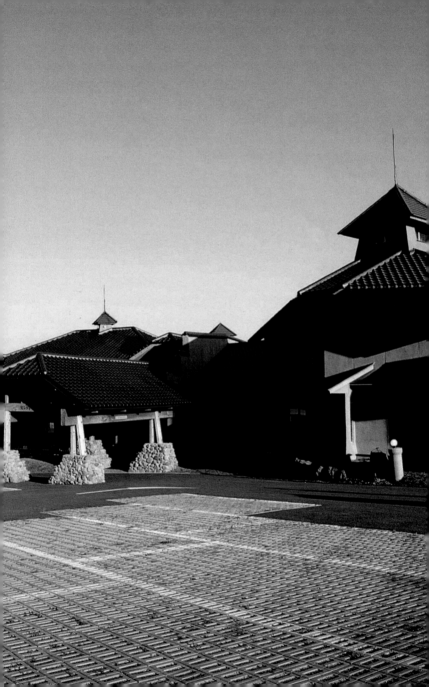

Resonate Club Kuju

Address: **1773 Hirouchi, Ariuji, Kuju-cho,**
Naoiri-gun, Oita, Japan
Tel.: **+81 (0) 974 761223**
Fax: **+81 (0) 974 761460**
www.resonate.co.jp

Owners and designers: **Kinya Maruyama and**
Atelier Mobile
Opening date: **1993**
Photos: © **Club Kuju**

285

Style: Classical Japanese spa reconstructed

Rooms: 58

Special features: Golf, ski, horse riding

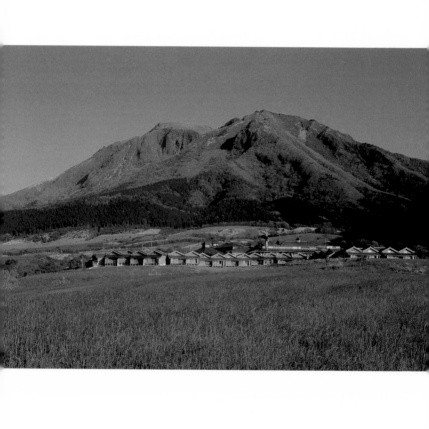

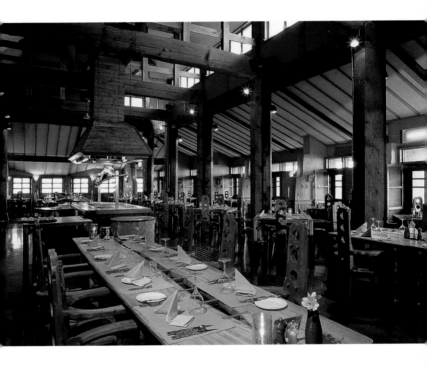

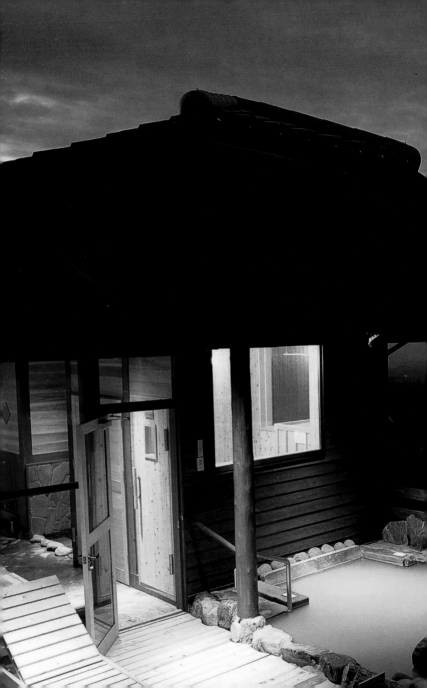

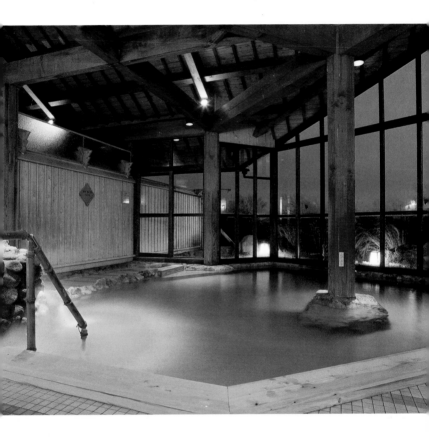

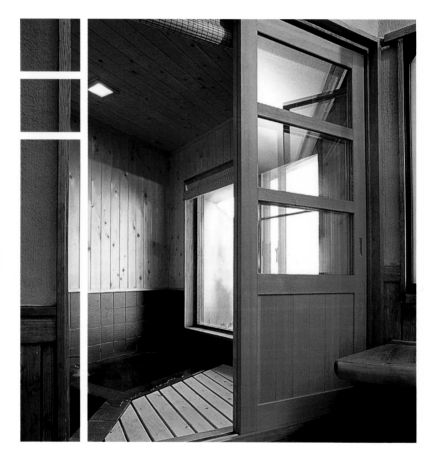

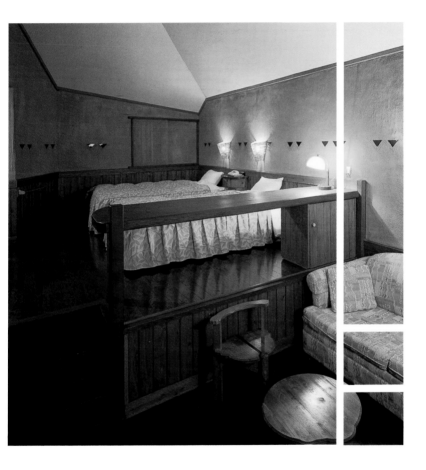

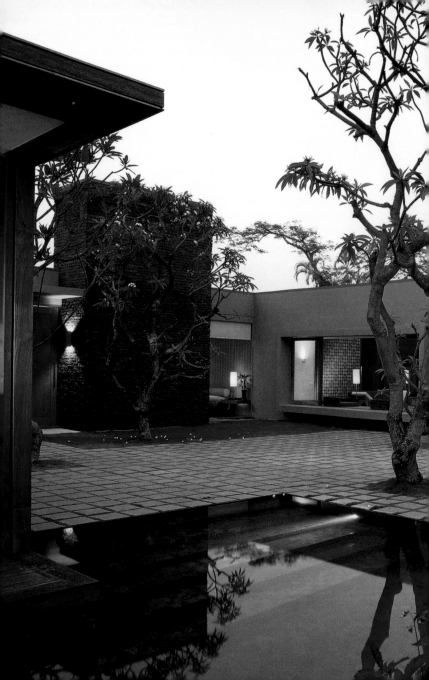

The Lalu

Address: **142 Jungshing Road,**
 Yuchr Shiang Nantou, Taiwan
Tel.: **+886 (049) 285 5311**
Fax: **+886 (049) 285 5312**
www.ghmhotels.com

Architects: **Kerry Hill and Nathan Thompson**
Opening date: **2003**
Photos: © **The Lalu**

Style: Minimalist

Rooms: 98

Special features: Luxurious living with spectacular views

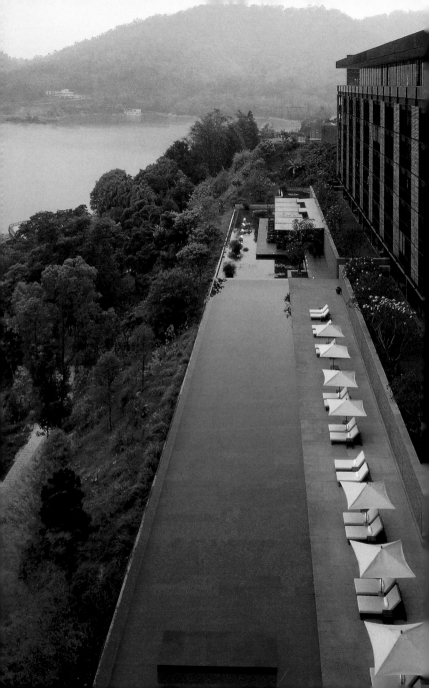

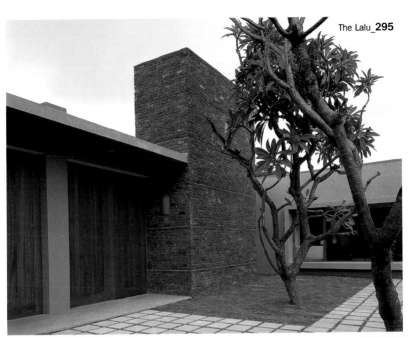

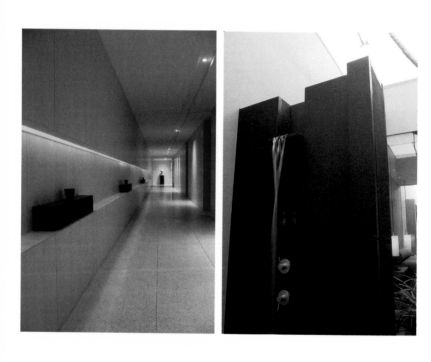

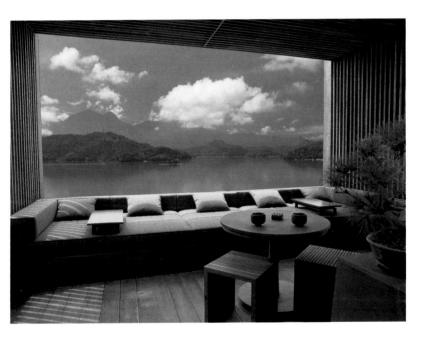

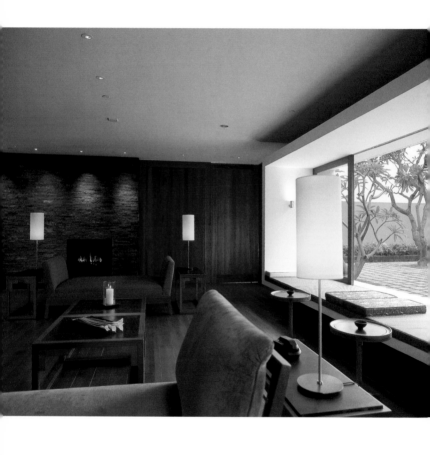

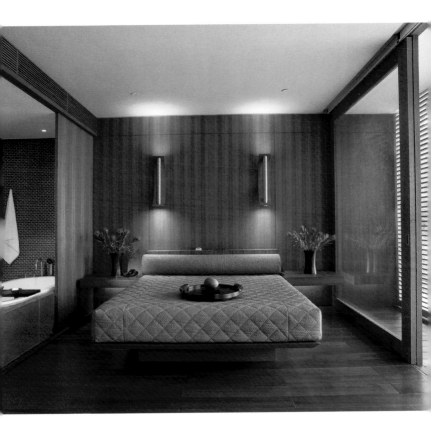

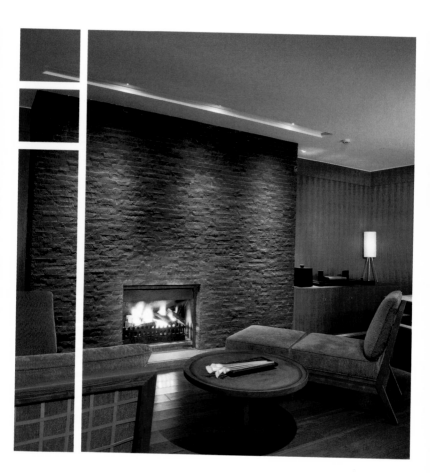

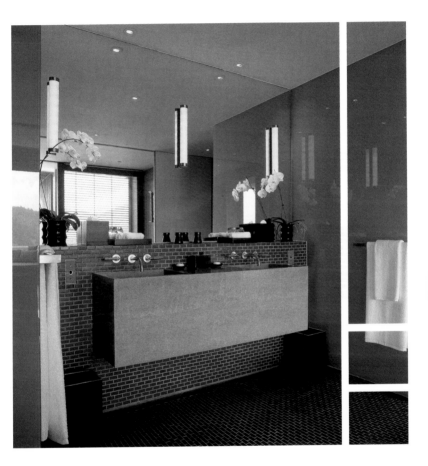

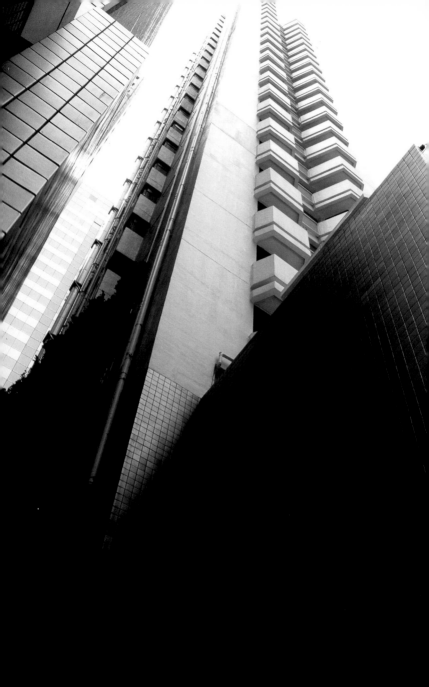

The Jia

Address: **1-5 Irving Street, Causeway Bay,**
Hong Kong, China
Tel.: **+852 3196 9000**
Fax: **+852 3196 9001**
www.jiahongkong.com

Owners and designers: **John Hitchcox and Philippe Starck**
Opening date: **2004**
Photos: © **Zapaimages/Reto Guntli**

303

Style: Contemporary design

Rooms: 55 chic hotel apartments, 2 penthouses

Special features: Glamorous design

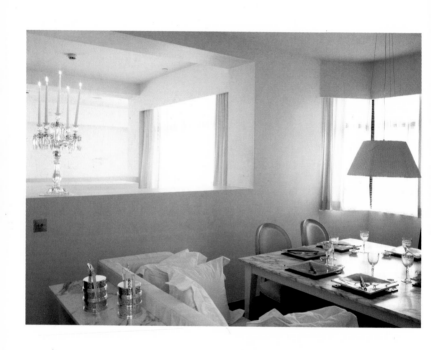

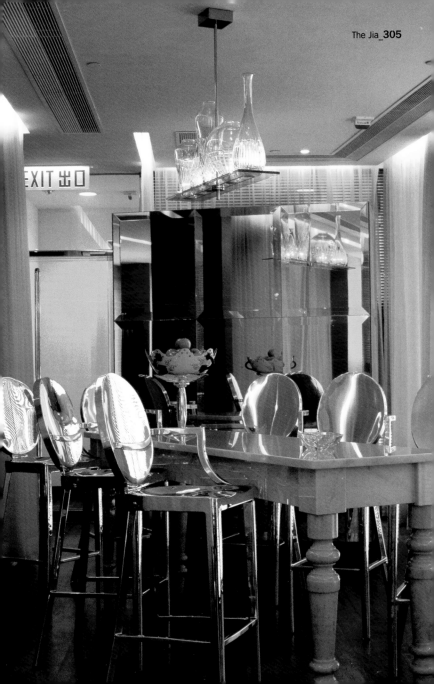

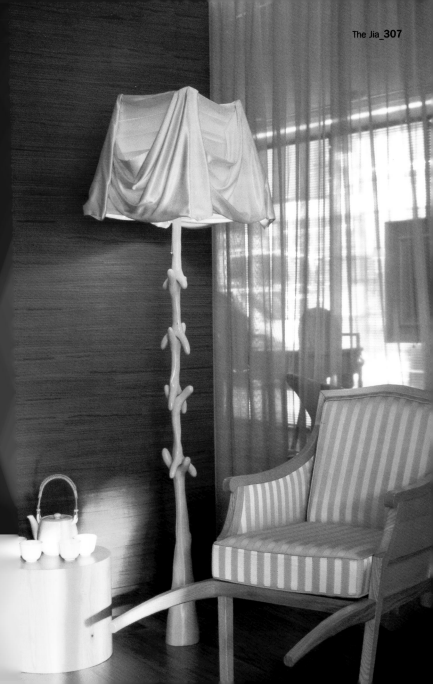

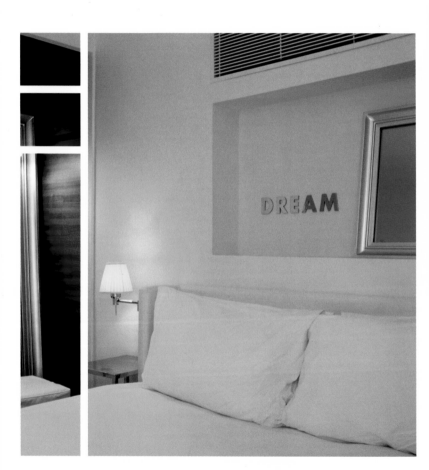

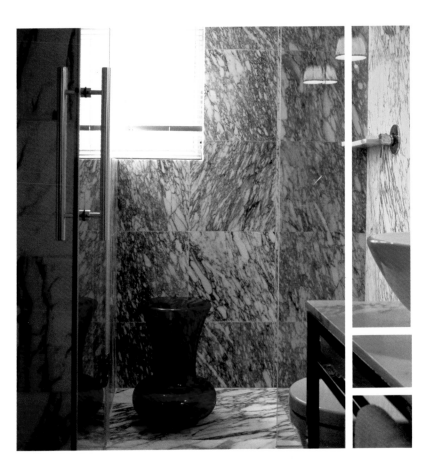

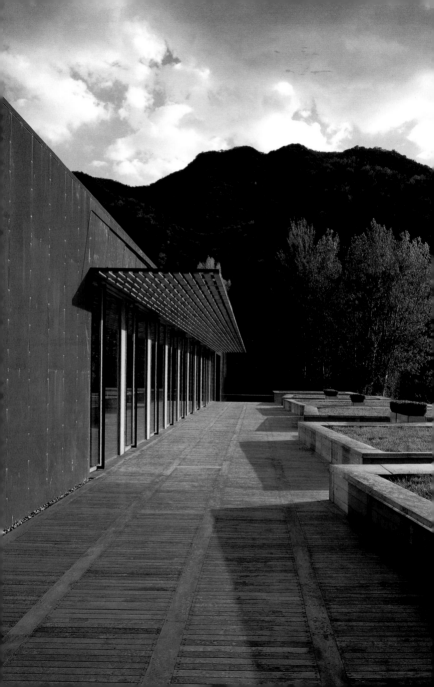

The Commune by the Great Wall

Address: **Badaling Highway,**
Beijing, China
Tel.: **+86 10 8118 1888**
FAx: **+86 10 8118 1866**
www.commune.com.cn

Architects: **G. Chang, S. Ban, C. Kai, R. Yim, Ch. Hsueh Yi, A. Ochoa, K.**
Kuma, K. R'Kul, T. Kay Ngee, N. Furuya, Ch. Yung Ho, S. H Sang
Interior designers: **H. Zimmern, S. Mouille, T. Hoppe, V. Robinson, Ph.**
Starck, A. Strub, C. Colucci, R. Menuez, K. Okajima,
J. Damon, K. Rashid, M. Hilton, M. Newson, M. Young
Opening date: **2002**
Photos: © **Satoshi Asakawa, Ma Xiaochun**

311

Style: Boutique hotel

Rooms: 59 villas and 1 clubhouse: 4 to 6 bedrooms at each house

Special features: The Commune by the Great
Wall is a private collection
of contemporary architecture
designed by 12 Asian affluent
architects: one of the most
cool hotels in the world

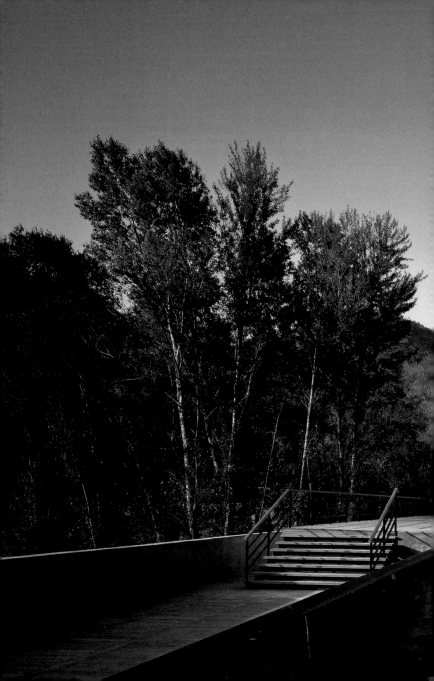

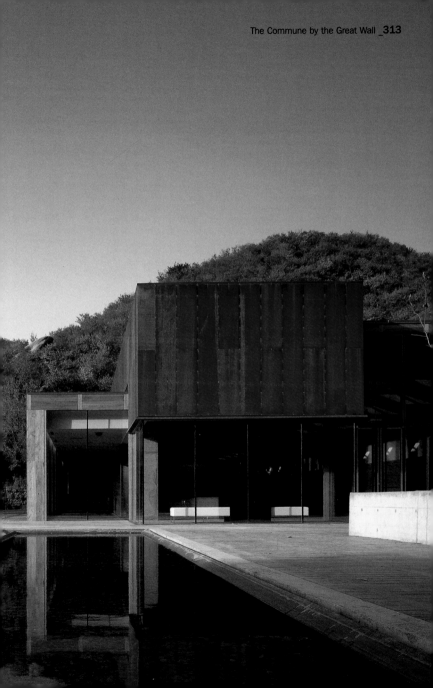

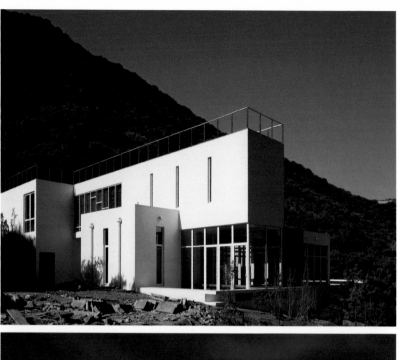
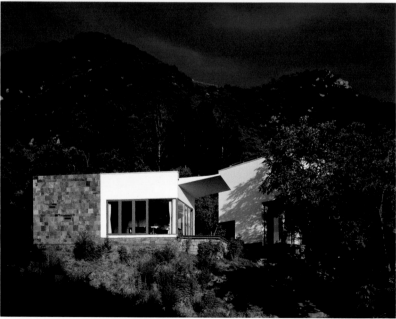

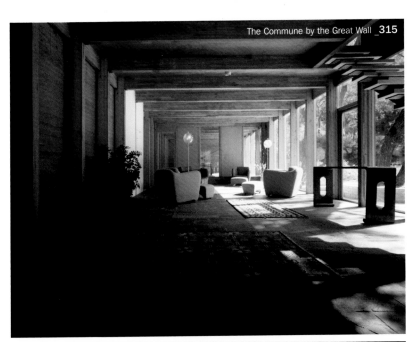

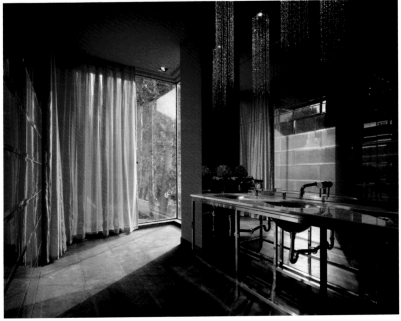

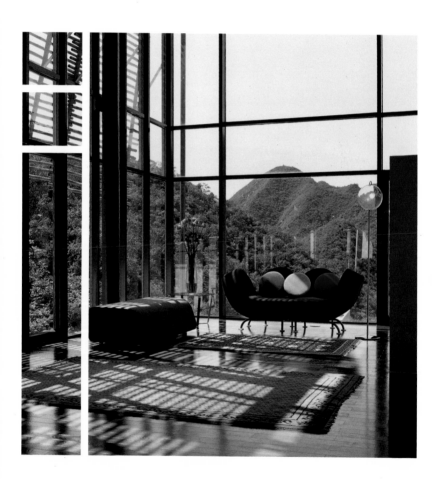

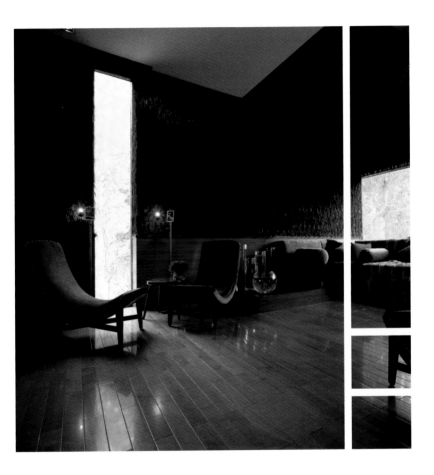

Oceania

Australia
New Zealand
Fiji Islands

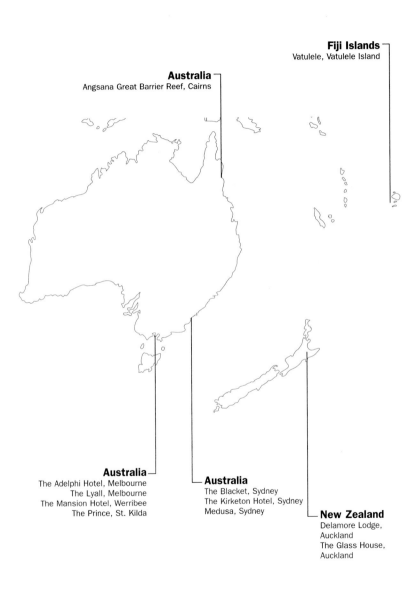

Fiji Islands
Vatulele, Vatulele Island

Australia
Angsana Great Barrier Reef, Cairns

Australia
The Adelphi Hotel, Melbourne
The Lyall, Melbourne
The Mansion Hotel, Werribee
The Prince, St. Kilda

Australia
The Blacket, Sydney
The Kirketon Hotel, Sydney
Medusa, Sydney

New Zealand
Delamore Lodge,
Auckland
The Glass House,
Auckland

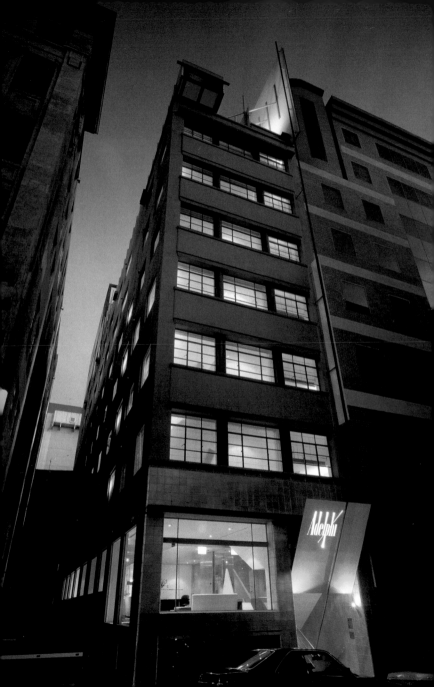

The Adelphi Hotel

Address: **187 Flinders Lane, Victoria 3000**
Melbourne, Australia
Tel.: **+61 3 9650 7555**
Tax: **+61 3 9650 2710**
www.adelphi.com.au

Owner and designer: **Denton Corker Marshall DCM**
Opening date: **1992**
Photos: © **John Gollings**

321

Style: Contemporary

Rooms: 34

Special features: 85 feet long heated salt-water roof-top lap pool

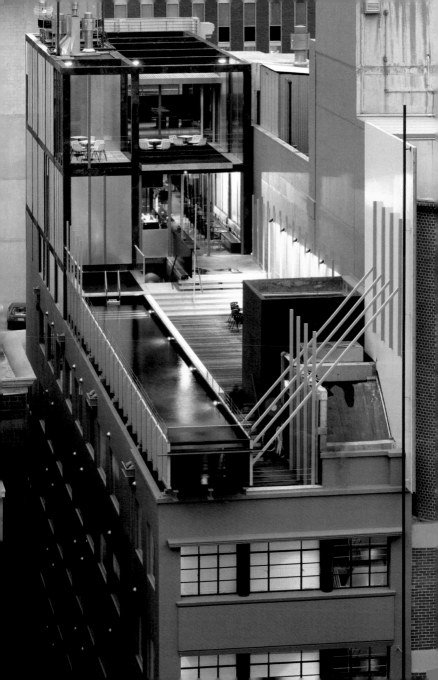

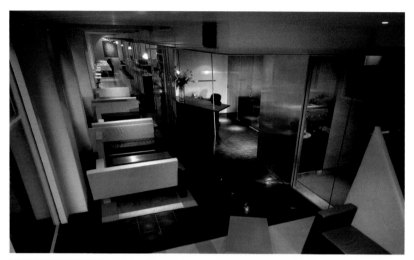

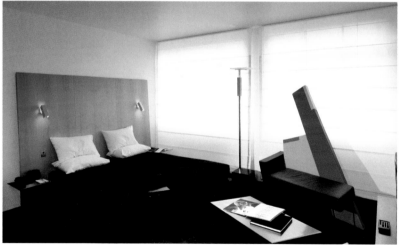

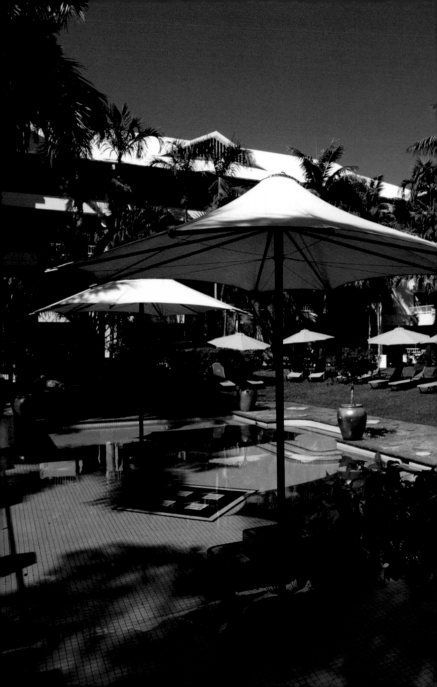

Angsana Great Barrier Reef

Address: **1 Veivers Road, Palm Cove,**
Cairns, Queensland 4879, Australia
Tel.: **+61 7 4055 3000**
Fax: **+61 7 4055 3090**
www.angsana.com

Architect: **Ho Kwoncjan/Architrave Design & Planning**
Interior Designer: **Dharmali Kusumadi/**
Architrave Design & Planning
Opening date: **2000**
Photos: © **Angsana Media**

325

Style: International

Rooms: 67 suites

Special features: All the water sports: snorkel, water-skiing, scuba diving and others

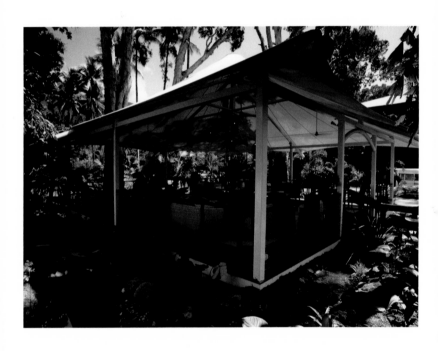

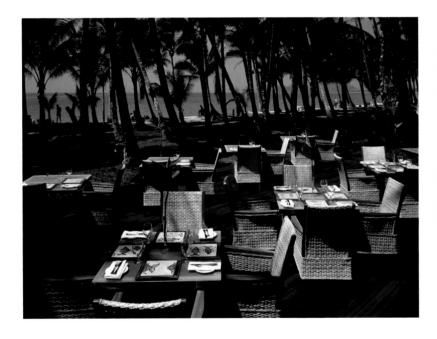

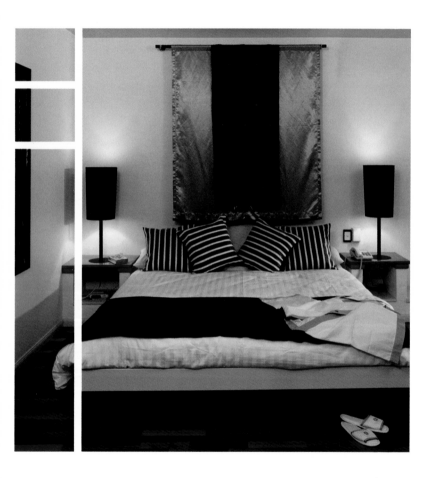

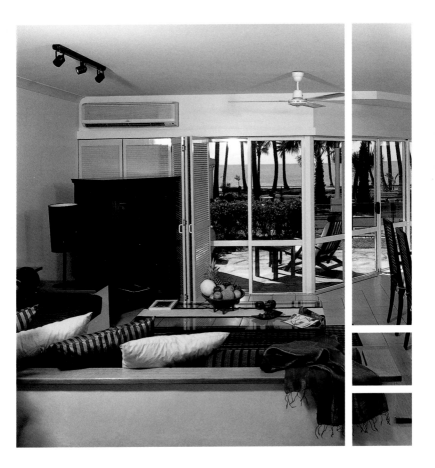

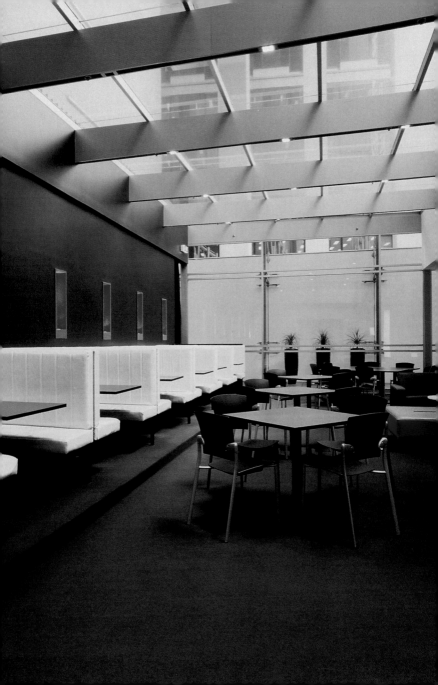

The Blacket

Address: **70 King Street,**
Sydney NSW 2000, Australia
Tel.: **+61 2 9279 3030**
Fax: **+61 2 9279 3020**
www.theblaket.com

Architect: **Edmund Thomas Blacket (1850)**
Designer: **John Harrs**
Opening date: **2001**
Photos: © **Marian Riabic**

331

Style: Contemporary design

Rooms: 42

Special features: Cool ambient in the heart of Sydney's corporate, retail and leisure

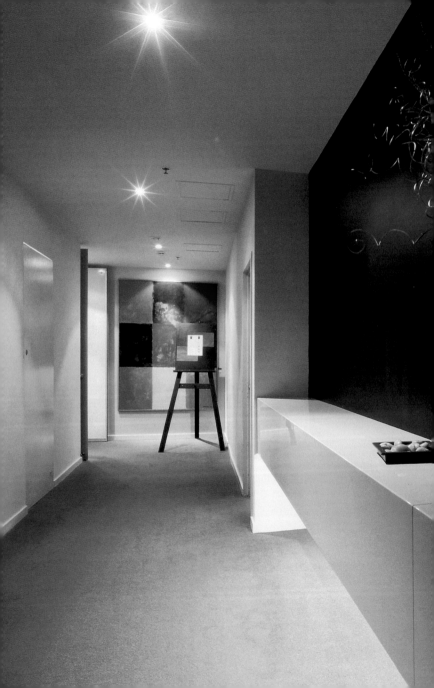

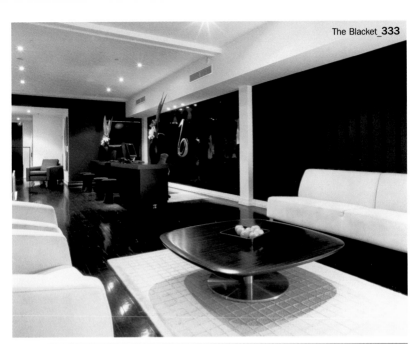

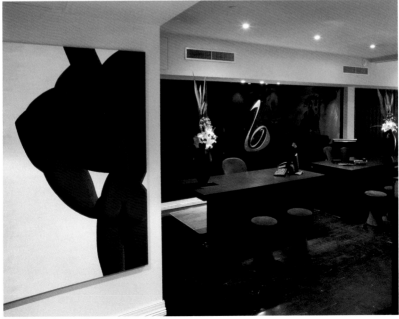

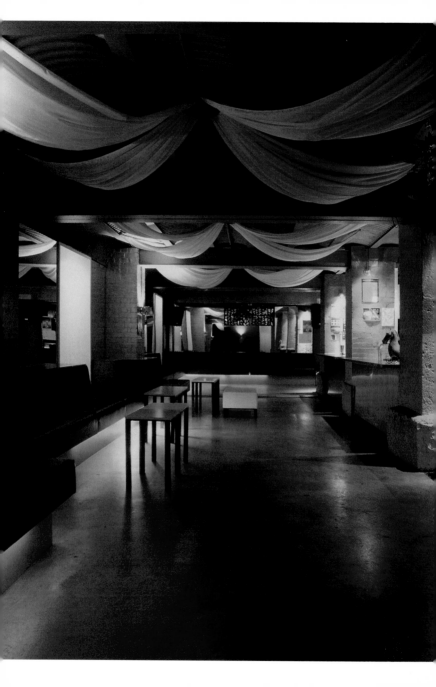

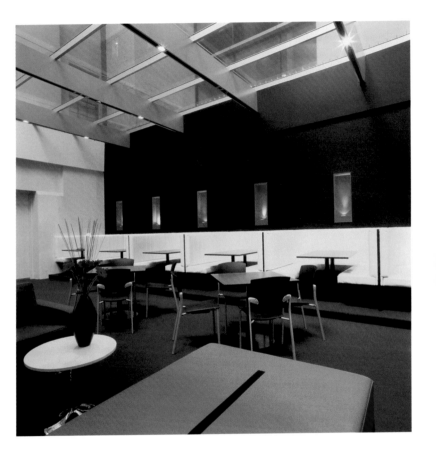

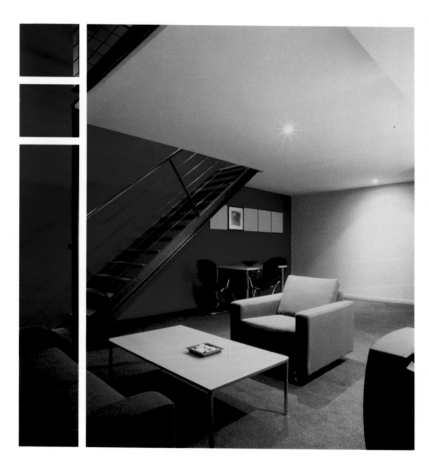

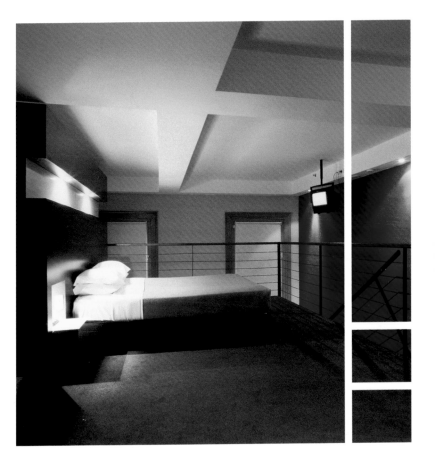

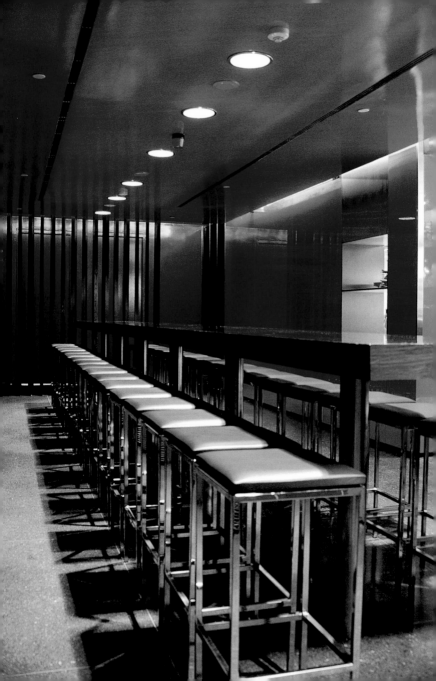

The Kirketon Hotel

Address. **229 Darlinghurst Road,**
Darlinghurst NSW 2010, Sydney, Australia
Tel.: **+61 2 9332 2011**
Fax: **+61 2 9332 2499**
www.kirketon.com.au

Architects: **Burley Katon Halliday Architects**
Opening date: **1999**
Photos: © **Sharin Rees**

339

Style: Contemporary

Rooms: 40

Special features: One of the most fashion hotels in Sydney

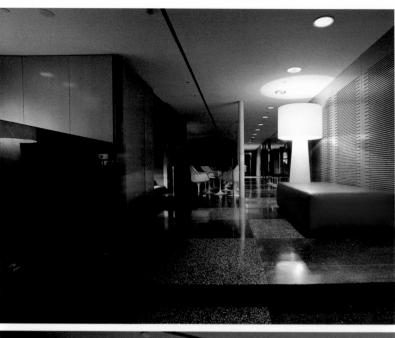

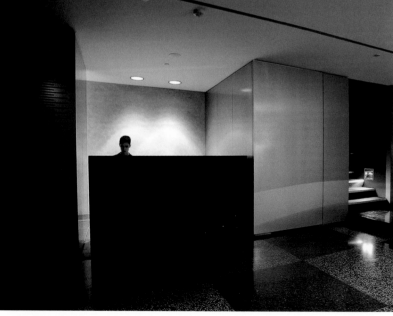

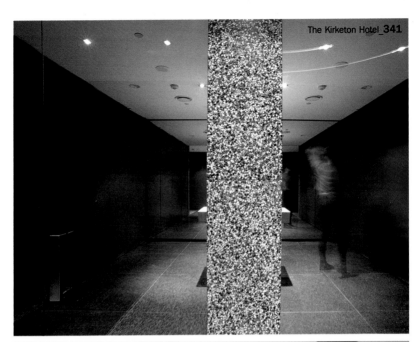

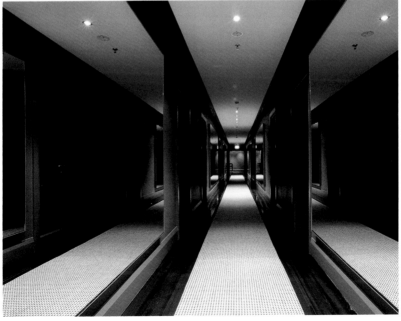

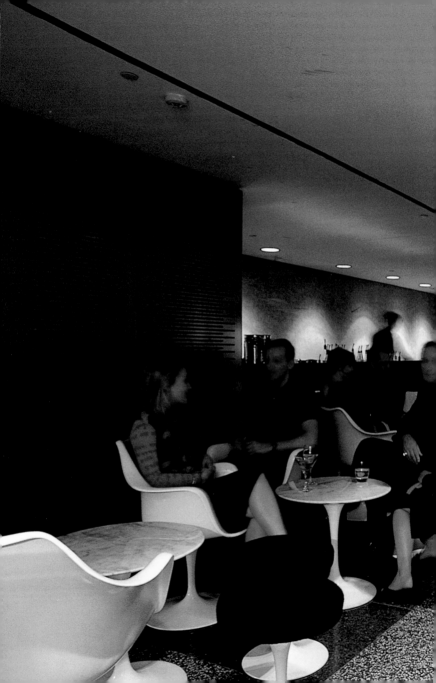

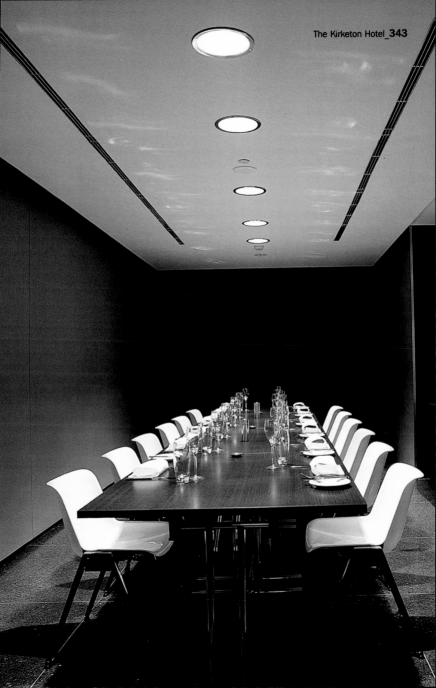

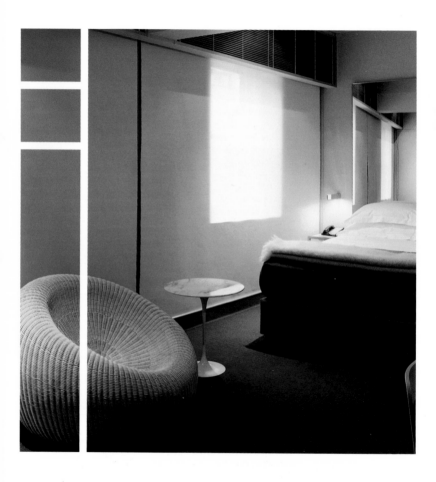

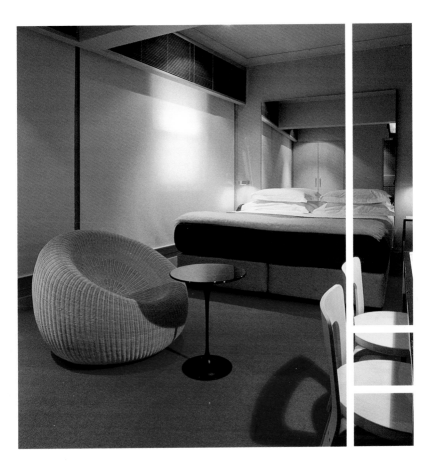

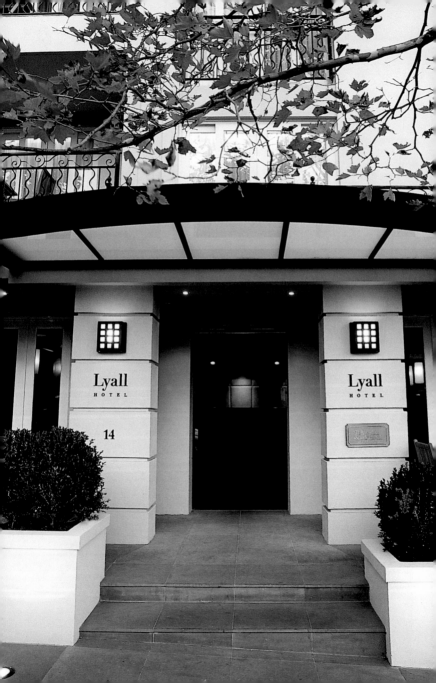

The Lyall

Address: **14 Murphy St, South Yarra,**
 Victoria 3141, Melbourne, Australia
Tel.: **+61 3 9868 8222**
Fax: **+61 3 9820 1724**
www.thelyall.com

Architects: **Bruce Henderson Architects**
Interior designers: **Peter and Rowina Thomas**
Furniture: **Pierre and Charlotte Julien**
Garden and landscape designer: **Paul Bangay**
Opening date: **2002**
Photos: © **Lyall**

347

Style: Contemporary in a French-renaissance style

Rooms: 40

Special features: Gymnasium opened 24 hours; tranquil place in the middle of a busy city

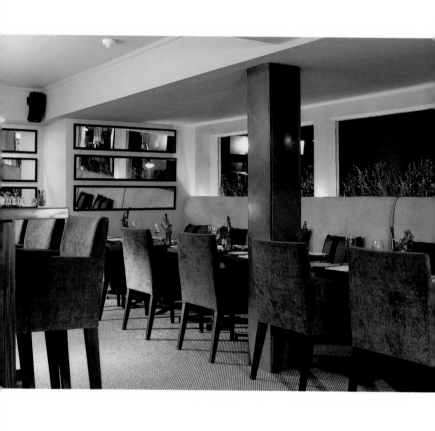

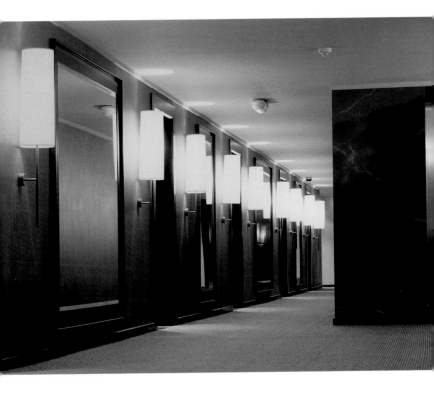

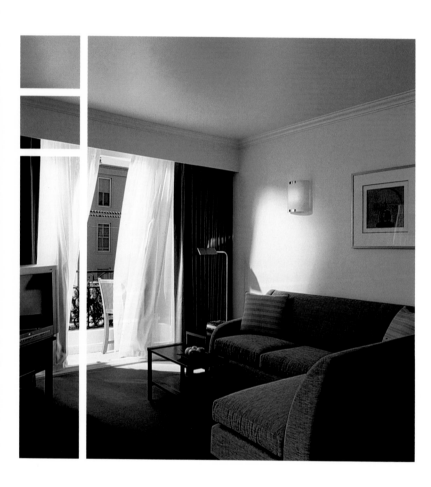

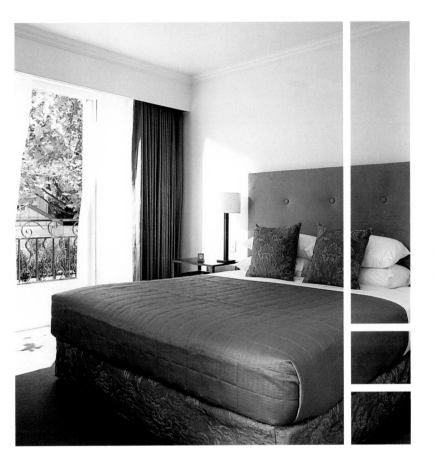

The Mansion Hotel

Address: **K Road, Werribee,**
Victoria 3030, Australia
Tel.: **+61 3 9731 4000**
Fax: **+61 3 9731 4001**
www.mansionhotel.com.au

Architect: **Wood Marsh**
Interior designers: **Rice & Skinner**
Opening date: **1997**
Photos: © **Earl Carter**

353

Style: Contemporary and remodeled Scottish colonial house

Rooms: 60 room-residences, 92 guestrooms

Special features: Charming, luxury and peaceful ambience in Werribee Park; the Shadowfax Winery is also part of the development

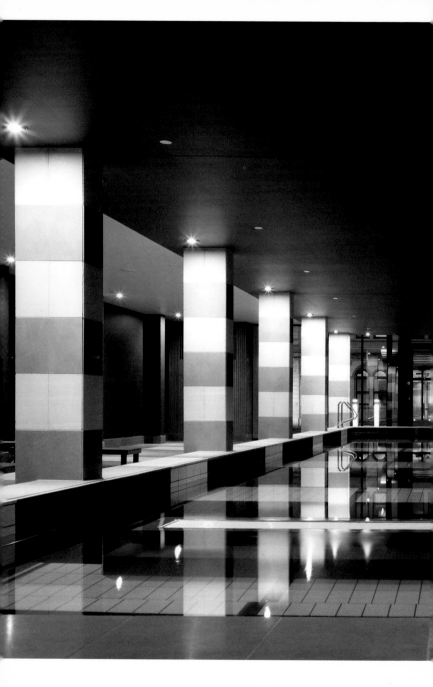

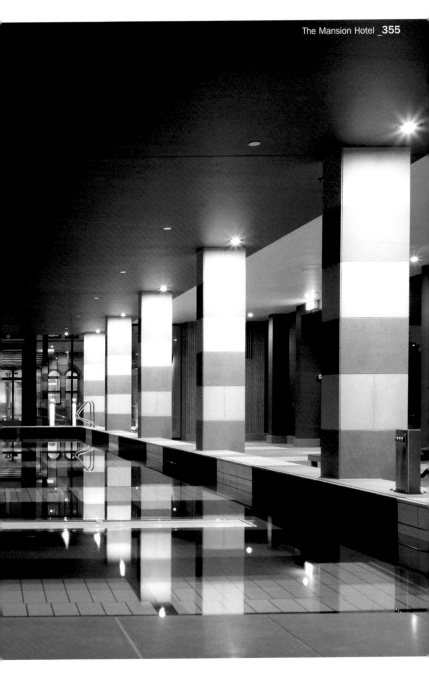

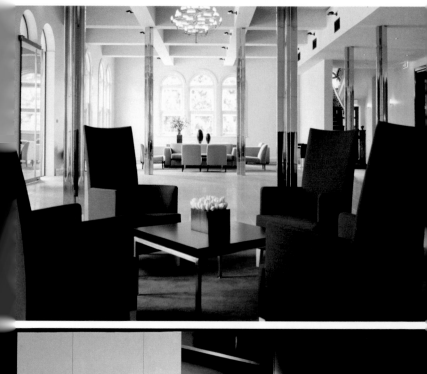

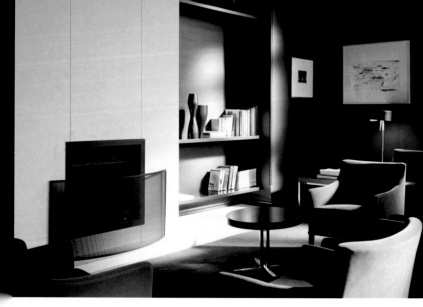

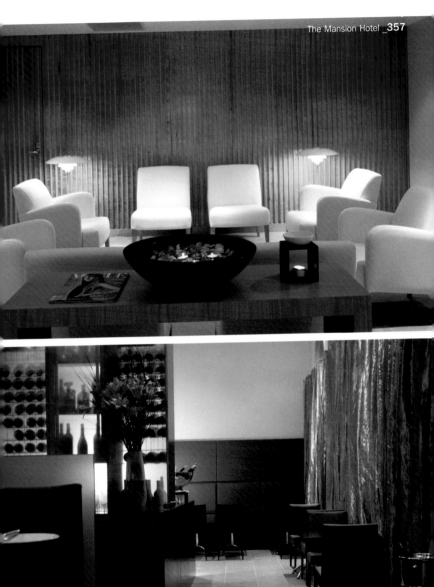

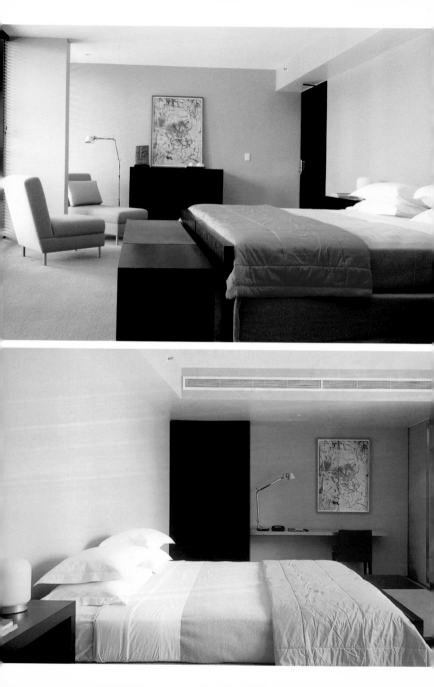

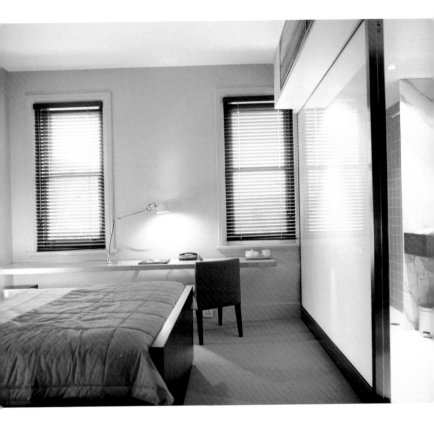

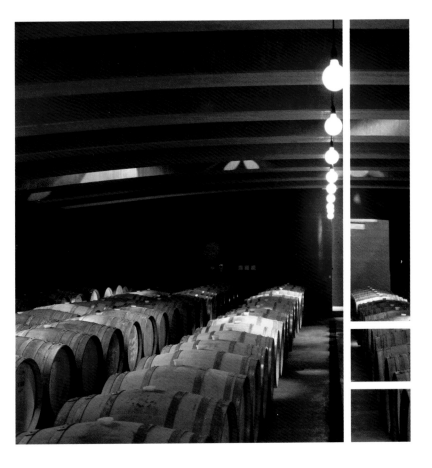

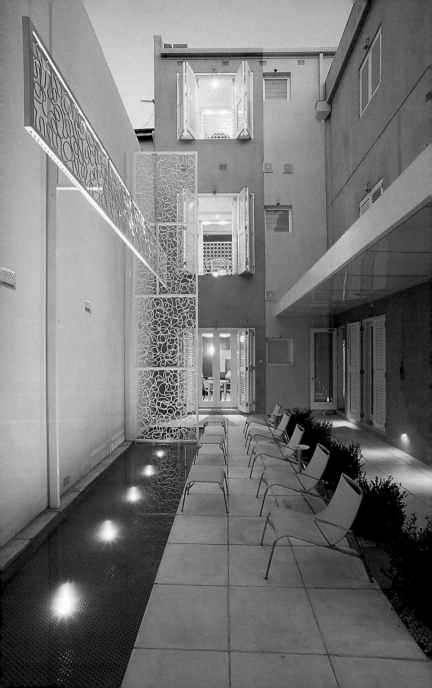

Medusa

Address: **267 Darlinghurst Road**
 Darlinghurst NSW 2010, Sydney, Australia
Tel.: **+ 61 2 9331 1000**
Fax: **+ 61 2 9380 6901**
www.medusa.com.au

Architect and interior designer: **Scott Weston**
Opening date: **1998**
Photos: **© Medusa**

363

Style: Glamorous retro

Rooms: 18

Special features: Colorful design

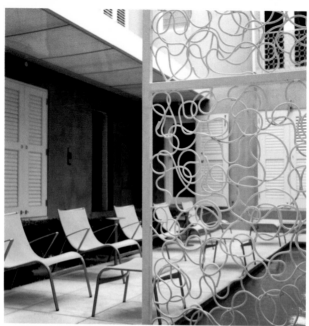

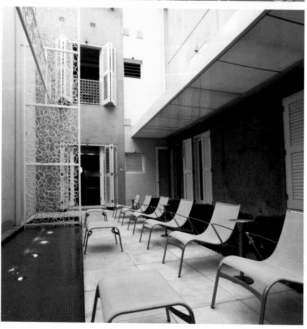

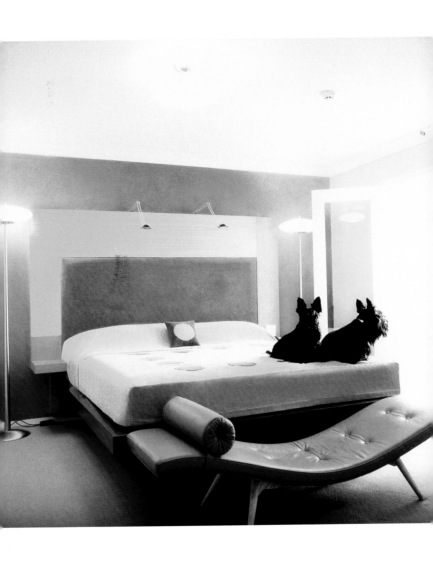

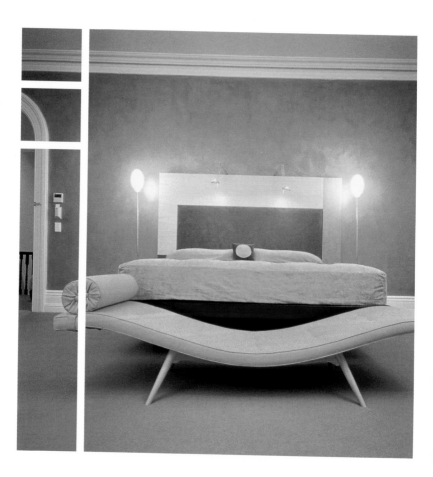

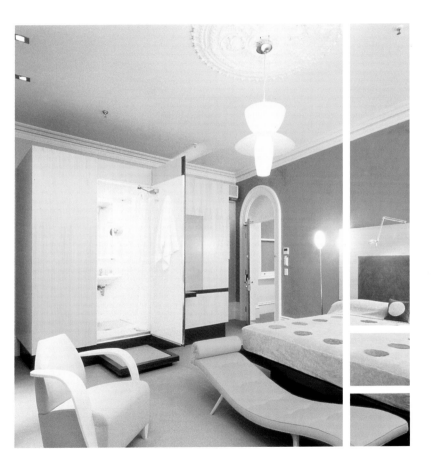

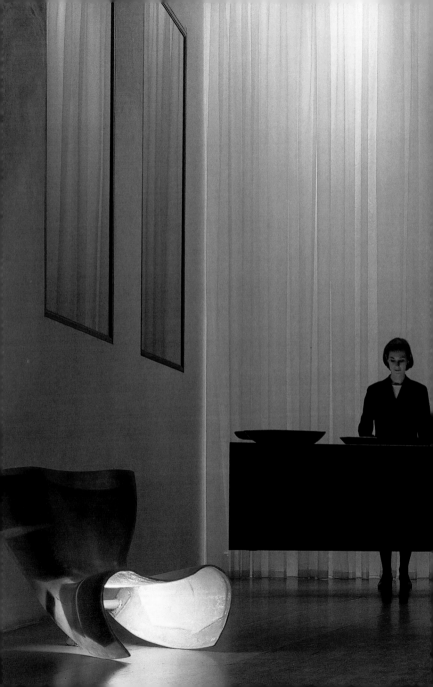

The Prince

Address: **2 Acland Street, St. Kilda,**
Victoria 3182, Australia
Tel.: **+61 3 9536 1111**
Fax: **+61 3 9536 1100**
www.theprince.com.au

Architect: **Alan Powell**
Interior designer: **Paul Hecker**
Opening date: **1999**
Photos: © **Earl Carter**

369

Style: Contemporary design

Rooms: 40

Special features: A hotel with a personality of its own with spectacular views of Port Philips Bay

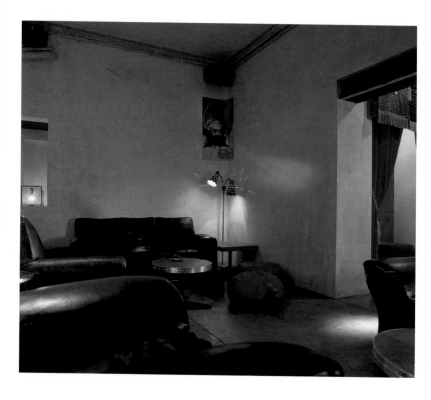

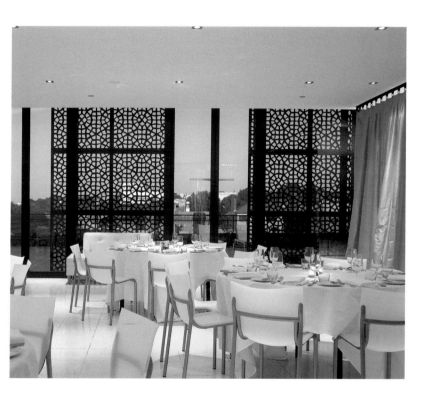

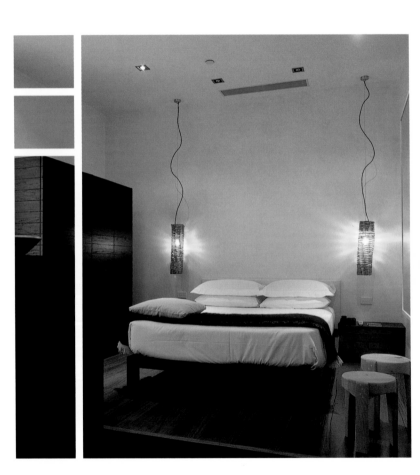

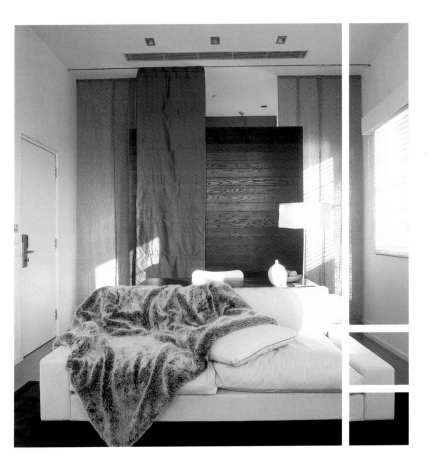

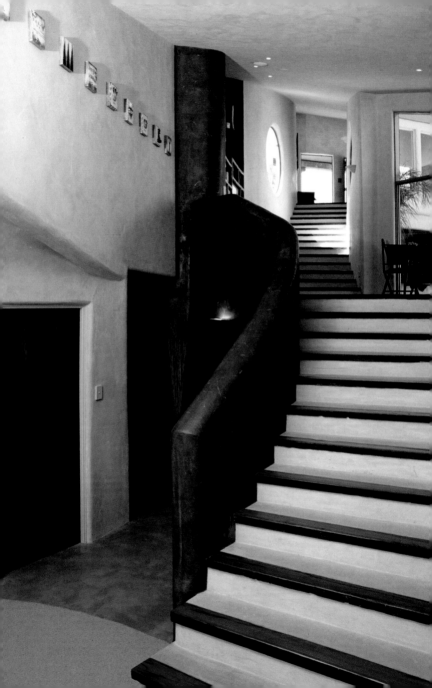

Delamore Lodge

Address: **83 Delamore Drive, P.O. Box 572, Waiheke Island,**
Auckland, New Zealand
Tel.: **+64 9 372 7372**
Fax: **+64 9 372 7382**
www.delamorelodge.com

Architect: **Ron Stevenson**
Opening date: **2003**
Photos: © **Cliff Schafer Microflight**

375

Style: Contemporary

Rooms: 4 rooms

Special features: Magical view of the sparkling Hauraki Gulf

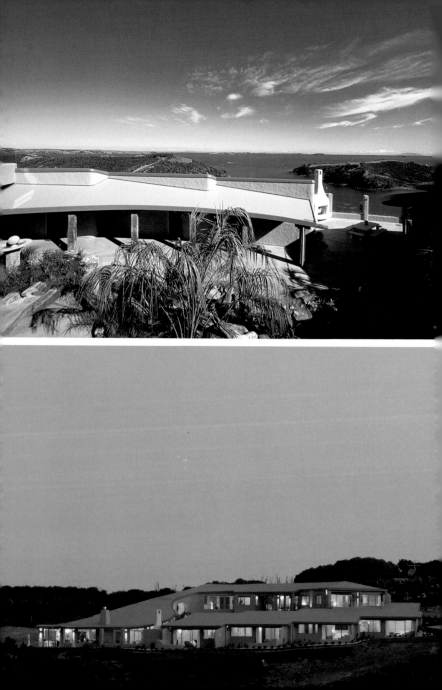

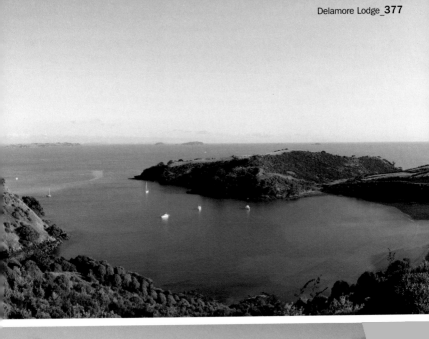

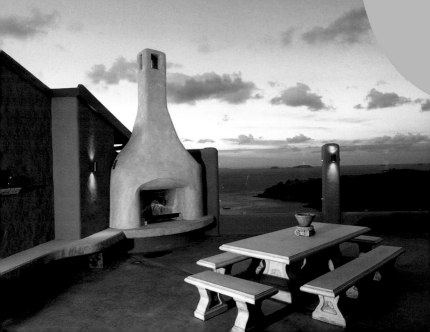

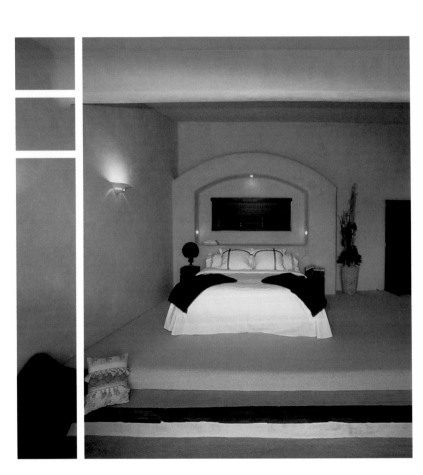

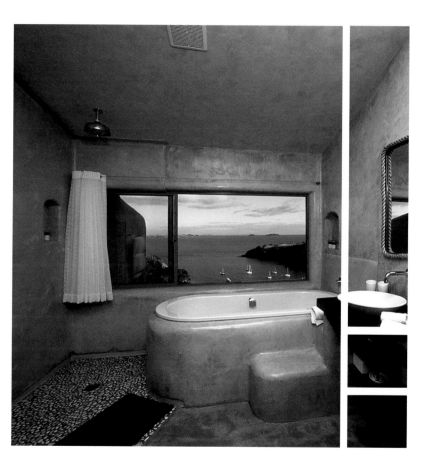

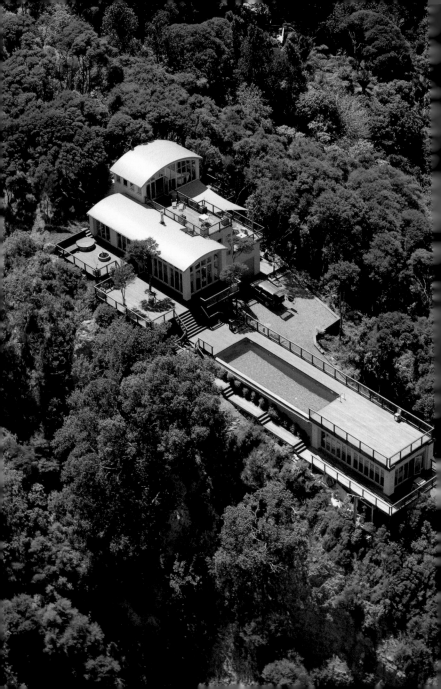

The Glass House

Address: **33 Okoka Road, Rock Bay,**
 Auckland, New Zealand
Tel.: **+64 9 372 3173**
Fax: **+64 9 372 4195**

Designers: **Matthew Harris and Cowley Whit**
Opening date: **2003**
Photos: © **Matthew Harris**

381

Style: Minimalist

Rooms: 3

Special features: Directly adjacent to footpath leading to nature reserve and white beaches

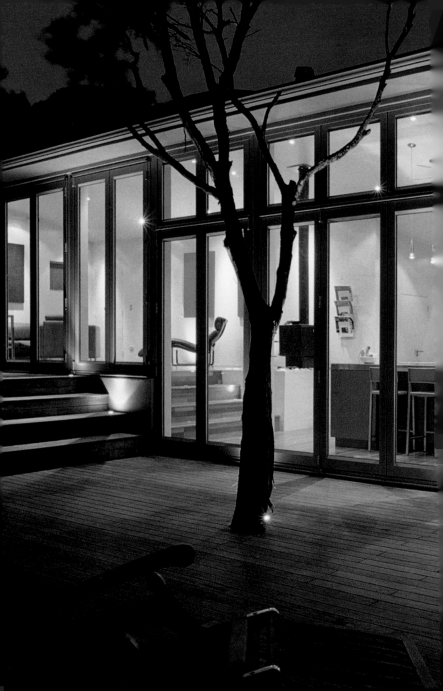

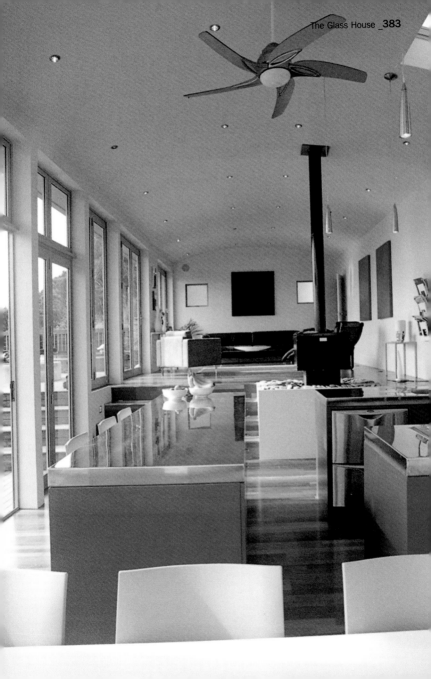

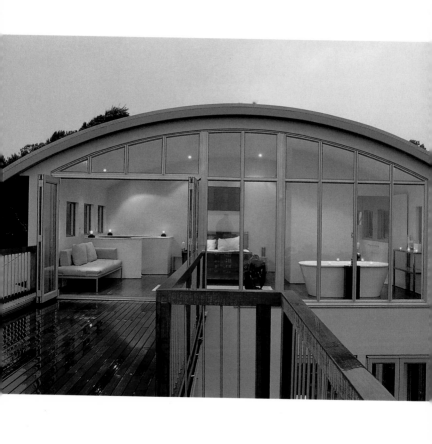

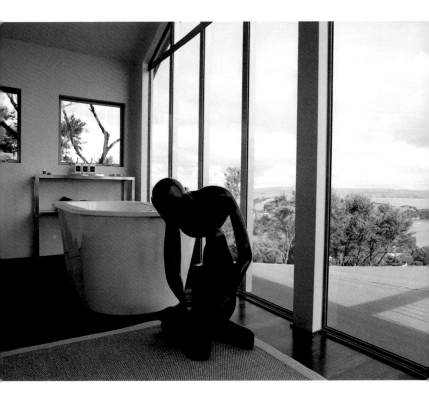

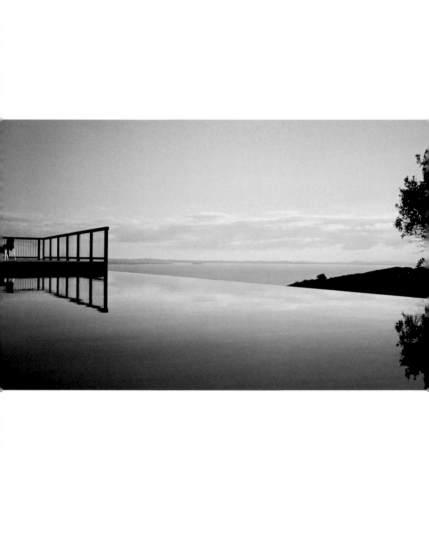

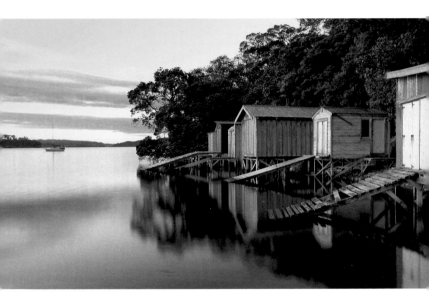

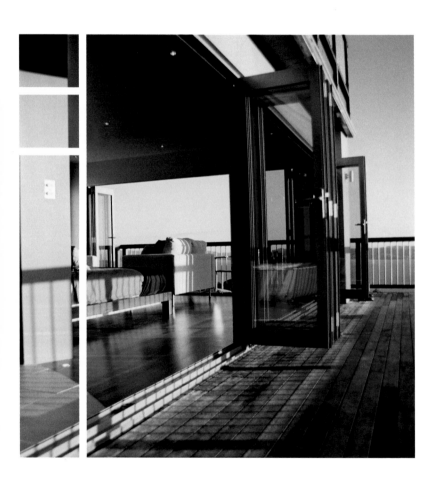

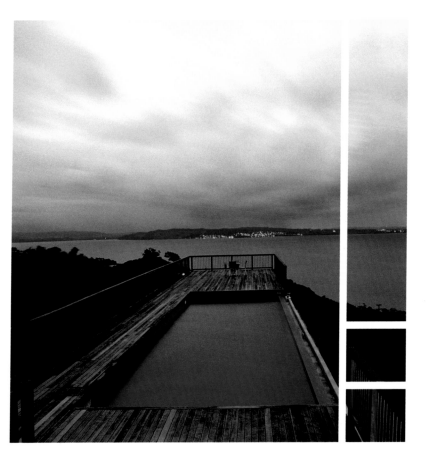

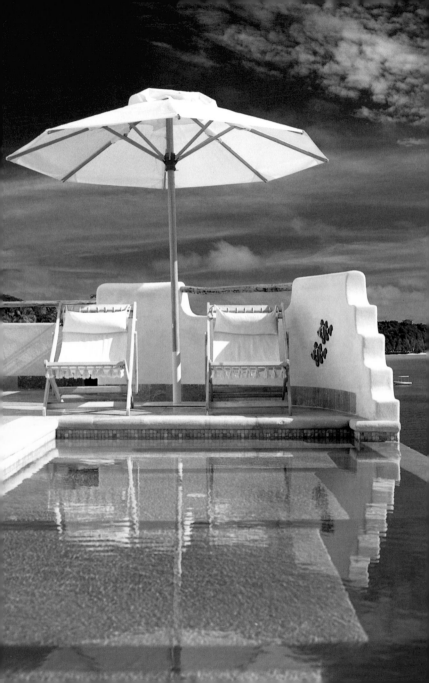

Vatulele

Address: **Vatulele Resort, Vatulele Island**
 Fiji Islands
Tel.: **+44 13 7246 9818**
Fax: **+44 13 7247 0057**
www.vatulele.com

Architects: **Doug Nelson & Martin Livingston;**
 Henry Crawford (The Point Villa)
Interior designer: **Henry Crawford**
Opening date: **1990**
Photos: **© Earl Carter & Peter Carrette/**
 Vatulele Island Resort

391

Style: Cool casual Pacific
Rooms: 19 "bures" or villas, 1 Grand Honeymoon Bure and
 The Point Villa

Special features: The best quite and
relaxing atmosphere

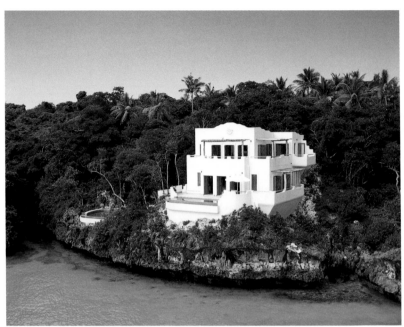

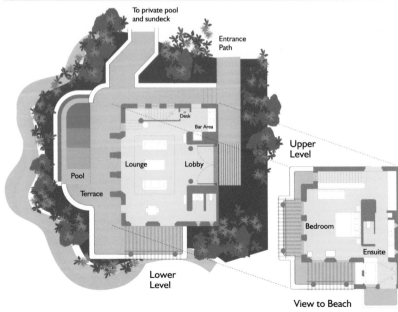

To private pool
and sundeck

Entrance
Path

Desk

Bar Area

Upper
Level

Lounge

Lobby

Pool

Terrace

Bedroom

Ensuite

Lower
Level

View to Beach
▼

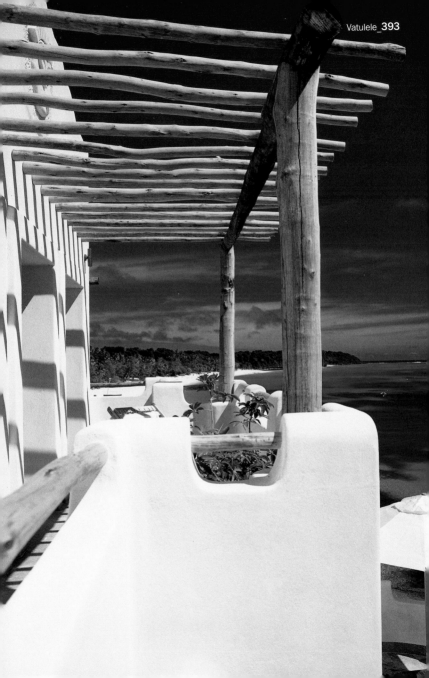

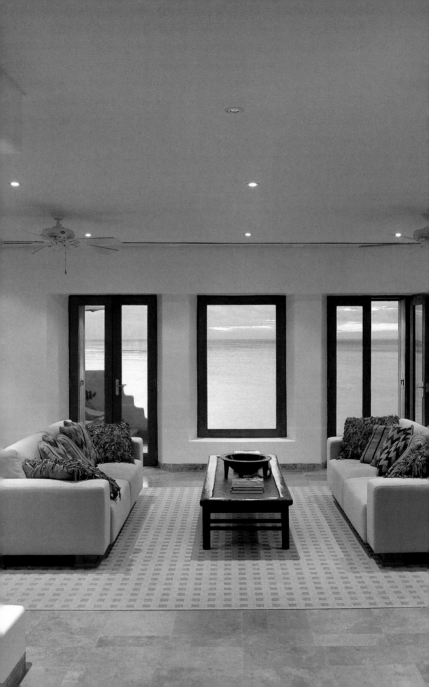

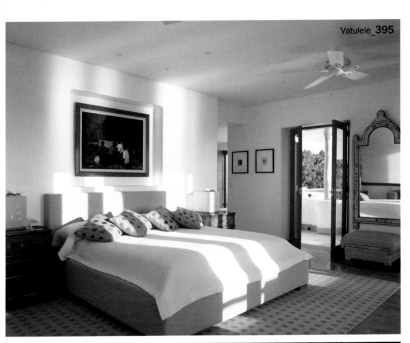

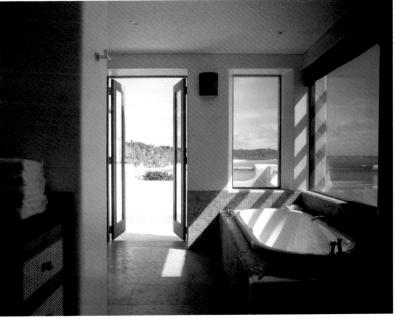

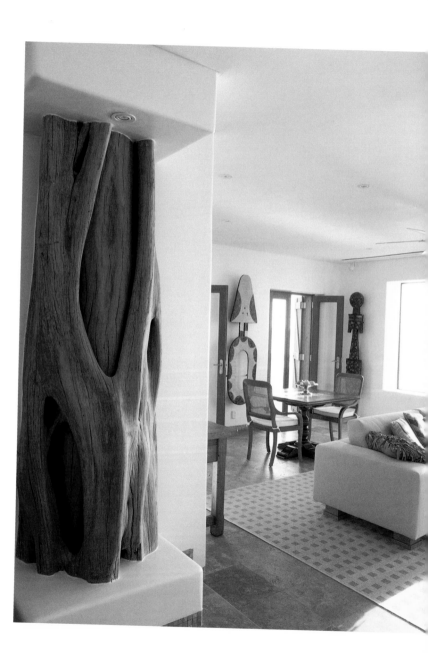

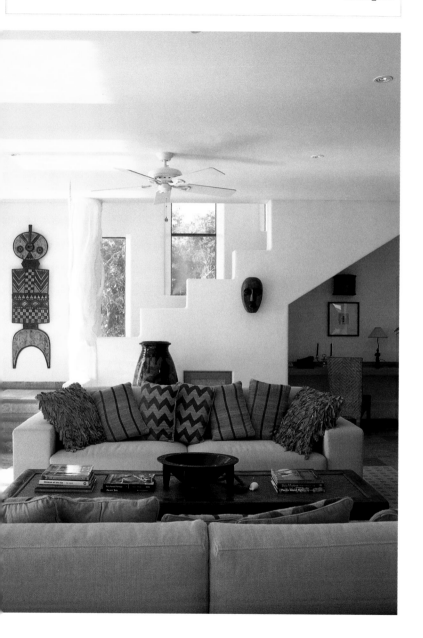

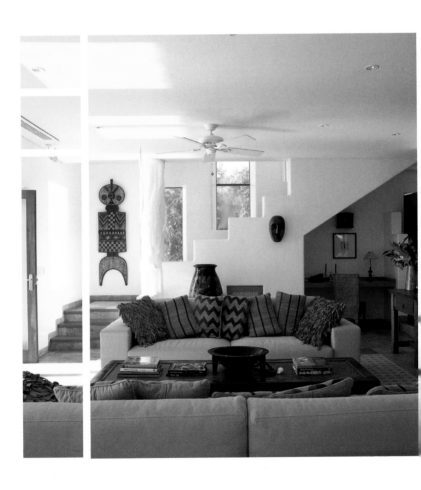